# UNDERSTANDING
# PHOTOGRAPHY

# UNDERSTANDING PHOTOGRAPHY

## Master Your Digital Camera and Capture That Perfect Photo

### SEAN T. McHUGH

**no starch press**

San Francisco

Printed in USA
First Printing

22 21 20 19 18    1 2 3 4 5 6 7 8 9

ISBN-10: 1-59327-894-2
ISBN-13: 978-1-59327-894-6

Publisher: **William Pollock**
Production Editor: **Laurel Chun**
Cover and Interior Design: **Mimi Heft**
Cover Photography: **Sean T. McHugh**
Developmental Editor: **Annie Choi**
Technical Reviewers: **Jeff Carlson and Richard Lynch**
Copyeditor: **Barton D. Reed**
Proofreader: **Paula L. Fleming**
Compositor: **Danielle Foster**

For information on distribution, translations, or bulk sales, please contact No Starch Press, Inc. directly:
No Starch Press, Inc.
245 8th Street, San Francisco, CA 94103
phone: 415.863.9900; info@nostarch.com
www.nostarch.com

Library of Congress Cataloging-in-Publication Data:
Names: McHugh, Sean (Sean T.), author.
Title: Understanding photography : master your digital camera and capture
   that perfect photo / Sean T. McHugh.
Description: San Francisco : No Starch Press, Inc., [2019].
Identifiers: LCCN 2018036966 (print) | LCCN 2018044393 (ebook) | ISBN
   9781593278953 (epub) | ISBN 1593278950 (epub) | ISBN 9781593278946 | ISBN
   9781593278946 (print) | ISBN 1593278942 (print) | ISBN
   9781593278953 (ebook) | ISBN 1593278950 (ebook)

*To everyone who has helped a friend or partner follow their passions,*
*even though that journey didn't always have a clear destination*

# CONTENTS

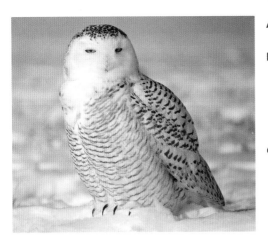

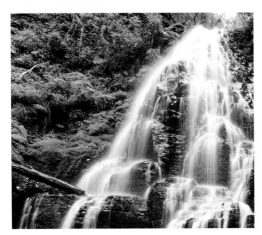

# ABOUT THE AUTHOR

Sean T. McHugh is the founder and owner of Cambridge in Colour (*www.cambridgeincolour .com*), an online learning community for photographers, and he was formerly head of product at a leading digital camera company. A scientist by training, he is fascinated by the interaction between technological developments and the range of creative options available to photographers. He has conducted several student workshops on general camera and DSLR technique.

# ACKNOWLEDGMENTS

This book would not have been possible without all the feedback and careful reading from photographers, specialists, and many others who have visited *www.cambridgeincolour.com* over more than a decade. Thank you.

Thanks to Bill Pollock, Annie Choi, Laurel Chun, Mimi Heft, Bart Reed, Paula Fleming, and Danielle Foster for editing and producing this book. Thanks also to Jeff Carlson and Richard Lynch for their technical review.

# Introduction

**VISION IS PERHAPS THE SENSE** we most associate with reality. We are therefore more conscious of what we see than how we see, but that all has to change when you learn photography. You have to augment your own eyesight with a deeper understanding of what is both technically possible and creatively desirable. Such an understanding is built not by following instructions for a specific camera model but by becoming fluent in the language of photography.

# COMPONENTS OF PHOTOGRAPHY

Before you dig in, read through this introduction to start building a foundational understanding of light and its interaction with the key components of a photographic system. Each of these topics is discussed in more depth in subsequent chapters.

## LIGHT

Let's start with the concept of light. After all, photography is essentially the process of capturing and recording light to produce an image. What we commonly refer to as *light* is just a particular type of electromagnetic radiation that spans a wide range of phenomena, from X-rays to microwaves to radio waves. The human eye only sees a narrow range called the *visible spectrum*, which fits between ultraviolet and infrared radiation and represents all the colors in a rainbow (see **FIGURE 1**).

**FIGURE 1**
Qualitative depiction of the visible spectrum among other invisible wavelengths in the electromagnetic spectrum (not to scale)

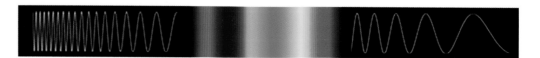

If you were creating a painting, the visible spectrum would represent all the colors of paint you could have in your palette. Every color and shade that you have ever seen, from the most intense sunsets to the most subtle nightscapes, is some combination of light from this spectrum. Our eyes perceive this color using a combination of three different color-sensing cells, each of which has peak sensitivity for a different region in the visible spectrum. Contrary to common belief, color is actually a sensation just like taste and smell. Our sensitivity to color is uniquely human, and it's a potent photographic tool for evoking emotions in the viewer.

## LENS

The first time light interacts with your photographic system is usually when it hits the front of your camera's lens. Your choice of lens is one of the first creative choices that irreversibly sculpts the recorded image (**FIGURE 2**, left). If the colors of light are your paint, then the lens is your paint brush.

In reality, lenses are far more powerful than that. For example, they can influence the viewer's sense of scale and depth, control the angle of view, or isolate a subject against an otherwise busy background. Lenses often receive less attention than camera bodies, but a good lens often outlives a good camera and thus deserves at least as much attention. Your lens choice can also have more of an impact on image quality than anything else in your photographic system.

The camera's lens effectively takes an angle of view plus a subject of focus and projects that onto the camera's sensor. Although often only the outer portion of glass is visible, modern lenses are actually composed of a series of carefully engineered, specialty glass elements that precisely control incoming light rays and focus those with maximal fidelity (**FIGURE 2**, right). For this reason, photographers often also refer to having a good lens as having "good glass."

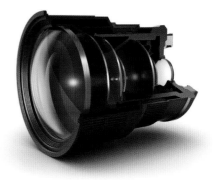

**FIGURE 2**
Digital SLR camera with a variety of lenses (left).
Cross section of a lens showing internal glass
elements (right).

## SENSORS

After light passes through your lens, it hits the digital sensor (**FIGURE 3**, left), which is what
receives light and converts it into an electrical signal (with film cameras, the sensor is instead
an exposed rectangular frame on the film strip but is otherwise very similar physically). If
light is your paint and the lens is your paint brush, then the sensor can be thought of as your
canvas. However, just as with the lens, the sensor determines far more than just the window
onto your scene; it controls how much detail you'll be able to extract, what lenses you'll be
able to use and the effect they'll have, and whether dramatic lighting can be fully recorded—
from the deepest shadows to the brightest highlights. In today's highly competitive camera
market that features cameras with well-tailored user interfaces and ergonomics, a good
sensor is often what determines a good camera.

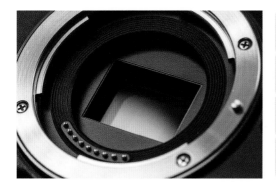

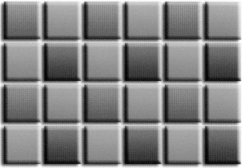

**FIGURE 3**
Camera sensor exposed
underneath a digital
SLR lens mount (left).
Qualitative illustration
of red, green, and blue
photosites within a tiny
portion of this sensor if
magnified 1000× (right).

Most camera sensors try to approximate the result of the three color-sensing cells in our eyes with their own variety of color-sensing elements, or *photosites*—usually of the red, green, and blue variety. The most common is the *Bayer array*, which includes alternating rows of red/green and green/blue photosites (**FIGURE 3**, right). Data from each of these photosites is later combined to create full-color images by both your camera and photo-editing software. The lens actually projects a circular image onto the sensor, but due to typical display and print formats, the sensor only records a central rectangular window from this larger imaging circle.

## CAMERA BODY

The camera body is what mechanically ties everything together, but just as importantly, it also electrically and optically coordinates all the components in your photographic system (**FIGURE 4**). Unlike the other components, though, the camera body has no close analogue in a painter's tool kit, except perhaps an extremely mobile canvas and easel. Portability is therefore where modern photography truly shines; you can often take your camera with you everywhere, allowing you to think about your everyday surroundings in a whole new way.

**FIGURE 4**
The outside of a digital SLR camera (top) along with an illustration of the key internal components (bottom)

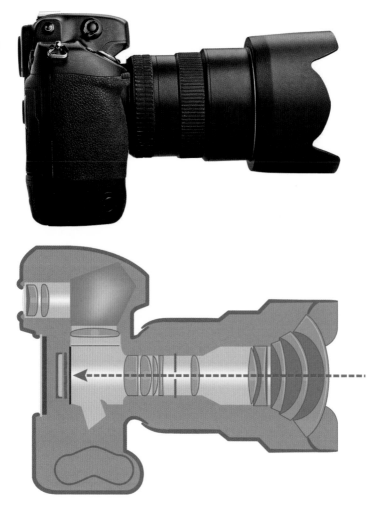

The camera body primarily controls or assists with the following: how much light is received, where and how to focus, how image information is stylized and recorded, and how an image is previewed. Camera bodies also come in many varieties, depending on your preference for image quality, mobility, price, and lens compatibility. Common types include smartphone or compact cameras, DSLR (digital single-lens reflex) cameras, and mirrorless cameras to name a few (**FIGURE 5**). This book focuses on DSLR and mirrorless cameras, but you can apply most of the concepts discussed here universally.

Other important but optional components of a photographic system include tripods for sharp, long exposures; lens filters for specialty shots; and lighting equipment for portraits and other carefully controlled shots. These optional components are discussed in Chapters 4 through 6 and Chapter 8.

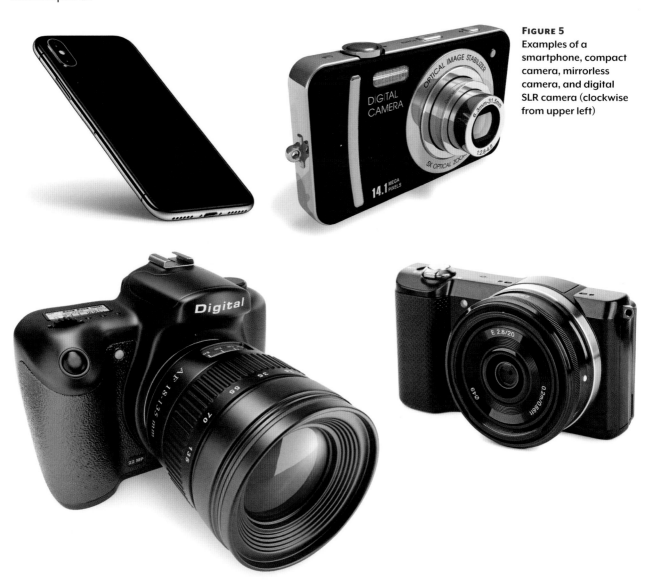

**FIGURE 5**
Examples of a smartphone, compact camera, mirrorless camera, and digital SLR camera (clockwise from upper left)

# WHO SHOULD READ THIS BOOK?

The components of photography covered here comprise what you need to physically take a photograph, but we've yet to discuss the most important component: the artist. As you practice and better understand your equipment, you'll learn how to make creative decisions about the images you create—from choosing a lens that accentuates your stylistic goals to selecting camera settings for exposing under challenging lighting. Eventually, you'll be thinking more artistically than technically because technique will become second nature.

To make creative decisions with confidence, though, you need to understand not only which camera settings are often used depending on subject matter but also, more importantly, why those settings are so frequently recommended. This book is therefore for photographic enthusiasts who want to take the time to build that educational foundation by deepening their overall understanding of light and cameras. The book focuses on everything prior to image processing—from the various ways you could record a subject all the way to maximizing image quality during an exposure.

# ABOUT THIS BOOK

Photography is often considered simple to grasp but complex to master, so you can use this book either to absorb everything from start to finish or to explore specific sections and fill in the gaps in your current knowledge. You can start with the basics and go straight to shooting or, if you feel ready, skip to the more advanced topics right away. Regardless of your experience level, photography offers hobbyists virtually limitless potential to hone their craft.

Here's an overview of what you'll find in each chapter:

- **Chapter 1: Basic Concepts in Photography** introduces exposure, camera metering, and depth of field.

- **Chapter 2: Digital Image Characteristics** introduces bit depth, digital sensors, histograms, and image noise.

- **Chapter 3: Understanding Camera Lenses** explains the key lens specifications plus how to use wide-angle and telephoto lenses in particular.

- **Chapter 4: Camera Types and Tripods** covers compact, mirrorless, and DSLR camera types, plus how to choose the right tripod.

- **Chapter 5: Lens Filters** shows when to use ultraviolet (UV), color, polarizing, neutral density (ND), and graduated neutral density (GND) filter types.

- **Chapter 6: Using Flash to Enhance Subject Illumination** introduces common flash equipment and exposure settings.

- **Chapter 7: Working with Natural Light and Weather** shows you how time of day and atmospheric conditions affect the qualities of light.

- **Chapter 8: Introduction to Portrait Lighting** shows you how the size, position, and relative intensity of single and dual light sources affect portraits.
- **Chapter 9: Other Shooting Techniques** discusses camera shake, autofocus, creative shutter speeds, and the rule of thirds.
- **Appendix: Cleaning Camera Sensors** shares techniques for cleaning your camera sensor.

Concepts such as light, exposure, and lens choice should all become part of your visual intuition; only then will you be able to push your equipment and creativity to their full potential.

Let's get started.

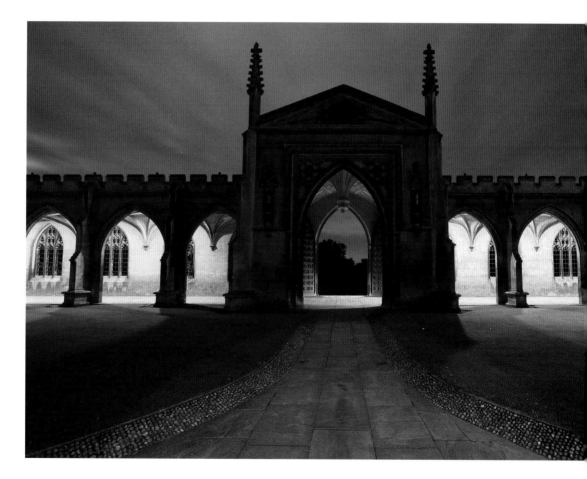

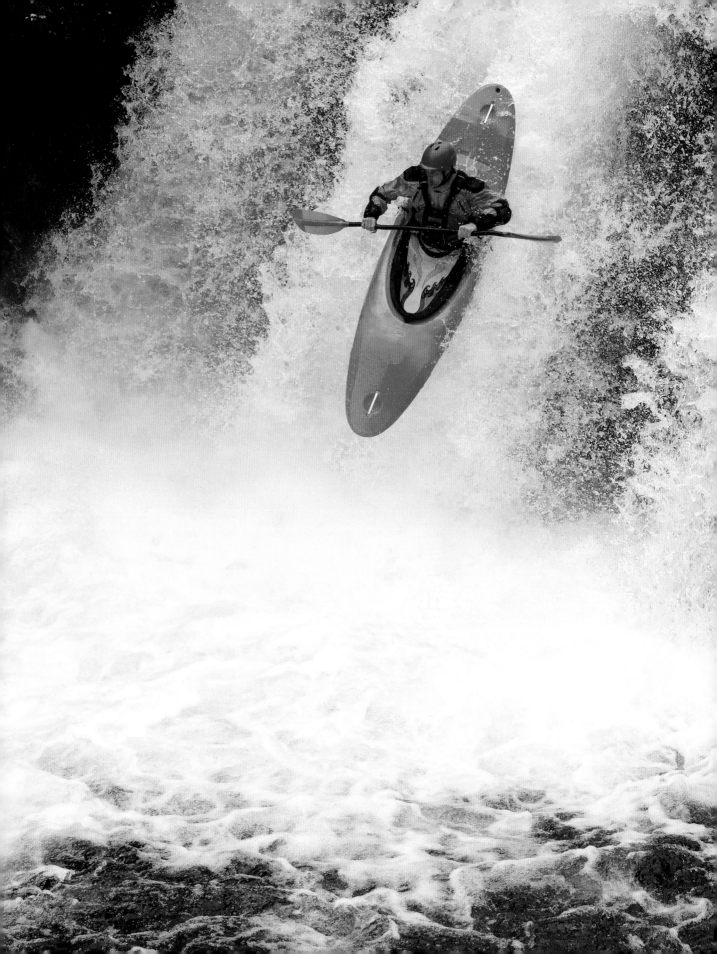

# 1

# Basic Concepts in Photography

**PHOTOGRAPHY BECOMES MOST ENJOYABLE** when you get comfortable with your camera. Achieving that level of comfort is less about remembering a list of settings and more about building the right understanding of the core concepts in photography.

Just like people who know how to ride a bike can focus more on where they're going than on turning the pedals or switching gears, when you become comfortable with your camera, you can focus more on capturing evocative imagery than on what settings are necessary to achieve those photos. In this chapter, we start that process by covering the key concepts and terminology in photography, which include the following topics:

- **Exposure** Aperture, ISO speed, and shutter speed are the three core controls that manipulate exposure. We discuss their technical impact on light and imagery as well as their limitations and trade-offs.

- **Camera metering** The engine that assesses light and exposure. We look at typical settings as well as some scenarios where camera metering comes in handy.

- **Depth of field** An important characteristic that influences our perception of space. We discuss how we quantify depth of field and which settings affect it.

Each high-level topic applies equally to both digital and traditional film photography. Let's begin by discussing exposure.

# UNDERSTANDING EXPOSURE

Exposure determines how light or dark an image will appear when it has been captured by your camera. Learning to control exposure is an essential part of developing your own intuition for photography.

Exposing a photograph is like collecting rain in a bucket. Although the rate of rainfall is uncontrollable, three factors remain under your control: the bucket's width, how long you leave the bucket in the rain, and the quantity of rain you need to collect. You don't want to collect too little (known as *underexposure*), but you also don't want to collect too much (known as *overexposure*). The key is that there are many different combinations of width, time, and quantity that can collect the amount of rainfall you want. For example, to get the same quantity of water, you can get away with less time in the rain if you pick a bucket that's really wide. Alternatively, for the same amount of time in the rain, a narrower bucket works fine if you can get by with less water.

## EXPOSURE TRIANGLE

Just as collecting rain in a bucket is controlled by the bucket's width, the duration of its exposure to the rain, and the quantity of rain desired, collecting light for exposure is determined by three camera settings: shutter speed, aperture, and ISO speed. Together, these settings are known as the *exposure triangle*. Let's take a closer look at how these control exposure:

- **Shutter speed**  Controls the duration of the exposure
- **Aperture**  Controls the area through which light can enter your camera
- **ISO speed**  Controls the sensitivity of your camera's sensor to a given amount of light

**FIGURE 1-1**
The exposure triangle

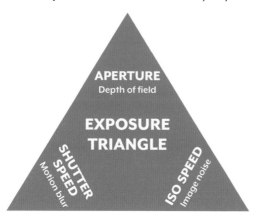

You can use many combinations of these three settings to achieve the same exposure. The key, however, is deciding which trade-offs to make, since each setting also influences other image properties. For example, aperture affects depth of field (which we'll discuss in "Understanding Depth of Field" on page 14), shutter speed affects motion blur, and ISO speed affects image noise. **FIGURE 1-1** illustrates the settings that make up the exposure triangle and the different image properties affected by each setting.

The next sections explain how these settings are quantified, how each of the three exposure controls affect the image, and how you can control these settings with exposure modes.

# SHUTTER SPEED

Let's begin by exploring how shutter speed affects your image. A camera's shutter determines when the camera sensor will be open or closed to incoming light from the camera lens. The shutter speed, or exposure time, refers to how long this light is permitted to enter the camera. *Shutter speed* and *exposure time* are often used interchangeably and refer to the same concept. A faster shutter speed means a shorter exposure time.

## QUANTIFYING SHUTTER SPEED

Shutter speed's influence on exposure is the simplest of the three camera settings: it correlates 1:1 with the amount of light entering the camera. For example, when the exposure time doubles, the amount of light entering the camera doubles. It's also the setting with the widest range of possibilities. **TABLE 1-1** illustrates the range of shutter speed settings and provides examples of what each can achieve.

**TABLE 1-1** Range of Shutter Speeds

| SHUTTER SPEED | TYPICAL EXAMPLE |
|---|---|
| 1 to 30+ seconds | To take specialty night and low-light photos on a tripod |
| 1/2 to 2 seconds | To add a silky look to flowing water landscape photos on a tripod for enhanced depth of field |
| 1/30 to 1/2 second | To add motion blur to the background of moving-subject, carefully taken, handheld photos with stabilization |
| 1/250 to 1/50 second | To take typical handheld photos without substantial zoom |
| 1/500 to 1/250 second | To freeze everyday sports/action, in moving-subject, handheld photos with substantial zoom (telephoto lens) |
| 1/8000 to 1/1000 second | To freeze extremely fast, up-close subject motion |

Note that the range in shutter speeds spans a 100,000× ratio between the shortest exposure and longest exposure, enabling cameras with this capability to record a wide variety of subject motion.

## HOW SHUTTER SPEED AFFECTS YOUR IMAGE

Slow shutter speed is useful for blurring motion, as when capturing waterfalls or when experimenting with creative shots. **FIGURE 1-2** uses a slow (1-second) shutter speed to blur the motion of the waterfall.

Most often, photographers try to avoid motion blurs using shutter speed. For example, a faster shutter speed can create sharper photos by reducing subject movement. **FIGURE 1-3** is a picture taken with a faster (1/60-second) shutter speed. A fast shutter speed also helps minimize camera shake when taking handheld shots.

**FIGURE 1-2**
Slow shutter speed
(blurs motion)

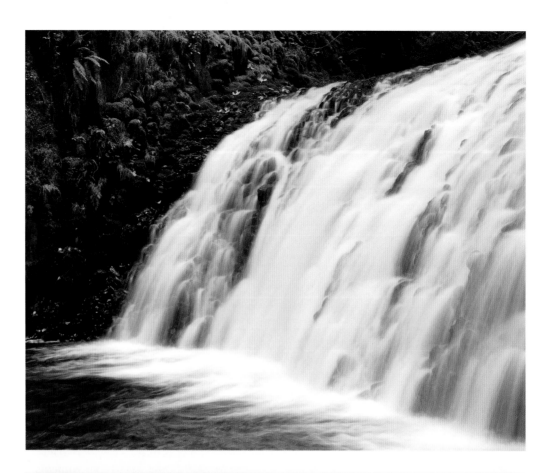

**FIGURE 1-3**
Fast shutter speed
(freezes motion)

How do you know which shutter speed will give you a sharp handheld shot? With digital cameras, the best way to find out is to experiment and look at the results on your camera's LCD (liquid crystal display) screen at full zoom. If a properly focused photo comes out blurred, you usually need to increase the shutter speed, keep your hands steadier, or use a camera tripod.

## APERTURE

A camera's *aperture* setting controls the width of the opening that lets light into your camera lens. We measure a camera's aperture using an *f-stop* value, which can be counterintuitive because the area of the opening increases as the f-stop decreases. For example, when photographers say they're "stopping down" or "opening up" their lens, they're referring to increasing and decreasing the f-stop value, respectively. **FIGURE 1-4** helps you visualize the area of the lens opening that corresponds to each f-stop value.

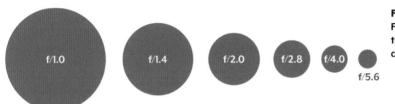

**FIGURE 1-4**
F-stop values and the corresponding aperture area

### QUANTIFYING APERTURE

Every time the f-stop value halves, the light-collecting area quadruples. There's a formula for this, but most photographers just memorize the f-stop numbers that correspond to each doubling or halving of light. **TABLE 1-2** lists some aperture and shutter speed combinations that result in the same exposure.

**TABLE 1-2** Example of Aperture Settings and Shutter Speed Combinations

| APERTURE SETTING | RELATIVE LIGHT | SAMPLE SHUTTER SPEED | APERTURE SETTING | RELATIVE LIGHT | SAMPLE SHUTTER SPEED |
|---|---|---|---|---|---|
| f/22 | 1× | 1 second | f/4.0 | 32× | 1/30 second |
| f/16 | 2× | 1/2 second | f/2.8 | 64× | 1/60 second |
| f/11 | 4× | 1/4 second | f/2.0 | 128× | 1/125 second |
| f/8.0 | 8× | 1/8 second | f/1.4 | 256× | 1/250 second |
| f/5.6 | 16× | 1/15 second | | | |

*NOTE: These sample shutter speeds are approximations of the Relative Light column based on typically available camera settings.*

You can see that as the f-stop value decreases (allowing more light in), the shutter speed has to be faster to compensate for the amount of light passing through the lens. Shutter speed values don't always come in increments of exactly double or half a shutter speed, but they're usually close enough that the difference is negligible.

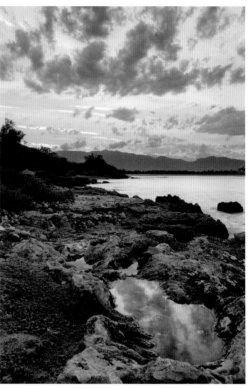

▲ **Figure 1-5**
Using a wide-aperture, low f-stop value (f/2.0) for a shallow depth of field

▶ **Figure 1-6**
Using a narrow-aperture, high f-stop value (f/16) for an expansive depth of field

The f-stop numbers in **Table 1-2** are all standard options in any camera, although most cameras also allow finer adjustments in 1/3- and 1/2-stop increments, such as f/3.2 and f/6.3. The range of values may also vary from camera to camera or lens to lens. For example, a compact camera might have an available range of f/2.8 to f/8.0, whereas a digital SLR (single-lens reflex) camera might have a range of f/1.4 to f/32 with a portrait lens. A narrow aperture range usually isn't a big problem, but a greater range gives you more creative flexibility.

## HOW APERTURE AFFECTS YOUR IMAGE

A camera's aperture setting affects the distance from the lens to where objects appear acceptably sharp, both in front of and behind where the camera is focusing. This range of sharpness is commonly referred to as the *depth of field*, and it's an important creative tool in portraiture for isolating a subject from its surroundings by making the subject look sharper than the backdrop. It can also maximize detail throughout, as with an expansive landscape vista.

Lower f-stop values create a shallower depth of field, whereas higher f-stop values create a more expansive depth of field. For example, with many cameras, f/2.8 and lower are common settings when a shallow depth of field is desired, whereas f/8.0 and higher are used when sharpness throughout is key.

**FIGURE 1-5** shows an example of a picture taken with wide aperture settings to achieve a shallow depth of field. You'll notice that the flower in the foreground, which the camera focuses on, is sharper than the rest of the objects. **FIGURE 1-6** shows an example of the opposite effect.

In this case, a narrow aperture creates a wider depth of field to bring all objects into relatively sharp focus. You can also control depth of field using settings other than aperture. We'll take a deeper look at other considerations affecting depth of field as well as how depth of field is defined and quantified in "Understanding Depth of Field" on page 14.

## ISO SPEED

The *ISO speed* determines how sensitive the camera is to incoming light. Similar to shutter speed, it also correlates 1:1 with how much the exposure increases or decreases. However, unlike aperture and shutter speed, a lower ISO speed is almost always desirable since higher ISO speeds dramatically increase *image noise*, or fine-scale variations of color or brightness in the image that are not present in the actual scene. Image noise is also called *film grain* in traditional film photography. **FIGURE 1-7** shows the relationship between image noise and ISO speed and what image noise looks like.

**FIGURE 1-7**
ISO speed and
image noise

**Low ISO speed**
(less image noise)

**High ISO speed**
(more image noise)

You can see that a low ISO speed results in less image noise, whereas a high ISO speed results in more image noise. You'd usually increase ISO from its base or default value only if you can't otherwise obtain the desired aperture and shutter speed. For example, you might want to increase the ISO speed to achieve both a fast shutter speed with moving subjects and a more expansive depth of field, or to be able to take a sharp handheld shot in low light when your lens is already at its widest aperture setting.

Common ISO speeds include 100, 200, 400, and 800, although many cameras also permit lower or higher values. With compact cameras, an ISO speed in the range of 50–400 generally produces acceptably low image noise, whereas with digital SLR cameras, a range of 100–3200 (or even higher) is often acceptable.

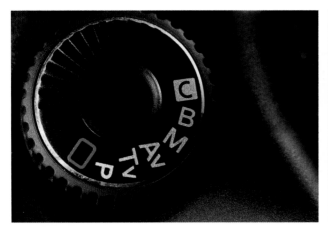

▲ **Figure 1-8**
Typical camera exposure modes
(including pre-set modes)

▶ **Figure 1-9**
Using S or Tv mode to
increase shutter speed

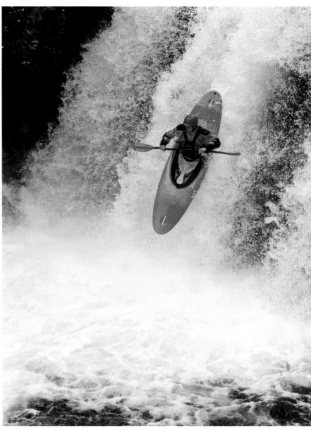

## CAMERA EXPOSURE MODES

Most digital cameras have one of the following standardized exposure modes: Auto (□), Program (P), Aperture Priority (A or Av), Shutter Priority (S or Tv), Manual (M), and Bulb (B). Av, Tv, and P modes are often called *creative modes* or *auto-exposure (AE) modes*. **Figure 1-8** shows some exposure modes you would see on a typical camera.

Each mode influences how aperture, ISO speed, and shutter speed values are chosen for a given exposure. Some modes attempt to pick all three values for you, whereas others let you specify one setting and the camera picks the other two when possible. **Table 1-3** describes how each mode determines exposure.

Auto-exposure mode doesn't allow for much creative control because it doesn't let you prioritize which camera settings are most important for achieving your artistic intent. For example, for an action shot of a kayaker, like **Figure 1-9**, you might want to use S or Tv mode because achieving a faster shutter speed is likely more important than the scene's depth of field. Similarly, for a static landscape shot, you might want to use A or Av mode because achieving an expansive depth of field is likely more important than the exposure duration.

In addition, the camera may also have several pre-set modes. The most common pre-set modes include landscape, portrait, sports, and night modes. The symbols used for each mode vary slightly from camera to camera but will likely appear similar to those shown in **Table 1-4**, which gives descriptions of the most common pre-set modes you'll find on a camera.

**TABLE 1-3** Descriptions of Common Exposure Modes

| EXPOSURE MODE | HOW IT WORKS |
| --- | --- |
| Auto (▢) | The camera automatically selects all exposure settings. |
| Program (**P**) | The camera automatically selects aperture and shutter speed. You choose a corresponding ISO speed and exposure compensation. With some cameras, P can also act as a hybrid of the Av and Tv modes. |
| Aperture Priority (**Av or A**) | You specify the aperture and ISO speed. The camera's metering (discussed in the next section) determines the corresponding shutter speed. |
| Shutter Priority (**Tv or S**) | You specify the shutter speed and ISO speed. The camera's metering determines the corresponding aperture. |
| Manual (**M**) | You specify the aperture, ISO speed, and shutter speed—regardless of whether these values lead to a correct exposure. |
| Bulb (**B**) | You specify the aperture and ISO speed. The shutter speed is determined by a remote release switch or, depending on the camera, by double-pressing or holding the shutter button. Useful for exposures longer than 30 seconds. |

**TABLE 1-4** Pre-set Exposure Modes

| EXPOSURE MODE | HOW IT WORKS |
| --- | --- |
| Portrait | The camera tries to pick the lowest f-stop value possible for a given exposure. This ensures the shallowest possible depth of field. |
| Landscape | The camera tries to pick a high f-stop to ensure a deep depth of field. Compact cameras also often set their focus distance to distant objects or infinity. |
| Sports/action | The camera tries to achieve as fast a shutter speed as possible for a given exposure (ideally 1/250 second or faster). In addition to using a low f-stop, the camera may also achieve a faster shutter speed by increasing the ISO speed to more than would be acceptable in portrait mode. |
| Night/low-light | The camera permits shutter speeds longer than ordinarily allowed for handheld shots and increases the ISO speed to near its maximum available value. However, for some cameras, this setting means that a flash is used for the foreground and that a long shutter speed and high ISO speed are used to expose the background. Check your camera's instruction manual for any unique characteristics. |

Some of the modes can also control camera settings unrelated to exposure, although this varies from camera to camera. These additional settings include the autofocus points, metering mode, and autofocus modes, among others.

Keep in mind that most of the modes rely on the camera's metering system to achieve proper exposure. The metering system is not foolproof, however. It's a good idea to be aware of what might go awry and what you can do to compensate for such exposure errors. In the next section, we discuss camera metering in more detail.

# CAMERA METERING

Knowing how your camera meters light is critical for achieving consistent and accurate exposures. The term *metering* refers to what was traditionally performed by a separate *light meter*, a device used to determine the proper shutter speed and aperture by measuring the amount of light available. In-camera metering options include spot, evaluative or matrix, and center-weighted metering. Each has its advantages and disadvantages, depending on the type of subject and distribution of lighting. Next, we discuss the difference between incident and reflected light to see how in-camera light meters determine proper exposure.

## INCIDENT VS. REFLECTED LIGHT

*Incident light* is the amount of light hitting the subject, and it's also a measurement that correlates directly with exposure. *Reflected light* refers to the amount of incident light that reflects back to the camera after hitting the subject and therefore only indirectly measures incident light. Whereas handheld light meters measure incident light, in-camera light meters can only measure reflected light. **FIGURE 1-10** illustrates the difference between incident light and reflected light.

**FIGURE 1-10**
Incident vs.
reflected light

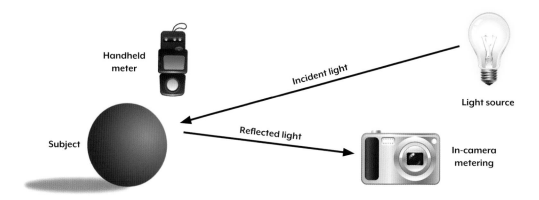

If all objects reflected light in the same way, getting the right exposure would be simple. However, real-world subjects vary greatly in their reflectance. For this reason, in-camera metering is standardized based on the intensity of light reflected from an object that

appears middle gray in tone. In fact, in-camera meters are designed for such middle-toned subjects. For example, if you fill the camera's image frame with an object lighter or darker than middle gray, the camera's metering will often incorrectly under- or overexpose the image, respectively. On the other hand, a handheld light meter results in the same exposure for any object given the same incident lighting because it measures incident light.

What constitutes middle gray? In the printing industry, it's defined as the ink density that reflects 18 percent of incident light. **FIGURE 1-11** shows approximations of 18 percent luminance using different colors.

**FIGURE 1-11**
Approximations of 18 percent luminance

18% gray tone    18% red tone    18% green tone    18% blue tone

Cameras adhere to a different standard than the printing industry. Whereas each camera defines middle gray slightly differently, it's generally defined as a tone ranging between 10 and 18 percent reflectance. Metering off a subject that reflects more or less light than this may cause your camera's metering algorithm to go awry, resulting in either under- or overexposure.

 **TECHNICAL NOTE**

Gray cards are more often used for white balance than for exposure. For studio work, many photographers use a light meter because it's far more accurate. A gray card has 10 to 18 percent reflectance (as opposed to 50 percent reflectance) to account for how our human visual system works. Because we perceive light intensity logarithmically as opposed to linearly, our visual system requires much less than half the reflectance for an object to be perceived as half as bright.

## METERING OPTIONS

To accurately expose a greater range of subject lighting and reflectance combinations, most cameras have several built-in metering options. Each option works by assigning a relative weighting to different light regions within the image. Those regions with a higher weighting are considered more reliable and thus contribute more to the final exposure calculation. **FIGURE 1-12** shows what different metering options might look like.

**FIGURE 1-12**
Partial and spot areas shown for 13.5 percent and 3.8 percent of the picture area, respectively, based on a Canon 1-series DSLR camera.

Center-weighted          Partial metering          Spot metering

As you can see in **Figure 1-12**, the whitest regions have a higher weighting and contribute most to the exposure calculation, whereas black areas don't. This means that subject matter placed within the whitest regions will appear closer to the intended exposure than subject matter placed within the darker regions. Each of these metering diagrams can also be off-center, depending on the metering options and autofocus point used.

More sophisticated metering algorithms like evaluative, zone, and matrix go beyond just using a regional map. These are usually the default when you set the camera to auto-exposure. These settings work by dividing the image into numerous subsections. Each subsection is then analyzed in terms of its relative location, light intensity, or color. The location of the autofocus point and orientation of the camera (portrait versus landscape) may also contribute to metering calculations.

### WHEN TO USE PARTIAL AND SPOT METERING

Partial and spot metering give the photographer far more control over exposure than the other settings, but these are also more difficult to use, at least initially, because the photographer has to be more careful about which portions of the scene are used for metering. *Partial* and *spot metering* work very similarly, but partial metering is based on a larger fraction of the frame than spot metering (as depicted in **Figure 1-12**), although the exact percentages vary based on camera brand and model. Partial and spot metering are often useful when there's a relatively small object in your scene that you need perfectly exposed or know will provide the closest match to middle gray, as shown in **Figure 1-13**.

**Figure 1-13**
A situation where you might want to use off-center partial or spot metering

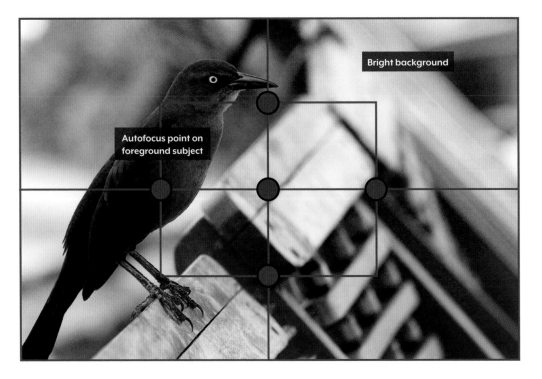

Bright background

Autofocus point on foreground subject

One of the most common applications of partial metering is in portraiture when the subject is backlit. Partially metering off the face can help avoid an exposure that makes the subject appear as an underexposed silhouette against the bright background. On the other hand, the shade of your subject's skin may lead to unintended exposure if it's too far from middle gray reflectance—although this is less likely with backlighting.

Spot metering is used less often because its metering area is very small and thus quite specific. This can be an advantage when you're unsure of your subject's reflectance and have a specially designed gray card or other standardized object from which to meter off.

Partial and spot metering are also useful for creative exposures or when the ambient lighting is unusual, like in **FIGURE 1-14**, which is an example of a photo taken with partial metering. In this case, the photographer meters off the directly lit stone below the sky opening to achieve a good balance between brightness in the sky and darkness on the rocks.

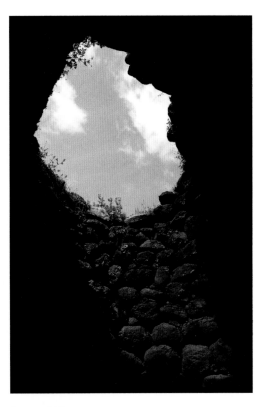

**FIGURE 1-14**
A photo taken using partial metering

### CENTER-WEIGHTED METERING

*Center-weighted metering* is when all regions of the frame contribute to the exposure calculation, but subject matter closer to the center of the frame contributes more to this calculation than does subject matter farther from the center. This was once a very common default setting in cameras because it coped well with a bright sky above a darker landscape. Nowadays, evaluative and matrix metering allow more flexibility, and partial and spot metering provide more specificity.

On the other hand, center-weighted metering produces very predictable results, whereas matrix and evaluative metering modes have complicated algorithms whose results are harder to predict. For this reason, some still prefer center-weighted as the default metering mode.

Note that there is no one correct way to achieve an exposure, since that is both a technical and a creative decision. Metering is just a technical tool that gives the photographer more control and predictability over their creative intent with the image.

## EXPOSURE COMPENSATION

With any of the previously discussed metering modes, you can use a feature called *exposure compensation (EC)*. When you activate EC, the metering calculation works normally, but the final exposure target gets compensated by the EC value. This allows for manual corrections if a metering mode is consistently under- or overexposing. Most cameras allow up to two stops of EC, where each stop provides either a doubling or halving of light compared to what the metering mode would have done without compensation. The default setting of zero means no compensation will be applied.

**FIGURE 1-15**
Example of a high reflec-
tance scene requiring
high positive exposure
compensation

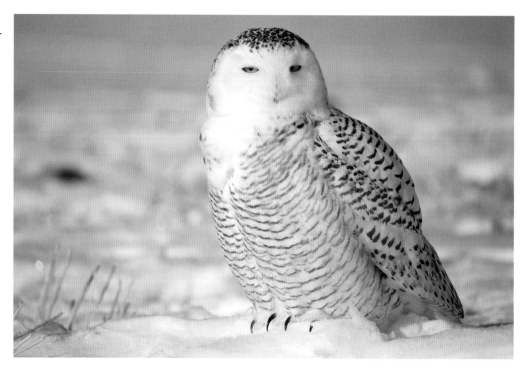

EC is ideal for correcting in-camera metering errors caused by the subject's reflectivity. For example, subjects in the snow with high reflectivity always require around +1 exposure compensation, whereas dark gray (unreflective) subjects may require negative compensation. **FIGURE 1-15** is an example of a highly reflective scene requiring high positive exposure compensation to avoid appearing too dark.

As you can see, exposure compensation is handy for countering the way an in-camera light meter underexposes a subject like a white owl in the snow, due to its high reflectivity.

## UNDERSTANDING DEPTH OF FIELD

This section covers the technical aspects of depth of field to give you a deeper understanding of how it's measured and defined. Feel free to skim through this section if you'd rather focus on the concepts and techniques to control depth of field, which we'll cover in "Controlling Depth of Field" on page 16.

*Depth of field* refers to the range of distance that appears acceptably sharp within an image. This distance varies depending on camera type, aperture, and focusing distance. Print size and viewing distance can also influence our perception of depth of field.

The depth of field doesn't abruptly change from sharp to blurry but instead gradually transitions. In fact, when you focus your camera on a subject, everything immediately in front of or in back of the focusing distance begins to lose sharpness—even if this transition is not perceived by your eyes or by the resolution of the camera.

## CIRCLE OF CONFUSION

Because there's no single critical point of transition, a more rigorous term called the *circle of confusion* is used to define the depth of field. The circle of confusion is defined by how much a point needs to be blurred so it's no longer perceived as sharp. When the circle of confusion becomes blurry enough to be perceptible to our eyes, this region is said to be outside the depth of field and thus no longer acceptably sharp. **FIGURE 1-16** illustrates a circle of confusion and its relationship to the depth of field.

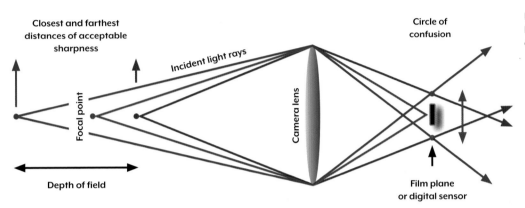

**FIGURE 1-16**
Diagram illustrating the circle of confusion

In this diagram, the left side of the camera lens represents light from your subject, whereas the right side of the lens represents the image created by that light after it has passed through the lens and entered your camera. As you can see, the blue lines represent the light from subject matter that coincides with the *focal plane*, which is the distance at which the subject is in sharpest focus. The purple and green dots on either side of the focal plane represent the closest and farthest distances of acceptable sharpness.

As you can see in **FIGURE 1-17**, a point light source can have various degrees of blur when recorded by your camera, and the threshold by which such blur is no longer deemed acceptably sharp is what defines the circle of confusion. Note that the circle of confusion has been exaggerated for the sake of demonstration; in reality, this would occupy only a tiny fraction of the camera sensor's area.

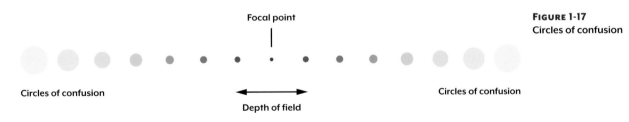

**FIGURE 1-17**
Circles of confusion

When does the circle of confusion become perceptible to our eyes? An acceptably sharp circle of confusion is commonly defined as one that would go unnoticed when enlarged to a standard 8 × 10 inch print and observed from a standard viewing distance of about 1 foot.

**FIGURE 1-18**
Lens depth of field
markers

At this viewing distance and print size, camera manufacturers assume a circle of confusion is negligible if it's no larger than 0.01 inches. In other words, anything blurred by more than 0.01 inches would appear blurry. Camera manufacturers use the 0.01 inch standard when providing lens depth-of-field markers. **FIGURE 1-18** shows an example of depth-of-field markers on a 50 mm lens.

In reality, a person with 20/20 vision or better can distinguish features much smaller than 0.01 inches. In other words, the sharpness standard of a camera is three times worse than someone with 20/20 vision! This means that the circle of confusion has to be even smaller to achieve acceptable sharpness throughout the image.

A different maximum circle of confusion also applies for each print size and viewing distance combination. In the earlier example of blurred dots, the circle of confusion is actually smaller than the resolution of your screen (or printer) for the two dots on either side of the focal point, and so these are considered within the depth of field. Alternatively, the depth of field can be based on when the circle of confusion becomes larger than the size of your digital camera's pixels.

Note that depth of field only determines when a subject is deemed acceptably sharp; it doesn't describe what happens to regions once they become out of focus. These regions are also called *bokeh* (pronounced *boh-keh*) from the Japanese word meaning "blur." Two images with identical depths of field may have significantly different bokeh, depending on the shape of the lens diaphragm. In fact, the circle of confusion isn't actually a circle but only approximated as such when it's very small. When it becomes large, most lenses render it as a polygon with five to eight sides.

## CONTROLLING DEPTH OF FIELD

Although print size and viewing distance influence how large the circle of confusion appears to our eyes, aperture and focusing distance are the two main factors that determine how big the circle of confusion will be on your camera's sensor. Larger apertures (smaller f-stop number) and closer focusing distances produce a shallower depth of field. In **FIGURE 1-19**, all three photos have the same focusing distance but vary in aperture setting.

FIGURE 1-19
Images taken with a
200 mm lens at the
same focus distance
with varying apertures

| f/8.0 | f/5.6 | f/2.8 |

As you can see from this example, f/2.8 creates a photo with the least depth of field since the background is the most blurred relative to the foreground, whereas f/5.6 and f/8.0 create a progressively sharper background. In all three photos, the focus was placed on the foreground statue.

 **TECHNICAL NOTE**

Your choice of lens focal length doesn't influence depth of field, contrary to common belief. The only factors that have a substantial influence on depth of field are aperture, subject magnification, and the size of your camera's image sensor. All of these topics will be discussed in more depth in subsequent chapters.

If sharpness throughout the image is the goal, you might be wondering why you can't just always use the smallest aperture to achieve the best possible depth of field. Other than potentially requiring prohibitively long shutter speeds without a camera tripod, too small an aperture softens the image, even where you're focusing, due to an effect called *diffraction*. Diffraction becomes a more limiting factor than depth of field as the aperture gets smaller. This is why pinhole cameras have limited resolution despite their extreme depth of field.

## SUMMARY

In this chapter, you learned how aperture, ISO speed, and shutter speed affect exposure. You also learned about the standard camera exposure modes you can use to control exposure in your image. You learned about different metering options that give you even more control over exposure. Finally, you explored the various factors that affect depth of field in your image.

In the next chapter, you'll learn about the unique characteristics of a digital image so you can better interpret these as a photographer.

# 2

# Digital Image Characteristics

**IN THIS CHAPTER, YOU'LL FAMILIARIZE** yourself with the unique characteristics of digital imagery so you can make the most of your images. First, you'll learn how the digital color palette is quantified and when it has a visual impact, which you'll need to know in order to understand bit depth. Then you'll explore how digital camera sensors convert light and color into discrete pixels.

The last two sections of this chapter cover how to interpret image histograms for more predictable exposures, as well as the different types of image noise and ways to minimize it.

# UNDERSTANDING BIT DEPTH

*Bit depth* quantifies the number of unique colors in an image's color palette in terms of the zeros and ones, or bits, we use to specify each color. This doesn't mean that an image necessarily uses all of these colors, but it does mean that the palette can specify colors with a high level of precision.

In a grayscale image, for example, the bit depth quantifies how many unique shades of gray are available. In other words, a higher bit depth means that more colors or shades can be encoded because more combinations of zeros and ones are available to represent the intensity of each color. We use a grayscale example here because the way we perceive intensity in color images is much more complex.

## TERMINOLOGY

Every color pixel in a digital image is created through some combination of the three primary colors: red, green, and blue. Each primary color is often referred to as a *color channel* and can have any range of intensity values specified by its bit depth. The bit depth for each primary color is called the *bits per channel*. The *bits per pixel (bpp)* refers to the sum of the bits in all three color channels and represents the total colors available at each pixel.

Confusion arises frequently regarding color images because it may be unclear whether a posted number refers to the bits per pixel or bits per channel. Therefore, using bpp to specify the unit of measurement helps distinguish these two terms.

For example, most color images you take with digital cameras have 8 bits per channel, which means that they can use a total of eight 0s and 1s. This allows for $2^8$ (or 256) different combinations, which translate to 256 different intensity values for each primary color. When all three primary colors are combined at each pixel, this allows for as many as $2^{8*3}$ (or 16,777,216) different colors, or *true color*. Combining red, green, and blue at each pixel in this way is referred to as *24 bits per pixel* because each pixel is composed of three 8-bit color channels. We can generalize the number of colors available for any *x*-bit image with the expression $2^x$, where *x* refers to the bits per pixel, or $2^{3x}$, where *x* refers to the bits per channel.

**TABLE 2-1** illustrates different image types in terms of bit depth, total colors available, and common names. Many of the lower bit depths were only important with early computers; nowadays, most images are 24 bpp or higher.

**TABLE 2-1**  Comparing the Bit Depth of Different Image Types

| BITS PER PIXEL | NUMBER OF COLORS AVAILABLE | COMMON NAME(S) |
|---|---|---|
| 1 | 2 | Monochrome |
| 2 | 4 | CGA |
| 4 | 16 | EGA |
| 8 | 256 | VGA |
| 16 | 65,536 | XGA, high color |
| 24 | 16,777,216 | SVGA, true color |
| 32 | 16,777,216 + transparency | |
| 48 | 281 trillion | |

## VISUALIZING BIT DEPTH

Note how **Figure 2-1** changes when the bit depth is reduced. The difference between 24 bpp and 16 bpp may look subtle, but will be clearly visible on a monitor if you have it set to true color or higher (24 or 32 bpp).

24 bpp

## DIGITAL PHOTO TIPS

Although the concept of bit depth may at first seem needlessly technical, understanding when to use high- versus low-bit depth images has important practical applications. Key tips include:

- The human eye can discern only about 10 million different colors, so saving an image in any more than 24 bpp is excessive if the intended purpose is for viewing only. On the other hand, images with more than 24 bpp are still quite useful because they hold up better under post-processing.

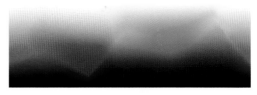

16 bpp

- You can get undesirable color gradations in images with fewer than 8 bits per color channel, as shown in **Figure 2-2**. This effect is commonly referred to as *posterization*.

- The available bit depth settings depend on the file type. Standard JPEG and TIFF files can use only 8 and 16 bits per channel, respectively.

8 bpp

**Figure 2-1**
Visual depiction of 8 bpp, 16 bpp, and 24 bpp using rainbow color gradients

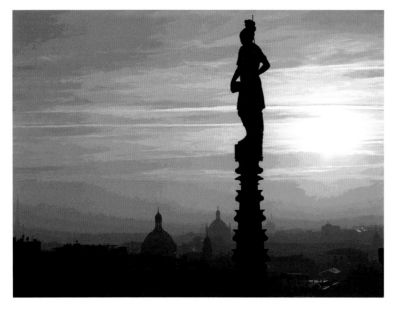

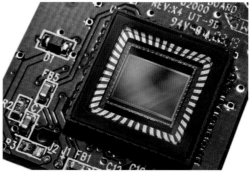

◄ **FIGURE 2-2**
A limited palette of 256 colors results in a banded appearance called posterization.

▲ **FIGURE 2-3**
A digital sensor with millions of imperceptible color filters

# DIGITAL CAMERA SENSORS

A digital camera uses a sensor array of millions of tiny pixels (see **FIGURE 2-3**) to produce the final image. When you press your camera's shutter button and the exposure begins, each of these pixels has a cavity called a *photosite* that is uncovered to collect and store photons.

After the exposure finishes, the camera closes each of these photosites and then tries to assess how many photons fell into each. The relative quantity of photons in each cavity is then sorted into various intensity levels, whose precision is determined by bit depth (0–255 levels for an 8-bit image). **FIGURE 2-4** illustrates how these cavities collect photons.

**FIGURE 2-4**
Using cavities to collect photons

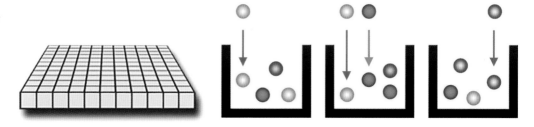

The grid on the left represents the array of light-gathering photosites on your sensor, whereas the reservoirs shown on the right depict a zoomed in cross section of those same photosites. In **FIGURE 2-4**, each cavity is unable to distinguish how much of each color has fallen in, so the grid diagram illustrated here would only be able to create grayscale images.

# BAYER ARRAY

To capture color images, each cavity has to have a filter placed over it that allows penetration of only a particular color of light. Virtually all current digital cameras can capture only one of the three primary colors in each cavity, so they discard roughly two-thirds of the incoming light. As a result, the camera has to approximate the other two primary colors to have information about all three colors at every pixel. The most common type of color filter array, called a *Bayer array*, is shown in **FIGURE 2-5**.

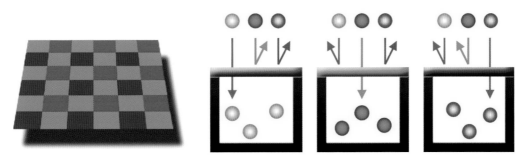

**FIGURE 2-5**
A Bayer array

As you can see, a Bayer array consists of alternating rows of red-green and green-blue filters (as shown in **FIGURES 2-5** and **2-6**). Notice that the Bayer array contains twice as many green as red or blue sensors. In fact, each primary color doesn't receive an equal fraction of the total area because the human eye is more sensitive to green light than both red and blue light. Creating redundancy with green photosites in this way produces an image that appears less noisy and has finer detail than if each color were treated equally. This also explains why noise in the green channel is much less than for the other two primary colors, as you'll learn later in the chapter in the discussion of image noise.

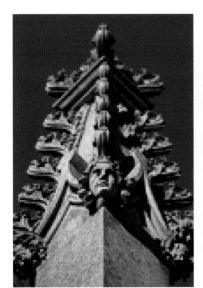

**FIGURE 2-6**
Full color versus Bayer array representations of an image

**Original scene**
(with enlarged pixels)

**Equivalent Bayer array**
**of original scene**

Not all digital cameras use a Bayer array. For example, the Foveon sensor is one example of a sensor type that captures all three colors at each pixel location. Other cameras may capture four colors in a similar array: red, green, blue, and emerald green. But a Bayer array remains by far the most common setup in digital camera sensors.

## BAYER DEMOSAICING

*Bayer demosaicing* is the process of translating a Bayer array of primary colors into a final image that contains full-color information at each pixel. How is this possible when the camera is unable to directly measure full color? One way of understanding this is to instead think of each 2×2 array of red, green, and blue as a single full-color cavity, as shown in **FIGURE 2-7**.

Although this 2×2 approach is sufficient for simple demosaicing, most cameras take additional steps to extract even more image detail. If the camera treated all the colors in each 2×2 array as having landed in the same place, then it would only be able to achieve half the resolution in both the horizontal and vertical directions.

On the other hand, if a camera computes the color using several overlapping 2×2 arrays, then it can achieve a higher resolution than would be possible with a single set of 2×2 arrays. **FIGURE 2-8** shows how the camera combines overlapping 2×2 arrays to extract more image information.

**FIGURE 2-7**
Bayer demosaicing using 2×2 arrays

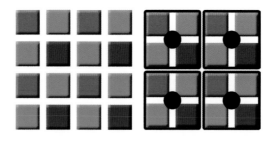

**FIGURE 2-8**
Combining overlapping 2×2 arrays to get more image information

Note that we do not calculate image information at the very edges of the array because we assume the image continues in each direction. If these were actually the edges of the cavity array, then demosaicing calculations here would be less accurate, because there are no longer pixels on all sides. This effect is typically negligible, because we can easily crop out information at the very edges of an image.

Other demosaicing algorithms exist that can extract slightly more resolution, produce images that are less noisy, or adapt to best approximate the image at each location.

## DEMOSAICING ARTIFACTS

Images with pixel-scale detail can sometimes trick the demosaicing algorithm, producing an unrealistic-looking result. We refer to this as a *digital artifact*, which is any undesired or unintended alteration in data introduced in a digital process. The most common artifact in digital photography is *moiré* (pronounced "more-ay"), which appears as repeating patterns, color artifacts, or pixels arranged in an unrealistic maze-like pattern, as shown in **Figures 2-9** and **2-10**.

**Figure 2-9**
Image with pixel-scale details captured at 100 percent

**Figure 2-10**
Captured at 65 percent of the size as in Figure 2-9, resulting in more moiré

You can see moiré in all four squares in **Figure 2-10** and also in the third square of **Figure 2-9**, where it is more subtle. Both maze-like and color artifacts can be seen in the third square of the downsized version. These artifacts depend on both the type of texture you're trying to capture and the software you're using to develop the digital camera's files.

However, even if you use a theoretically perfect sensor that could capture and distinguish all colors at each photosite, moiré and other artifacts could still appear. This is an unavoidable consequence of any system that samples an otherwise continuous signal at discrete intervals or locations. For this reason, virtually every photographic digital sensor incorporates something called an *optical low-pass filter (OLPF)* or an *anti-aliasing (AA) filter*. This is typically a thin layer directly in front of the sensor, and it works by effectively blurring any potentially problematic details that are finer than the resolution of the sensor. However, an effective OLPF also marginally softens details coarser than the resolution of the sensor, thus slightly reducing the camera's maximum resolving power. For this reason, cameras that are designed for astronomical or landscape photography may exclude the OLPF because for these applications, the slightly higher resolution is often deemed more important than a reduction of aliasing.

## MICROLENS ARRAYS

You might wonder why **FIGURES 2-4** and **2-5** do not show the cavities placed directly next to each other. Real-world camera sensors do not have photosites that cover the entire surface of the sensor in order to accommodate other electronics. Digital cameras instead contain *microlenses* above each photosite to enhance their light-gathering ability. These lenses are analogous to funnels that direct photons into the photosite, as shown in **FIGURE 2-11**.

Without microlenses, the photons would go unused, as shown in **FIGURE 2-12**.

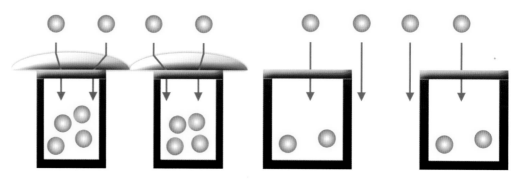

**FIGURE 2-11**
Microlenses direct photons into the photosites.

**FIGURE 2-12**
Without microlenses, some photons go unused.

Well-designed microlenses can improve the photon signal at each photosite and subsequently create images that have less noise for the same exposure time. Camera manufacturers have been able to use improvements in microlens design to reduce or maintain noise in the latest high-resolution cameras, despite the fact that these cameras have smaller photosites that squeeze more megapixels into the same sensor area.

## IMAGE HISTOGRAMS

Image histogram is probably the single most important concept you'll need to understand when working with pictures from a digital camera. A histogram can tell you whether your image has been properly exposed, whether the lighting is harsh or flat, and what adjustments will work best. It will improve your skills not only on the computer during post-processing but also as a photographer.

Recall that each pixel in an image has a color produced by some combination of the primary colors red, green, and blue (RGB). Each of these colors can have a brightness value ranging from 0 to 255 for a digital image with a bit depth of 8 bits. An *RGB histogram* results when the computer scans through each of these RGB brightness values and counts how many are at each level, from 0 through 255. Although other types of histograms exist, all have the same basic layout as the example shown in **FIGURE 2-13**.

In this histogram, the horizontal axis represents an increasing tonal level from 0 to 255, whereas the vertical axis represents the relative count of pixels at each of those tonal levels. Shadows, midtones, and highlights represent tones in the darkest, middle, and brightest regions of the image, respectively.

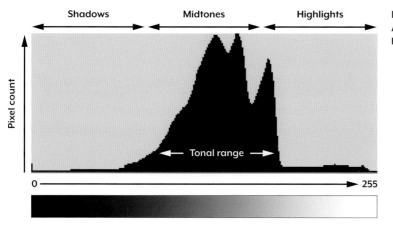

FIGURE 2-13
An example of a histogram

## TONAL RANGE

The *tonal range* is the region where most of the brightness values are present. Tonal range can vary drastically from image to image, so developing an intuition for how numbers map to actual brightness values is often critical—both before and after the photo has been taken. Note that there is not a single ideal histogram that all images should mimic. Histograms merely represent the tonal range in the scene and what the photographer wishes to convey.

For example, the staircase image in **FIGURE 2-14** contains a broad tonal range with markers to illustrate which regions in the image map to brightness levels on the histogram.

Highlights are within the window in the upper center, midtones are on the steps being hit by light, and shadows are toward the end of the staircase and where steps are not directly illuminated. Due to the relatively high fraction of shadows in the image, the histogram is higher toward the left than the right.

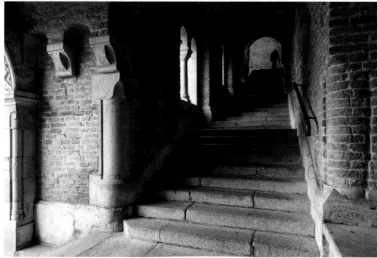

FIGURE 2-14
An image with broad tonal range

FIGURE 2-15
Example of a standard histogram composed primarily of midtones

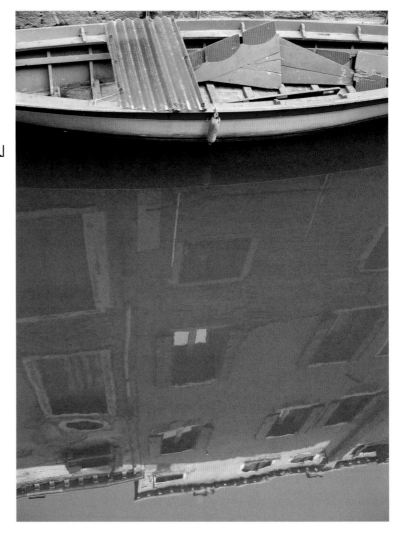

But lighting is often not as varied as with **FIGURE 2-14**. Conditions of ordinary and even lighting, when combined with a properly exposed subject, usually produce a histogram that peaks in the center, gradually tapering off into the shadows and highlights, as in **FIGURE 2-15**.

With the exception of the direct sunlight reflecting off the top of the building and some windows, the boat scene is quite evenly lit. Most cameras will have no trouble automatically reproducing an image that has a histogram similar to the one shown here.

## HIGH- AND LOW-KEY IMAGES

Although most cameras produce midtone-centric histograms when in automatic exposure mode, the distribution of brightness levels within a histogram also depends on the tonal range of the subject matter. Images where most of the tones occur in the shadows are called *low key*, whereas images where most of the tones are in the highlights are called *high key*. **FIGURES 2-16** and **2-17** show examples of high-key and low-key images, respectively.

Before you take a photo, it's useful to assess whether your subject matter qualifies as high or low key. Recall that because cameras measure reflected light, not incident light, they can only estimate subject illumination. These estimates frequently result in an image with average brightness whose histogram primarily features midtones.

Although this is usually acceptable, it isn't always ideal. In fact, high- and low-key scenes frequently require the photographer to manually adjust the exposure relative to what the camera would do automatically. A good rule of thumb is to manually adjust the exposure whenever you want the average brightness in your image to appear brighter or darker than the midtones.

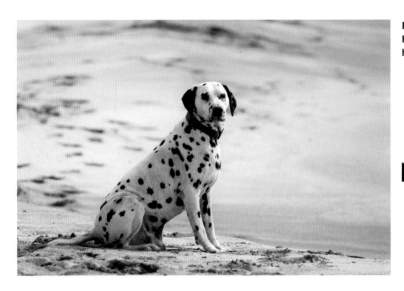

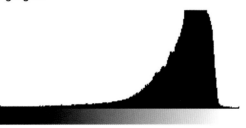

**FIGURE 2-16**
High-key histogram of an image with mostly highlights

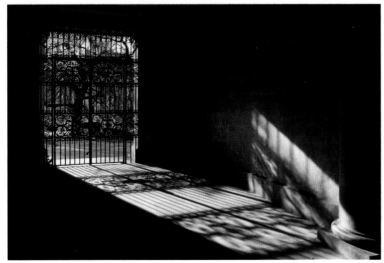

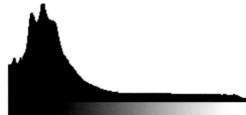

**FIGURE 2-17**
Low-key histogram of an image with mostly shadow tones

**FIGURE 2-18**
Underexposed despite a central histogram

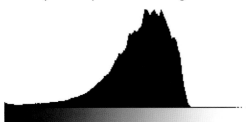

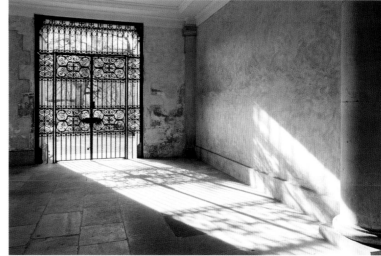

**FIGURE 2-19**
Overexposed despite a central histogram

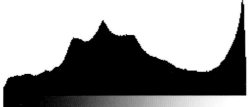

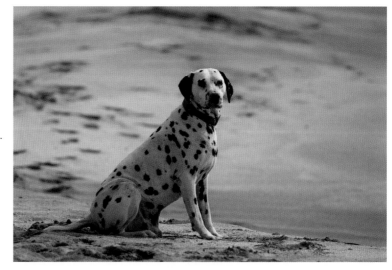

In general, a camera will have trouble with auto-exposure whenever you want the average brightness in an image to appear brighter or darker than a central histogram. The dog and gate images shown in **FIGURES 2-18** and **2-19**, respectively, are common sources of auto-exposure error. Note that the central peak histogram is brought closer to the midtones in both cases of mistaken exposure.

As you can see here, the camera gets tricked into creating a central histogram, which renders the average brightness of an image in the midtones, even though the content of the image is primarily composed of brighter highlight tones. This creates an image that is muted and gray instead of bright and white, as it would appear in person.

Most digital cameras are better at reproducing low-key scenes accurately because they try to prevent any region from becoming so bright that it turns into solid white, regardless of how dark the rest of the image might become as a result. As long as your low-key image has a few bright highlights, the camera is less likely to be tricked into overexposing the image, as

you can see in **FIGURE 2-19**. High-key scenes, on the other hand, often produce images that are significantly underexposed because the camera is still trying to avoid clipped highlights but has no reference for what should appear black.

Fortunately, underexposure is usually more forgiving than overexposure. For example, you can't recover detail from a region that is so overexposed it becomes solid white. When this occurs, the overly exposed highlights are said to be *clipped* or *blown*. **FIGURE 2-20** shows an example contrasting clipped highlights with unclipped highlights.

**FIGURE 2-20**
Clipped (left) versus unclipped detail (right)

As you can see, the clipped highlights on the floor in the left image lose detail from overexposure, whereas the unclipped highlights in the right image preserve more detail.

You can use the histogram to figure out whether clipping has occurred. For example, you'll know that clipping has occurred if the highlights are pushed to the edge of the chart, as shown in **FIGURE 2-21**.

 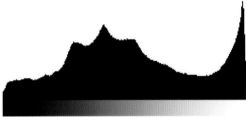

**FIGURE 2-21**
Substantially clipped highlights showing overexposure

Some clipping is usually acceptable in regions such as specular reflections on water or metal, when the sun is included in the frame, or when other bright sources of light are present. This is because our iris doesn't adjust to concentrated regions of brightness in an image. In such cases, we don't expect to see as many details in real life as in the image. But this would be less acceptable when we're looking at broader regions of brightness, where our eyes can adjust to the level of brightness and perceive more details.

Ultimately, the amount of clipping present is up to the photographer and what they wish to convey in the image.

## CONTRAST

A histogram can also describe the amount of *contrast*, which measures the difference in brightness between light and dark areas in a scene. Both subject matter and lighting conditions can affect the level of contrast in your image. For example, photos taken in the fog will have low contrast, whereas those taken under strong daylight will have higher contrast. Broad histograms reflect a scene with significant contrast (see **FIGURE 2-22**), whereas narrow histograms reflect less contrast and images may appear flat or dull (see **FIGURE 2-23**). Contrast can have a significant visual impact on an image by emphasizing texture.

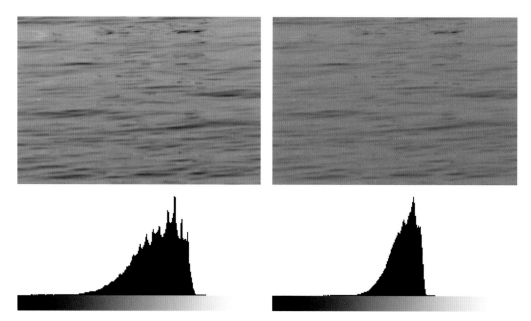

**FIGURE 2-22**
Wider histogram (higher contrast)

**FIGURE 2-23**
Narrower histogram (lower contrast)

The higher-contrast image of the water has deeper shadows and more pronounced high-lights, thus creating a texture that pops out at the viewer. **FIGURE 2-24** shows another high-contrast image.

**FIGURE 2-24**
Example of a scene with very high contrast

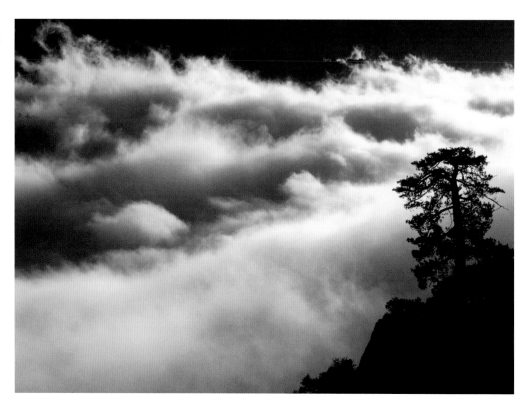

Contrast can also vary for different regions within the same image depending on both subject matter and lighting. For example, we can partition the earlier image of a boat into three separate regions, each with its own distinct histogram, as shown in **Figure 2-25**.

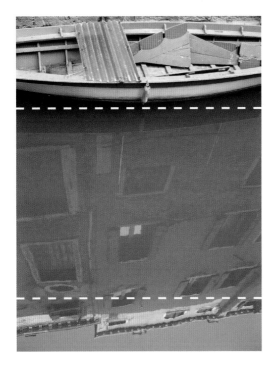

**Figure 2-25**
Histograms showing varying contrast for each region of the image

The upper region contains the most contrast of all three because the image is created from light that hasn't been reflected off the surface of water. This produces deeper shadows underneath the boat and its ledges and stronger highlights in the upward-facing and directly exposed areas. The result is a very wide histogram.

The middle and bottom regions are produced entirely from diffuse, reflected light and thus have lower contrast, similar to what you would get when taking photographs in the fog. The bottom region has more contrast than the middle despite the smooth and monotonic blue sky because it contains a combination of shade and more intense sunlight. Conditions in the bottom region create more pronounced highlights but still lack the deep shadows of the top region. The sum of the histograms in all three regions creates the overall histogram shown previously in **Figure 2-15**.

# IMAGE NOISE

*Image noise* is the digital equivalent of film grain that occurs with analog cameras. You can think of it as the subtle background hiss you may hear from your audio system at full volume. In digital images, noise is most apparent as random speckles on an otherwise smooth surface, and it can significantly degrade image quality.

However, you can use noise to impart an old-fashioned, grainy look that is reminiscent of early films, and you can also use it to improve perceived sharpness. Noise level changes depending on the sensitivity setting in the camera, the length of the exposure, the temperature, and even the camera model.

## SIGNAL-TO-NOISE RATIO

Some degree of noise is always present in any electronic device that transmits or receives a signal. With traditional televisions, this signal is broadcast and received at the antenna; with digital cameras, the signal is the light that hits the camera sensor.

Although noise is unavoidable, it can appear so small relative to the signal that it becomes effectively nonexistent. The *signal-to-noise ratio (SNR)* is therefore a useful and universal way of comparing the relative amounts of signal and noise for any electronic system. High and low SNR examples are illustrated in **FIGURES 2-26** and **2-27**, respectively.

**FIGURE 2-26**
High SNR example, where the camera produces a picture of the word *SIGNAL* against an otherwise smooth background

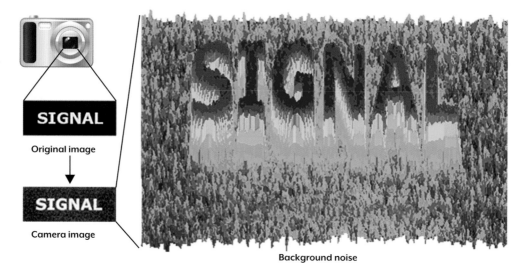

Original image

Camera image

Background noise

Even though **FIGURE 2-26** is still quite noisy, the SNR is high enough to clearly distinguish the word *SIGNAL* from the background noise. **FIGURE 2-27**, on the other hand, has barely discernible letters because of its lower SNR.

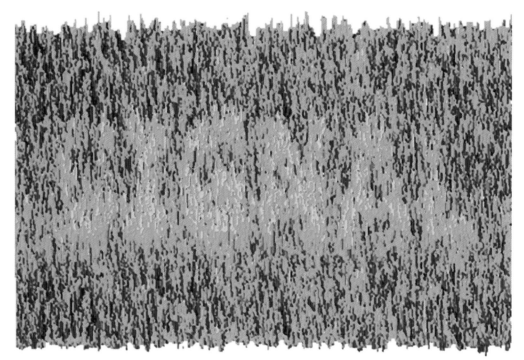

**FIGURE 2-27**
Low SNR example,
where the camera
barely has enough
SNR to distinguish
*SIGNAL* against the
background noise

## ISO SPEED

The ISO speed is perhaps the most important camera setting influencing the SNR of your image. Recall that a camera's ISO speed is a standard we use to describe its absolute sensitivity to light. ISO settings are usually listed as successive doublings, such as ISO 50, ISO 100, and ISO 200, where higher numbers represent greater sensitivity. You learned in the previous chapter that higher ISO speed increases image noise.

The ratio of two ISO numbers represents their relative sensitivity, meaning a photo at ISO 200 will take half as long to reach the same level of exposure as one taken at ISO 100 (all other factors being equal). ISO speed is the same concept and has the same units as ASA speed in film photography, where some film stocks are formulated with higher light sensitivity than others. You can amplify the image signal in the camera by using higher ISO speeds, resulting in progressively more noise.

## TYPES OF NOISE

Digital cameras produce three common types of noise: random noise, fixed-pattern noise, and banding noise. The three qualitative examples shown in **FIGURE 2-28** display pronounced and isolating cases for each type of noise against an ordinarily smooth gray background.

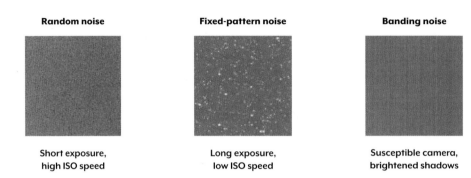

| Random noise | Fixed-pattern noise | Banding noise |
|:---:|:---:|:---:|
| Short exposure, high ISO speed | Long exposure, low ISO speed | Susceptible camera, brightened shadows |

*Random noise* results primarily from photon arrival statistics and thermal noise. There will always be some random noise, and this is most influenced by ISO speed. The pattern of random noise changes even if the exposure settings are identical. **FIGURE 2-29** shows an image that has substantial random noise in the darkest regions because it was captured at a high ISO speed.

*Fixed-pattern noise* includes what are called "hot," "stuck," or "dim" pixels. Fixed-pattern noise is exacerbated by long exposures and high temperatures. Fixed-pattern noise is also unique in that it has almost the same distribution with different images if taken under the same conditions (temperature, length of exposure, and ISO speed).

*Banding noise* is highly dependent on the camera and is introduced by camera electronics when reading data from the digital sensor. Banding noise is most visible at high ISO speeds and in the shadows, or when an image has been excessively brightened.

Although fixed-pattern noise appears more objectionable in **FIGURE 2-28**, it is usually easier to remove because of its pattern. For example, if a camera's internal electronics know the pattern, this can be used to identify and subtract the noise to reveal the true image. Fixed-pattern noise is therefore much less prevalent than random noise in the latest generation of digital cameras; however, if even the slightest amount remains, it is still more visually distracting than random noise.

The less objectionable random noise is usually much more difficult to remove without degrading the image. Noise-reduction software has a difficult time discerning random noise from fine texture patterns, so when you remove the random noise, you often end up adversely affecting these textures as well.

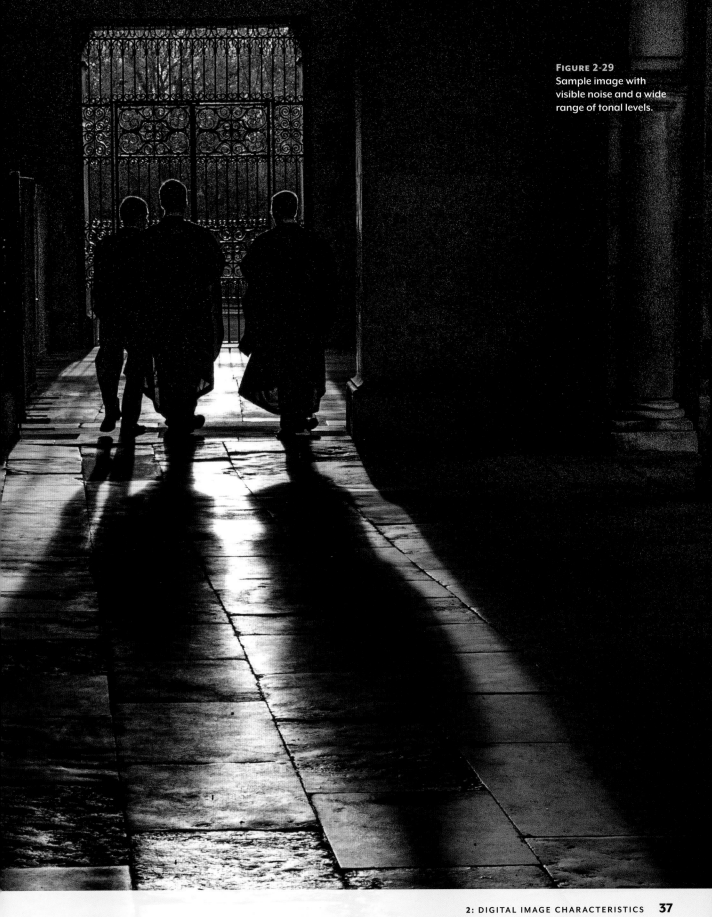

**Figure 2-29**
Sample image with
visible noise and a wide
range of tonal levels.

## HOW BRIGHTNESS AFFECTS NOISE

The noise level in your images not only changes depending on the exposure setting and camera model but can also vary within an individual image, similar to the way contrast can vary for different regions within the same image. With digital cameras, darker regions contain more noise than brighter regions, but the opposite is true with film.

**FIGURE 2-30** shows how noise becomes less pronounced as the tones become brighter (the original image used to create the patches is shown in **FIGURE 2-31**.

**FIGURE 2-30**
Noise is less visible in brighter tones

**FIGURE 2-31**
The original image used to create the four tonal patches in Figure 2-30

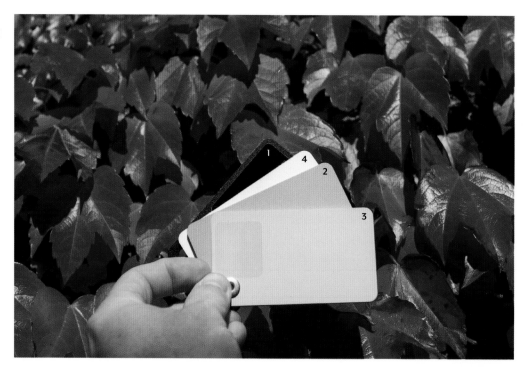

Brighter regions have a stronger signal because they receive more light, resulting in a higher overall SNR. This means that images that are underexposed will have more visible noise, even if you brighten them afterward. Similarly, overexposed images have less noise and can actually be advantageous, assuming that you can darken them later and that no highlight texture has become clipped to solid white.

# CHROMA AND LUMA NOISE

Noise fluctuations can be separated into two components: color and luminance. *Color noise*, also called *chroma noise*, usually appears more unnatural and can render images unusable if not kept under control. *Luminance noise*, or *luma noise*, is usually the more tolerable component of noise. **FIGURE 2-32** shows what chroma and luma noise look like on what was originally a neutral gray patch.

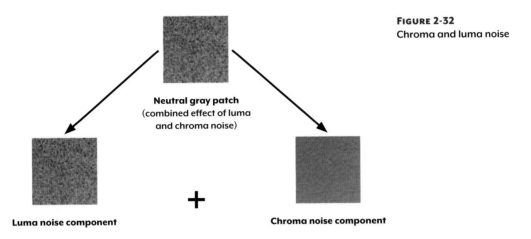

**Neutral gray patch**
(combined effect of luma
and chroma noise)

**FIGURE 2-32**
Chroma and luma noise

**Luma noise component**

+

**Chroma noise component**

The relative amounts of chroma and luma noise can vary significantly depending on the camera model. You can use noise-reduction software to selectively reduce either type of noise, but complete elimination of luminance noise can cause unnatural or plastic-looking images.

Noise is typically quantified by the intensity of its fluctuations, where lower intensity means less noise, but its spatial frequency is also important. The term *fine-grained noise* was used frequently with film to describe noise with fluctuations occurring over short distances, resulting in a high spatial frequency. These two properties of noise often go hand in hand; an image with more intense noise fluctuations will often also have more noise at lower frequencies (which appears in larger patches).

Let's take a look at **FIGURE 2-33** to see why it's important to keep spatial frequency in mind when assessing noise level.

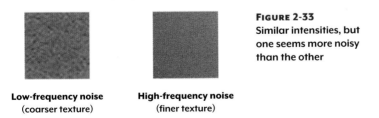

**FIGURE 2-33**
Similar intensities, but
one seems more noisy
than the other

**Low-frequency noise**
(coarser texture)

**High-frequency noise**
(finer texture)

The patches in this example have different spatial frequencies, but the noise fluctuates with a very similar intensity. If the "low versus high frequency" noise patches were compared based solely on the intensity of their fluctuations (as you'll see in most camera reviews), then the patches would be measured as having similar noise. However, this could be misleading because the patch on the right actually appears to be much less noisy.

The intensity of noise fluctuations still remains important, though. The example in **FIGURE 2-34** shows two patches that have different intensities but the same spatial frequency.

**FIGURE 2-34**
**Different intensities but same spatial frequency**

**Low-magnitude noise**
(smoother texture)

**High-magnitude noise**
(rougher texture)

Note that the patch on the left appears much smoother than the patch on the right because low-magnitude noise results in a smoother texture. On the other hand, high-magnitude noise can overpower fine textures, such as fabric and foliage, and can be more difficult to remove without destroying detail.

## NOISE LEVEL UNDER DIFFERENT ISO SETTINGS

Now let's experiment with actual cameras so you can get a feel for how much noise is produced at a given ISO setting. The examples in **FIGURE 2-35** show the noise characteristics for three different cameras against an otherwise smooth gray patch.

**FIGURE 2-35**
**Noise levels shown using best JPEG quality, daylight white balance, and default sharpening**

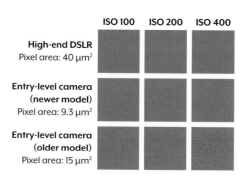

|  | ISO 100 | ISO 200 | ISO 400 |
|---|---|---|---|
| **High-end DSLR** Pixel area: 40 μm² |  |  |  |
| **Entry-level camera (newer model)** Pixel area: 9.3 μm² |  |  |  |
| **Entry-level camera (older model)** Pixel area: 15 μm² |  |  |  |

You can see how increasing the ISO speed always produces higher noise for a given camera, but that the amount of noise varies across cameras. The greater the area of a pixel in the camera sensor, the more light-gathering ability it has, thus producing a stronger signal. As a result, cameras with physically larger pixels generally appear less noisy because the signal is larger relative to the noise. This is why cameras with more megapixels packed into the same-sized camera sensor don't necessarily produce a better-looking image.

On the other hand, larger pixels alone don't necessarily lead to lower noise. For example, even though the older entry-level camera has much larger pixels than the newer entry-level camera, it has visibly more noise, especially at ISO 400. This is because the older entry-level camera has higher internal or "readout" noise levels caused by less-sophisticated electronics.

Also note that noise is not unique to digital photography, and it doesn't always look the same. Older devices, such as this CRT television image, often suffered from noise caused by a poor antenna signal (as shown in **FIGURE 2-36**).

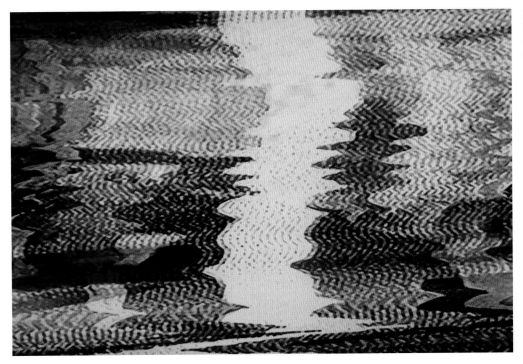

**FIGURE 2-36**
Example of how noise could appear in a CRT television image

## SUMMARY

In this chapter, you learned about several unique characteristics of digital images: bit depth, sensors, image histograms, and image noise. As you've seen, understanding how the camera processes light into a digital image lets you evaluate the quality of the image. It also lets you know what to adjust depending on what kind of noise is present. You also learned how to take advantage of certain types of image noise to achieve a particular effect.

In the next chapter, you'll build on your knowledge of exposure from Chapter 1 and learn how to use lenses to control the appearance of your images.

# 3

# Understanding Camera Lenses

**Now that you understand how** exposure and digital data work, the next most important thing is choosing the appropriate lens to control how the image appears. We'll discuss camera lenses first because they're the camera equipment you need for each and every shot, regardless of style. They also have a widespread influence on both the technical and creative aspects of photography.

In this chapter, you'll learn how light gets translated into an image. You'll start by learning the different components of a typical camera lens to understand how focal length, aperture, and lens type affect imagery. You'll also learn the trade-offs with zoom lenses versus prime or fixed focal length lenses. Then you'll learn how to use wide-angle lenses, which are an important tool for capturing expansive vistas and exaggerating relative subject size. Finally, you'll learn about telephoto lenses, which you can use to magnify distant subjects and layer a composition.

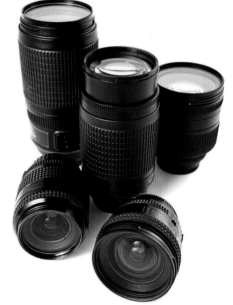

# HOW LENSES WORK

Understanding camera lenses gives you more creative control in your digital photography. As you'll soon learn, choosing the right lens for the task is a complex trade-off between cost, size, weight, lens speed, and image quality. Let's begin with an overview of the concepts you'll need to understand about how camera lenses can affect image quality, focal length, perspective, prime versus zoom, and f-number.

## LENS ELEMENTS

Unless you're dealing with a very simple camera, your camera lenses are actually composed of several *lens elements*. Each of these elements directs the path of light rays to re-create the image as accurately as possible on the digital sensor. The goal is to minimize aberrations while still utilizing the fewest and least expensive elements. **FIGURE 3-1** shows how the elements that make up a typical camera lens focus light onto the digital sensor.

**FIGURE 3-1**
Lens elements

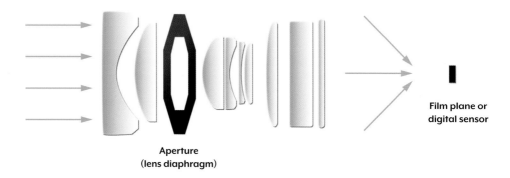

Aperture
(lens diaphragm)

Film plane or
digital sensor

As you can see here, the lens elements successfully focus light onto a single point. But when points in the scene don't translate back onto single points in the image after passing through the lens, optical aberrations occur, resulting in image blurring, reduced contrast, or misalignment of colors (or *chromatic aberration*). Lenses may also suffer from distortion or *vignetting* (when image brightness decreases radially and unevenly). Each of the image pairings in **FIGURE 3-2** illustrates effects on image quality in extreme cases.

Any of these aberrations is present to some degree with any lens. In the rest of this chapter, when we say that a lens has lower *optical quality* than another lens, it means that it suffers from some combination of the artifacts shown in **FIGURE 3-2**. Some of these lens artifacts may not be as objectionable as others, depending on the subject matter.

Original image

Loss of contrast

**Figure 3-2**
Examples of aberrations

Original image

Blurring

Original image

Chromatic aberration

Original image

Distortion

Original image

Vignetting

## INFLUENCE OF LENS FOCAL LENGTH

Because the focal length of a lens determines its angle of view, or the angle between the edges of your entire field of view, it also determines how much the subject will be magnified for a given photographic position. For example, wide-angle lenses have short focal lengths, whereas telephoto lenses have longer corresponding focal lengths. **FIGURE 3-3** shows how focal length affects how wide or narrow the angle of view is.

**FIGURE 3-3**
Short and long focal lengths

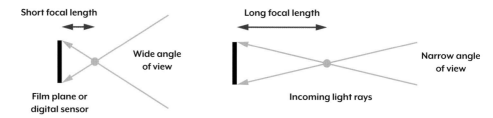

You'll hear people say that focal length also determines the perspective of an image, which is how your subjects appear in relation to each other when viewed from a particular vantage point. But strictly speaking, perspective only changes with your location relative to the subject. For example, if you try to fill the frame with the same subjects using both a wide-angle lens and a telephoto lens, perspective does indeed change, but only because you are forced to move closer to or farther from the subject to achieve the same framing. **FIGURE 3-4** demonstrates how this is true.

You can see that these two shots have the same subjects in the frame but are taken using different lenses. To achieve the same framing with both shots, you have to step back further when using the longer focal length than when using the shorter focal length. For these scenarios, the wide-angle lens exaggerates or stretches perspective, whereas the telephoto lens compresses or flattens perspective, making objects appear closer than they actually are.

Perspective can be a powerful compositional tool in photography, and when you can photograph from any position, you can control perspective by choosing the appropriate focal length. Although perspective is technically always the same regardless of the focal length of your lens, it can change when you physically move to a different vantage point. As you can see in **FIGURE 3-4**, the subjects within the frame remain nearly identical, but the relative sizes of objects change such that the distant doorway becomes smaller relative to the nearby lamps.

**Figure 3-4**
How focal length affects
the angle of view

Shorter focal length using a wide angle lens

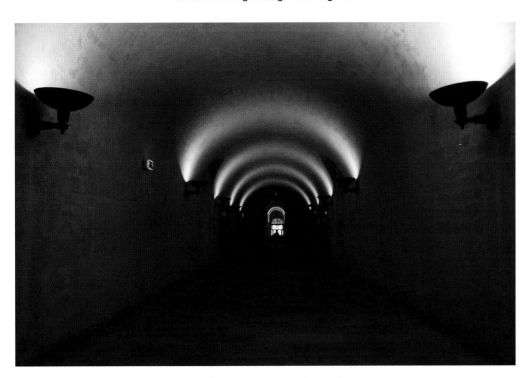

Longer focal length using a telephoto lens

## COMMON FOCAL LENGTHS

**TABLE 3-1** provides an overview of what focal lengths are required for a lens to be considered a wide-angle or telephoto lens, in addition to their typical uses.

**TABLE 3-1** Typical Focal Lengths and Their Uses

| LENS FOCAL LENGTH | TERMINOLOGY | TYPICAL PHOTOGRAPHY |
| --- | --- | --- |
| Less than 21 mm | Extreme wide angle | Architecture |
| 21–35 mm | Wide angle | Landscape |
| 35–70 mm | Normal | Street and documentary |
| 70–135 mm | Medium telephoto | Portraiture |
| 135–300+ mm | Telephoto | Sports, birds and wildlife |

Note that these focal lengths listed are just rough ranges; actual uses may vary considerably. Many photographers use telephoto lenses in distant landscapes to compress perspective, for example.

Lens focal length can also influence other factors. For example, telephoto lenses are more susceptible to camera shake because even the smallest hand movements become amplified when your angle of view is narrow; this is similar to the shakiness you experience while trying to look through binoculars.

On the other hand, wide-angle lenses are generally designed to be more resistant to *flare,* an artifact caused by non-image-forming light. This is in part because designers assume that the sun is more likely to be within the frame. Finally, medium-angle and telephoto lenses generally yield better optical quality for similar price ranges.

 **TECHNICAL NOTE**

Lens focal lengths are for 35 mm or "full frame" types of cameras. If you have a compact, mirrorless, or digital SLR camera, you likely have a different sensor size. To adjust the preceding numbers for your camera, look up your camera's crop factor online and multiply that by the focal length of your lens.

## HOW FOCAL LENGTH AFFECTS SHARPNESS

Although the focal length of a lens alone doesn't control the sharpness of an image, it can make it easier to achieve a sharp, handheld photograph—everything else being equal. This is because longer focal lengths require shorter exposure times to minimize blurring caused by shaky hands.

To demonstrate how this works, imagine trying to hold a laser pointer steady. When you point the laser at a nearby object, its bright spot appears steadier on a closer object, but it jumps around noticeably more for objects farther away. **FIGURE 3-5** illustrates this example.

**Figure 3-5**
Types of vibrations in a shaky laser pointer

Rotational vibrations with a shaky laser pointer

Vertical vibrations with a shaky laser pointer

This is primarily because slight rotational vibrations are magnified greatly with distance. On the other hand, if only up-and-down or side-to-side vibrations are present, the laser's bright spot does not change with distance. In practice, this typically means that longer focal-length lenses are more susceptible to shaky hands because these lenses magnify distant objects more than shorter focal-length lenses, similar to how the laser pointer jumps around more with distant objects due to rotational vibrations.

A common rule of thumb for estimating how fast the exposure needs to be for a given focal length is the *one-over-focal-length* rule, which states that for a 35 mm camera, the handheld exposure time needs to be at least as fast as 1 over the focal length in seconds. In other words, when you're using a 200 mm focal length on a 35 mm camera, the exposure time needs to be no more than 1/200th of a second; otherwise, you might get blurring.

Keep in mind that this rule is just for rough guidance. Some photographers may be able to hand hold a shot for much longer or shorter times, and some lenses that include image stabilization are more tolerant of unsteady hands. Users of digital cameras with cropped sensors, or sensors smaller than 35 mm (such as Micro Four Thirds, APS-C, and compact cameras), need to convert into a 35 mm equivalent focal length.

## ZOOM LENSES

A *zoom lens* allows us to vary the focal length within a predefined range. The primary advantage of a zoom lens is that it's easier to achieve a variety of compositions or perspectives without having to change lenses. This advantage is often critical for capturing dynamic subject matter, such as in photojournalism and children's photography.

Keep in mind that using a zoom lens doesn't necessarily mean that you no longer have to change your position; it just gives you more flexibility. **Figure 3-6** compares an image taken from the photographer's original position with two alternatives: zooming in (which changes the composition) and moving in closer while zooming out (which maintains composition but changes perspective). For the purposes of this discussion, having a different *composition* means that the subject matter framing has changed, whereas having a different *perspective* means that the relative sizes of near and far objects have changed.

**FIGURE 3-6**
Different ways to use
zoom lenses

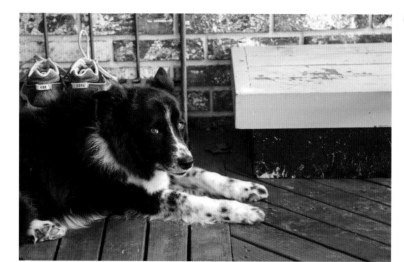

Original image

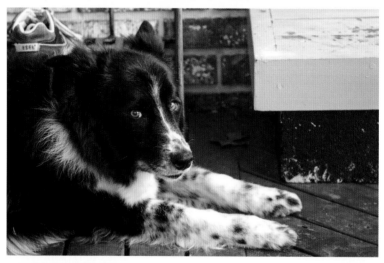

Changing the composition
by zooming in

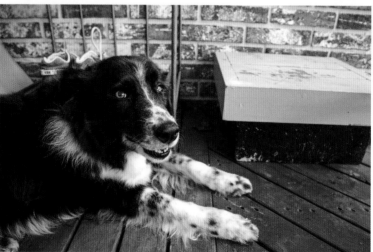

Changing the perspective
by moving closer while
zooming out

Using a zoom lens, you can get a tighter composition without having to crop the image or change positions by simply zooming in on the subject. If you had used a prime lens instead, a change of composition would not have been possible without cropping the image.

You can also change the perspective by zooming out and getting closer to the subject. Alternatively, to achieve the opposite perspective effect, you could zoom in and move farther from the subject.

## PRIME LENSES

Unlike zoom lenses, *prime lenses* (also known as *fixed focal length lenses*) don't allow us to vary focal length within a predefined range. If zoom lenses give you more flexibility, you may be wondering why you would intentionally restrict options by using a prime lens. Prime lenses existed long before zoom lenses were available, and they still offer many advantages over their more modern counterparts. When zoom lenses first arrived on the market, photographers often had to be willing to sacrifice a significant amount of optical quality. However, more recent high-end zoom lenses generally do not produce noticeably lower image quality, unless the image is scrutinized by the trained eye or is in very large print.

The primary advantages of prime lenses are cost, weight, and speed. An inexpensive prime lens can generally provide as good, if not better, image quality as a high-end zoom lens. Additionally, if only a small fraction of the focal length range is necessary for a zoom lens, then a prime lens with a similar focal length will provide the same functionality while being significantly smaller and lighter. Finally, the best prime lenses almost always offer better light-gathering ability, or larger maximum aperture, than the fastest zoom lenses. This light-gathering ability is often critical for low-light sports or theater photography and other scenarios where a shallow depth of field is necessary.

For lenses in compact digital cameras, a 3×, 4×, or higher zoom designation refers to the ratio between the longest and shortest focal lengths. Therefore, a larger zoom designation doesn't necessarily mean that the image can be magnified any more. It might just mean that the zoom has a wider angle of view when fully zoomed out. Additionally, *digital zoom* is not the same as *optical zoom*, because the former artificially enlarges the image through a digital process called *interpolation*, which actually degrades detail and resolution. Read the fine print to ensure that you're not misled by your lens's zoom designation.

## INFLUENCE OF LENS APERTURE

The aperture range of a lens refers to how much the lens can open up or close to let in more or less light, respectively. Apertures are listed in terms of *f-numbers*, which quantitatively describe the relative light-gathering area, as shown in **FIGURE 3-7**.

**FIGURE 3-7**
The f-numbers (from left to right) are f/2.0, f/2.8, f/4.0, and f/5.6.

As you learned in Chapter 1, larger aperture openings have lower f-numbers, which is often confusing to camera users. Because *aperture* and *f-number* are often mistakenly interchanged, I'll refer to lenses in terms of their aperture size for the rest of this book. Photographers also describe lenses with larger apertures as being faster, because for a given ISO speed, the shutter speed can be made faster for the same exposure. Additionally, a smaller aperture means that objects can be in focus over a wider range of distance—a concept you also explored in Chapter 1 when we discussed depth of field.

**TABLE 3-2** summarizes the effect f-numbers have on shutter speed and depth of field.

**TABLE 3-2**  How F-Numbers Affect Other Properties

|  | CORRESPONDING IMPACT ON OTHER PROPERTIES: | | |
| --- | --- | --- | --- |
| **F/#** | Light-gathering area | Required shutter speed | Depth of field |
| Higher | Smaller | Slower | Wider |
| Lower | Larger | Faster | Narrower |

As you can see, the f-number changes several key image properties simultaneously; as a photographer, you will want to make sure that all such changes are desirable for your particular shot.

## MAXIMUM APERTURE

When you're considering purchasing a lens, you should know that specifications ordinarily list the *maximum apertures* (and maybe the minimum). Lenses with a greater range of aperture settings provide greater artistic flexibility, in terms of both exposure options and depth of field. The most important lens aperture specification is perhaps the maximum aperture, which is often listed on the box along with focal length(s), as shown in **FIGURE 3-8**.

**FIGURE 3-8**
Example lens specifications from retail packaging

An f-number of 1.4 may be displayed as 1:1.4, instead of f/1.4, as shown in **FIGURE 3-9** for the 50 mm f/1.4 lens.

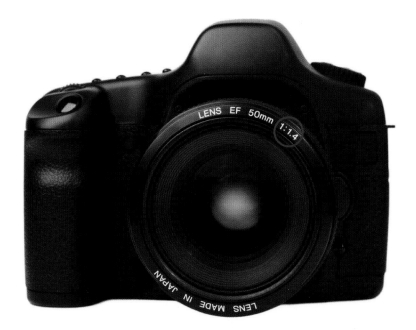

**FIGURE 3-9**
Example maximum aperture label on the front of a lens

Portrait and indoor sports photography or theater photography often requires lenses with very large maximum apertures to be capable of a narrower depth of field or a faster shutter speed, respectively. The narrow depth of field in a portrait helps isolate the subject from the background. For digital SLR cameras, lenses with larger maximum apertures provide significantly brighter viewfinder images, which may be critical for night and low-light photography. These also often give faster and more accurate auto-focusing in low light. Manual focusing is also easier using maximum apertures because the image in the viewfinder has a narrower depth of field, making it more visible when objects come into or out of focus.

**TABLE 3-3** summarizes some typical maximum apertures you'll find on a digital camera. You can see how even small changes in f-number lead to substantial changes in light-gathering area, because each halving of the f-number results in a quadrupling of the light-gathering area.

Minimum apertures for lenses are generally nowhere near as important as maximum apertures. This is primarily because the minimum apertures are rarely used due to photo blurring from lens diffraction, and it's because these may require prohibitively long exposure times. When you want extreme depth of field, you might consider choosing lenses with a smaller minimum aperture or a larger maximum f-number to allow for a wider depth of field.

**TABLE 3-3** Typical Maximum Apertures

| TYPICAL MAXIMUM APERTURES | RELATIVE LIGHT-GATHERING ABILITY | TYPICAL LENS TYPES |
| --- | --- | --- |
| f/1.0 | 32× | Fastest available prime lenses (for consumer use) |
| f/1.4 | 16× | Fast prime lenses |
| f/2.0 | 8× | Fast prime lenses |
| f/2.8 | 4× | Fastest zoom lenses (for constant aperture) |
| f/4.0 | 2× | Lightweight zoom lenses or extreme telephoto primes |
| f/5.6 | 1× | Lightweight zoom lenses or extreme telephoto primes |

### RANGE OF MAXIMUM APERTURE

Finally, some zoom lenses on digital SLR and compact digital cameras list a range of maximum aperture, which depends on how far you have zoomed in or out. These aperture ranges therefore refer only to the range of maximum aperture, not overall range. For example, a range of f/2.0–3.0 means that the maximum available aperture gradually changes from f/2.0 (fully zoomed out) to f/3.0 (fully zoomed in) as focal lengths change. The primary benefit of having a zoom lens with a constant maximum aperture instead of a range of maximum aperture is that exposure settings are more predictable, regardless of focal length. **FIGURE 3-10** shows an example of a lens that specifies the range of maximum aperture.

**FIGURE 3-10**
Range of maximum aperture

Also note that just because you don't use the maximum aperture of a lens often, this does not mean that such a wide aperture lens is unnecessary. Lenses typically have fewer aberrations when they perform the exposure stopped down one or two f-stops from their maximum aperture, such as a setting of f/4.0 on a lens with a maximum aperture of f/2.0. This means that if you want the best-quality f/2.8 photograph, an f/2.0 or f/1.4 lens may yield higher quality than a lens with a maximum aperture of f/2.8.

Other considerations for buying a lens are cost, size, and weight. Lenses with larger maximum apertures are typically much heavier, bigger, and more expensive. For example, minimizing size and weight may be critical for wildlife, hiking, and travel photography because it often utilizes heavier lenses or requires carrying equipment for extended periods of time.

# USING WIDE-ANGLE LENSES

A wide-angle lens can be a powerful tool for exaggerating depth and the relative size of subjects in a photo. **FIGURE 3-11** is an example of the kind of exaggeration you can achieve.

As you can see, the ultra-wide lens creates an exaggerated sky by manipulating the relative size of the near clouds versus the far clouds. For example, the clouds at the top of the frame appear as they would if you were looking directly up, whereas the ones in the distance appear as they would if you were looking at them from the side. This creates the effect of the clouds towering over you, resulting in a more evocative image.

However, wide-angle lenses are also one of the most difficult types of lenses to use. In this section, I dispel some common misconceptions and discuss techniques for taking full advantage of the unique characteristics of a wide-angle lens.

**FIGURE 3-11**
Example of exaggerated depth achieved with a 16 mm ultra-wide-angle lens

## OVERVIEW

A lens is generally considered a *wide-angle lens* when its focal length is less than around 35 mm on a full-frame camera. This translates into an angle of view that is greater than about 55 degrees across your photo's widest dimension, which begins to create a more unnatural perspective compared to what you would see with your own eyes.

The definition of *ultra-wide* is a little fuzzier, but most agree that this realm begins when focal lengths are around 20–24 mm or less. On a compact camera, wide angle is often what you get when you're fully zoomed out, but ultra-wide is usually never available without a special lens adapter. Regardless of what's considered wide angle, the key concept you should take away is that the shorter the focal length, the easier it is to notice the unique effects of a wide-angle lens.

## WHAT MAKES A WIDE-ANGLE LENS UNIQUE

A common misconception is that wide-angle lenses are primarily used when you cannot step far enough away from your subject but still want to capture the entire subject in a single camera frame. But this is not the only use of a wide-angle lens, and if you were to only use it this way, you'd really be missing out. In fact, wide-angle lenses are often used to achieve just the opposite: when you want to get closer to a subject!

Here are the characteristics that make a wide-angle lens unique:

- Its image encompasses a wide angle of view
- It generally has a close minimum focusing distance.

Although these might seem pretty basic, they result in a surprising range of possibilities. In the rest of this section, you'll learn how to take advantage of these traits for maximum impact in wide-angle photography.

## WIDE-ANGLE PERSPECTIVE

Obviously, a wide-angle lens is special because it has a wide angle of view—but what does this actually mean? A *wide angle of view* means that both the relative size and distance are exaggerated when comparing near and far objects. This causes nearby objects to appear gigantic and faraway objects to appear unusually tiny and distant. The reason for this is the angle of view, as illustrated in **FIGURE 3-12**.

**FIGURE 3-12**
Comparing two angles of view

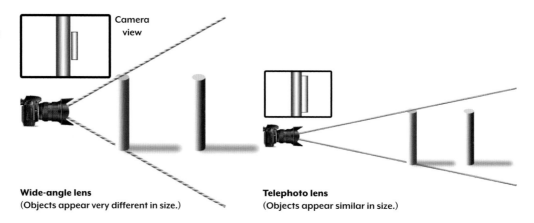

**Wide-angle lens**
(Objects appear very different in size.)

**Telephoto lens**
(Objects appear similar in size.)

▲ **FIGURE 3-13**
Exaggerated 3-inch flowers using a
16 mm ultra-wide-angle lens

▶ **FIGURE 3-14**
Disproportionate body parts caused
by a wide-angle lens

Even though the two cylinders in the figure are the same distance apart, their relative sizes become very different when you fill the frame with the closest cylinder. With a wider angle of view, objects that are farther away comprise a much lower fraction of the total angle of view.

A misconception is that a wide-angle lens affects perspective, but strictly speaking, this isn't true. Recall from **FIGURE 3-4** that perspective is only influenced by where you are when you take a photograph. However, in practice, wide-angle lenses often cause you to move much closer to your subject, which does affect perspective.

You can use this exaggeration of relative size to add emphasis and detail to foreground objects, while still capturing expansive backgrounds. To use this effect to full impact, you'll want to get as close as possible to the nearest subject in the scene. **FIGURE 3-13** shows an example of this technique in action.

In this extreme wide-angle example, the nearest flowers are almost touching the front of the lens, which greatly exaggerates their size. In real life, these flowers are only a few inches wide!

However, you need to take extra caution when photographing people using wide-angle lenses. Their noses, heads, and other features can appear out of proportion if you get too close to them when taking the photo, as shown in **FIGURE 3-14**.

In this example, the boy's head has become abnormally large relative to his body. This can be a useful tool for adding drama or extra character to a candid shot, but it certainly isn't how most people would want to be depicted in a standard portrait. This proportionality is in part why lenses with narrower focal lengths are much more common for traditional portrait photography.

Finally, because distant objects become quite small, sometimes it's a good idea to include foreground objects to anchor the composition. Otherwise, a landscape shot may appear overly busy and lack the key elements needed to draw your eye into the photograph.

Regardless, don't let this prevent you from getting closer to your subjects! As you'll learn in more detail shortly, the ability to get close is what wide angle is all about.

## CONVERGING VERTICAL LINES

Whenever you point a wide-angle lens above or below the horizon, it causes otherwise parallel vertical lines to appear as if they are converging. All lenses do this—even telephoto lenses. It's just that a wider expanse of converging lines is visible with a wide-angle lens. Furthermore, with a wide-angle lens, even small changes in composition can alter the location of the horizon substantially, resulting in a big difference in how sharply lines seem to converge. Converging lines can be a useful tool for emphasizing depth and perspective, but it can also be undesirable, particularly with architectural photography.

The key is to pay close attention to an image characteristic called the *vanishing point*, which is where parallel lines appear to converge. In the cathedral example shown in **FIGURE 3-15**, the vanishing point is a single central point near the horizon when the camera is aimed at the horizon. In this example, the image center is the same as the vanishing point because the camera is pointed at the level of the horizon.

However, when the camera is aimed above the horizon, the previously vertical lines begin to converge at a second vanishing point in the sky, creating a two-point perspective, as shown in **FIGURE 3-16**.

◄ **FIGURE 3-15**
Camera aimed near the horizon (vertical lines all appear parallel)

▲ **FIGURE 3-16**
Camera aimed above the horizon (vertical lines appear to converge)

▲ **Figure 3-17**
Wide-angle shot of trees on
Vancouver Island, Canada

▶ **Figure 3-18**
King's College Chapel, Cambridge, UK

Note that the image center doesn't change by much in terms of the total image, but the converging lines have a huge impact on how the cathedral appears. This can cause buildings to appear as though they are either falling toward or away from the viewer.

Although you should generally avoid converging vertical lines in architectural photography for these reasons, you can sometimes use them to your advantage. For example, **Figure 3-17** shows how a wide angle lens captures the towering trees in a way that makes them appear to be enveloping the viewer.

The trees look as if they are coming from all directions and converging in the middle of the image, even though they are actually all parallel to one another. However, the architectural example in **Figure 3-18** was taken close to the door to exaggerate the apparent height of the chapel, but this also gives the unwanted appearance that the building is about to fall over backward.

Here are some ways you can reduce converging verticals:

- Aim your camera closer to the horizon, even if this means you'll capture a lot of ground in addition to the subject (which you can crop out later).

- Get much farther from your subject and use a lens with a longer focal length.

- Use photo-editing software to distort the photo so that vertical lines diverge less.

- Use a tilt/shift lens to control perspective.

Unfortunately, all these options have their drawbacks. For example, the first and third may compromise resolution, while the second is not always feasible, depending on your physical location, and can affect perspective. The last option can be costly, requires technical knowledge, and can result in a slight reduction in image quality.

## INTERIORS AND ENCLOSED SPACES

You'll find a wide-angle lens absolutely indispensable in enclosed spaces, simply because you cannot move far enough away from your subject to get all of it in the photo using a normal lens. A common example is photography of interior rooms or other indoor architecture. You can make the most of a wide-angle lens for this type of photography where you're forced to be close to the subject.

Don't be afraid to get much closer! After all, this is where wide angle really shines. But you'll need to take extra care with the composition of extremely close objects, because camera movements of even a fraction of an inch can move objects a lot inside a close-up image. It can therefore become quite difficult to frame subjects the way you want.

**FIGURE 3-19** and **3-20** shows two photographs of enclosed spaces that benefit from a wide-angle lens.

In both examples here, the photographers might have been restricted in their position such that they could not move more than a few feet in any direction, yet the photos don't appear cramped.

▲ **FIGURE 3-19**
16 mm focal length in Antelope Canyon, Arizona, USA

▶ **FIGURE 3-20**
Spiral staircase in New Court, St John's College, Cambridge

## POLARIZING FILTERS

You should almost always avoid using a polarizing filter with a wide-angle lens. (You'll learn more about polarizing filters in Chapter 5, but for now you should know that they're a light-filtering tool used to decrease light reflections.) A key trait of a polarizer is that its effect varies depending on the angle of the subject relative to the sun. For example, when you face your camera 90 degrees from where the sun is coming from, you maximize its effect; similarly, whenever you face your camera directly away from or into the sun, you minimize the effect of a polarizer.

When you use a polarizing filter with an ultra-wide angle lens, one edge of your image frame might be nearly facing the sun, whereas the opposing edge might be facing 90 degrees away from the sun. This means you'll be able to see the changing influence of your polarizer across a single photo. This effect is usually undesirable. In **FIGURE 3-21**, for example, the polarizing filter causes the blue sky to clearly change in saturation and brightness as you move across the image from left to right.

## MANAGING LIGHT USING A GND FILTER

A common hurdle you might face when using wide-angle lenses is strong variation in the intensity of light across an image. For example, when you use an ordinary exposure, uneven light can make some parts of the image overexposed while leaving other parts underexposed. Although our eyes can adjust to this changing brightness as we look in different directions, cameras don't have this ability. You therefore need to take extra care when determining the desired exposure to ensure a balanced overall exposure across the wide-angle frame.

For example, in landscape photography, the foreground foliage is often much less intensely lit than the sky or a distant mountain. This often results in an overexposed sky and/or an underexposed foreground. Most photographers therefore use what is called a *graduated neutral density (GND)* filter to overcome this uneven lighting. **FIGURE 3-22** illustrates the effect of using a GND filter.

◀ **FIGURE 3-21**
Capitol Reef National
Park, Utah, USA

▲ **FIGURE 3-22**
GND filter example;
a lighthouse in Nora,
Sardinia

In this photograph of a lighthouse, the GND filter partially obstructs some of the light from the bright sky, while also gradually letting in more and more light for subjects placed progressively lower in the photo. At the bottom of the photo, you can see that the GND filter lets in the full amount of light. See Chapter 5 on camera lens filters for additional examples of this.

As you learned earlier in this chapter, a wide-angle lens is much more susceptible to lens flare, in part because the sun is much more likely to enter the composition. It can also be difficult to effectively shield the sides of the lens from stray light using a lens hood, because this hood cannot also block any of the image-forming light across the wide angle of coverage.

## WIDE-ANGLE LENSES AND DEPTH OF FIELD

You'll notice that nowhere in this discussion do I mention that a wide-angle lens has a greater depth of field. Unfortunately, this is another common misconception; people commonly believe that a wide-angle lens has a greater depth of field, but this is not true. In fact, if you're magnifying your subject by the same amount (meaning that they fill the image frame by the same proportion), then a wide-angle lens gives the same depth of field as a telephoto lens.

As we discussed, the reason that wide-angle lenses get the reputation of improving depth of field is not because of any inherent property of the lenses themselves. It's because of how they're most often used. People rarely get close enough to their subject to have it fill the same amount of the frame with a wide-angle lens as they do with lenses that have narrower angles of view.

 **TECHNICAL NOTE**

For situations of extreme magnification, the depth of field may differ by a small amount. However, this is an extreme case and is not relevant for the uses discussed here. See "Understanding Depth of Field" on page 14 for a more detailed discussion of this topic.

## TIPS FOR USING A WIDE-ANGLE LENS

Although there are no steadfast rules, you can use your wide-angle lens more effectively by experimenting with the following four guidelines:

- **Subject distance**  Get much closer to the foreground and physically immerse yourself among your subjects.

  A wide-angle lens exaggerates the relative sizes of near and far subjects. To emphasize this effect, it's important to get very close to your subject. Wide-angle lenses also typically have much closer minimum focusing distances, and they enable your viewer to see a lot more in tight spaces.

- **Organization** Carefully place near and far objects to achieve clear compositions.

  Wide-angle shots often encompass a vast set of subject matter, so it's easy for the viewer to get lost in the confusion. Experiment with different techniques of organizing your subject matter.

  Many photographers try to organize their subject matter into clear layers, or they include foreground objects to guide the eye into and across the image. Other times, they use a simple near-far composition with a close-up subject and a seemingly equidistant background.

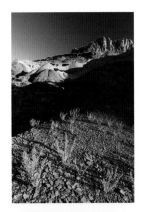

- **Perspective** Point your camera at the horizon to avoid converging verticals; otherwise, be acutely aware of how these will impact your subject.

  Even slight changes in where you point your camera can have a huge impact on whether otherwise parallel vertical lines will appear to converge. Pay careful attention to architecture, trees, and other geometric objects with converging vertical lines that are especially noticeable.

- **Distortion** Be aware of how edge and barrel distortion may impact your subject.

  The two most prevalent forms of distortion in wide-angle lenses are barrel and edge distortion. *Barrel distortion* results when otherwise straight lines appear bulged because they don't pass through the center of the image. *Edge distortion* causes objects at the extreme edges of the frame to appear stretched in a direction leading away from the center of the image.

# USING TELEPHOTO LENSES

You've probably heard that telephoto lenses are good at enlarging distant subjects, but they're also a powerful artistic tool for affecting the look of your subject. For example, they can normalize the relative size and distance for near and far objects, and they can make the depth of field appear shallower. Telephoto lenses are therefore useful not only for wildlife photography but also for landscape photography.

## OVERVIEW

A lens is generally considered to be a *medium telephoto lens* when its focal length is greater than about 70 mm (or the equivalent on a full-frame 35 mm camera). However, many don't consider a lens to be a *full telephoto lens* until its focal length becomes greater than around 135 mm, which translates into an angle of view that is less than about 15 degrees across your photo's widest dimension. On a compact camera with a 3×–4× or greater zoom lens, telephoto is simply when you've fully zoomed in. However, some compact cameras might require a special adapter in order to achieve full telephoto.

As you can see in **FIGURE 3-23**, the longer the focal length of a lens, the narrower its angle of view is. This diagram depicts the maximum angles that light rays can take when hitting your camera's sensor. The location where light rays cross is roughly proportional to the focal length.

**FIGURE 3-23**
Telephoto lenses have long focal lengths.

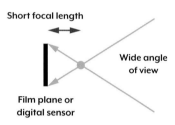
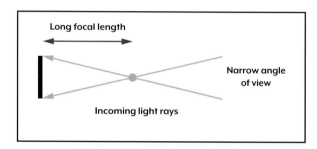

Practically speaking, the long focal length of a telephoto lens has the effect of emphasizing a narrow region within a broader scene, as shown in **FIGURE 3-24**. Here you can see how a telephoto lens is used to magnify and emphasize detail with a subject that is dangerous to get close to.

**FIGURE 3-24**
Distant cheetah through a telephoto lens

## HOW A TELEPHOTO LENS AFFECTS PERSPECTIVE

Now that you know a telephoto lens has a narrow angle of view, let's explore what that does to the image. A narrow angle of view means that both the relative size between subjects and the distance is normalized when comparing near and far objects. This causes nearby objects to appear similar in size to faraway objects, even if the closer object would actually appear larger in person, as shown on the right in **FIGURE 3-25**.

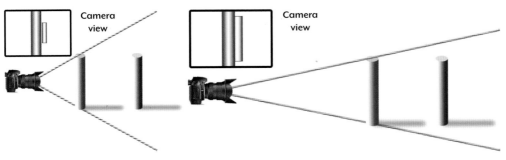

**Camera view**

**Camera view**

**FIGURE 3-25**
Comparing two angles of view

**Wide-angle lens**
(Objects appear very different in size.)

**Telephoto lens**
(Objects appear similar in size.)

As you see in this diagram, even though the two cylinders are the same distance apart, with a telephoto lens, farther objects comprise a much greater fraction of the total angle of view.

As you learned earlier in this chapter, a common misconception is that a telephoto lens affects perspective, but strictly speaking, this isn't true. Perspective is only influenced by where you are located when you take a photograph. However, in practical use, the very fact that you're using a telephoto lens may mean that you're far from your subject, which does affect perspective.

You can use a telephoto lens and its normalization of relative size to give a proper sense of scale. For this technique to have full impact, you'll want to get as far as possible from the nearest subject in the scene and zoom in if necessary.

In the telephoto example in **FIGURE 3-26**, the people in the foreground appear quite small compared to the background building.

But if you were to use a normal focal length lens to take this shot and be closer to the foreground people, they would appear much larger relative to the size of the building.

However, normalizing the relative size too much can make the scene appear static, flat, and uninteresting, because our eyes generally expect closer objects to be a little larger.

**FIGURE 3-26**
Objects appear in proper proportion to one another when a 135 mm telephoto lens is used.

◄ **FIGURE 3-27**
Exaggerated congestion on the
River Cam, Cambridge, UK

▲ **FIGURE 3-28**
Telephoto shot of flowers in
Cambridge, UK

Taking a photo of someone or something from very far away should therefore be done only when necessary.

In addition to affecting relative size, a telephoto lens can make the distance between objects appear compressed. This can be beneficial when you're trying to emphasize the number of objects or to enhance the appearance of congestion, as shown in **FIGURE 3-27**. In this example, the boats all appear to be right next to each other, even though they're much farther from each other in person.

In **FIGURE 3-28**, the flowers appear stacked on top of one another when in reality this image spans around 100 meters. As you can see, this technique has the effect of compressing perspective and making images feel crowded.

## BRINGING DISTANT SUBJECTS CLOSER

Perhaps the most common use for a telephoto lens is to bring otherwise small and distant subjects closer, such as in wildlife photography. This provides a vantage on subjects not otherwise possible in real life. You should therefore pay careful attention to distant detail and texture, which no longer appear tiny relative to nearby subject matter.

Furthermore, even if you were able to get a little closer to the subject, this may adversely impact the photograph because being closer might alter the subject's behavior. This is especially true when trying to capture candid photographs of people, because people usually act differently when they're aware that someone is taking their photograph.

Finally, because a telephoto lens encompasses a much narrower angle of view, you as the photographer can be much more selective with what you choose to contain within your camera frame. You might choose to capture just the region of the sky right around the sunset, as shown in **FIGURE 3-29**, or just the surfer on their wave, or just a tight region around someone's interesting facial expression. Unlike with a wide-angle lens, you can also make an image appear as if it were taken with a longer focal length just by cropping the image, although this comes at the expense of resolution.

This added selectivity can enable very simple and focused compositions like the one in **FIGURE 3-30**.

◄ **Figure 3-29**
Capturing a sunset using a telephoto lens

▲ **Figure 3-30**
A 320 mm detail shot of a parrot

## LAYERING IN LANDSCAPES

Standard photography textbooks often tell you that a wide-angle lens is for landscapes and a telephoto lens is for wildlife. Such claims aren't completely unfounded. For example, telephoto lenses compress the sense of depth, whereas wide-angle lenses exaggerate the sense of depth. Because spaciousness is an important quality of many landscapes, it's understandable to think that wide-angle lenses are therefore better suited. But this is not entirely accurate. In fact, very powerful and effective compositions can be made using a so-called inappropriate type of lens.

You can use telephoto lenses for landscapes; they just require different techniques. To improve the sense of depth, a common telephoto technique is to compose the scene with layered subject matter at distinctly different distances. For example, the closest layer could be a foreground set of trees, the subsequent layers could be successively more distant hillsides, and the furthest layer could be the sky or ocean, as in **FIGURE 3-31**.

In this Mt. Baldy example, the image would have seemed much less three-dimensional without the foreground layer of trees on the hill. Similarly, the separate layers of trees, clouds, and background mountainside also give this image more depth.

**Figure 3-31**
A 130 mm telephoto shot using layered subject matter

**FIGURE 3-32**
A 300 mm telephoto
shot using layered
subject matter

A telephoto lens can also enhance how fog, haze, or mist affects an image, as you can see in **FIGURE 3-32**.

Because these lenses make distant objects appear closer, the distant mountains in this expansive range appear relatively similar in size to the mountains in the foreground.

**FIGURE 3-33**
A 320 mm focal length, shallow depth-of-field telephoto shot of a cat among leaves

## POINT OF FOCUS

For a given subject distance, you can use a telephoto lens to capture the scene with a much shallower depth of field than you can using other lenses. Out-of-focus distant objects are also made much larger, which enlarges their blur. It's therefore critical that you achieve pinpoint accuracy with your chosen point of focus when using a telephoto lens. **FIGURE 3-33** illustrates this.

Here, the foreground fence was less than a foot from the cat's face, yet it appears extremely out of focus due to the shallow depth of field. Even a misfocus of an inch could have caused the cat's eyes to become blurred, which would have ruined the intent of the photograph.

Fortunately, telephoto lenses are rarely subject to these types of *focus and recompose errors* caused by shorter focal lengths, primarily because you are often much farther from your subject. This means that you can use your central autofocus point to achieve a focus lock, then recompose your frame without worrying about changing the distance at which objects are in sharpest focus (see "Understanding Autofocus" on page 196 for more on this topic).

## MINIMIZING CAMERA SHAKE

Previously, you learned that exposure time is important in handheld photographs. In this section, I'll explain how you can use a telephoto lens to easily achieve a sharp handheld photograph. Longer focal lengths require shorter exposure times to minimize blurring caused by shaky hands. Think of this as similar to trying to hold a laser pointer steady. For example, when you shine a laser pointer at a nearby object, its bright spot ordinarily jumps around less than for objects farther away, as you can see in **FIGURE 3-34**.

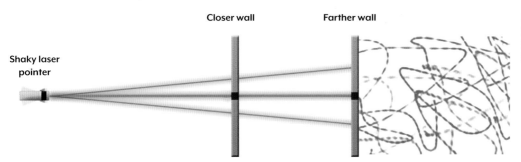

Closer wall    Farther wall

Shaky laser pointer

**FIGURE 3-34**
Laser movements become larger on the farther wall.

When you try to aim a laser pointer at a spot on a more distant wall, even small hand movements are magnified. Similarly, when you're using a telephoto lens and your camera shakes, even small movements are more noticeable because objects are magnified. Reducing camera shake requires either using a faster shutter speed or holding your camera steadier, or some combination of the two.

To achieve a faster shutter speed, you need to use a larger aperture (such as going from f/8.0 to f/2.8) and/or to increase the ISO speed. However, both of these options have drawbacks—a larger aperture decreases depth of field, and a higher ISO speed increases image noise.

To hold your camera steadier, you can use your other hand to stabilize the lens. Try taking the photo while crouching, or lean your body or lens against another solid object. However, using a camera tripod or monopod is the only truly consistent way to reduce camera shake.

## TELEPHOTO LENSES AND DEPTH OF FIELD

Earlier in this chapter, we talked about the misconception that wide-angle lenses improve depth of field and how that's not technically true. In a similar vein, many people mistakenly believe that telephoto lenses decrease depth of field.

In fact, a telephoto lens itself does not have less depth of field. For example, if you're magnifying your subject by the same amount as with another lens (meaning the subject appears the same size in your image frame), then a telephoto lens will give the *same* depth of field as the other lens.

 **TECHNICAL NOTE**

For situations of extreme magnification, the depth of field may differ by a small amount. However, this is an extreme case and is not relevant for the uses discussed here.

The reason that telephoto lenses get the reputation of decreasing depth of field is that people usually magnify their subject matter a lot more when using telephoto lenses than when using lenses with wider angles of view. In other words, people generally don't get farther from their subject, so this subject ends up filling more of the frame. It's this higher magnification that causes the shallower depth of field.

However, a telephoto lens does enlarge out-of-focus regions (or *bokeh*) since it enlarges the background relative to the foreground. This may also contribute to the appearance of a shallower depth of field.

You should therefore pay close attention to how a background will look and be positioned when it's out of focus. For example, poorly positioned out-of-focus highlights may prove distracting for a foreground subject, as in **FIGURE 3-35**.

**FIGURE 3-35**
Potentially distracting out-of-focus background

In **FIGURE 3-36**, a medium telephoto lens was used to compress perspective so that both near and far statue silhouettes would be clearly visible and more similar in size, but not so much that the sense of depth was lost to the viewer.

**FIGURE 3-36**
Medium telephoto
(93 mm) nightscape
of the Charles Bridge in
Prague, Czech Republic

## SUMMARY

In this chapter, we explored different characteristics of a camera lens, such as focal lengths, portability, aberrations, and aperture, to understand how they affect your image.

You learned how wide-angle lenses exaggerate relative subject size as well as the distance between subjects. You can take advantage of wide-angle lenses and their wide angle of view to emphasize foreground objects against a wide background. You also learned how to use telephoto lenses and their narrow angle of view to normalize the relative sizes of your subjects. As you saw in the examples, you can use telephoto lenses to bring faraway objects closer and create a much tighter and focused composition.

With both types of lenses, we dispelled some common misconceptions. For example, you learned that wide-angle lenses and telephoto lenses themselves don't increase and decrease depth of field, respectively. In fact, it's how people end up using these lenses that gives the impression that depth of field is changing. Understanding how lenses actually work will give you more flexibility and control over your images.

In the next chapter, we'll go over how you can use equipment and accessories like flash and tripods to enhance capture.

# 4

# Camera Types and Tripods

**IN THIS CHAPTER, YOU'LL LEARN** to make the most of what's in your camera bag. You'll learn about the key differences between a compact camera, mirrorless camera, and digital SLR camera by exploring how each affects portability, image quality, and creative control. You'll also learn how to select the right tripod for your camera, which you'll need to take razor-sharp photographs.

# CHOOSING A CAMERA TYPE

Choosing between a compact (point-and-shoot) camera (**Figure 4-1**), a mirrorless camera (**Figure 4-2**), or a digital single-lens reflex (DSLR) camera (**Figure 4-3**) is often the first big purchasing decision you have to make when starting out with photography. Not only is it a big financial decision, but it can also determine what kinds of shots you'll be capable of capturing.

 **TECHNICAL NOTE**

Compact cameras are technically also mirrorless. However, when photographers refer to a "mirrorless camera," they are typically using shorthand for what is more accurately described as a "mirrorless interchangeable lens camera." Unfortunately, no simple, brand-agnostic acronym has been established for these cameras on a par with the term *DSLR (digital SLR)*, so for the purposes of this book, we'll continue to use the abbreviated term mirrorless camera.

## UNDERSTANDING CAMERA TYPES

So what exactly distinguishes each camera type? Although the lines between camera types continue to blur, there are usually three main differences:

- Viewfinder mechanism

- Fixed versus interchangeable lenses

- Camera sensor size

SLR cameras (**Figure 4-3**) are most commonly known for having viewfinders that see the same light as the camera's sensor (more on this later), but in practice, this isn't the only distinction. Compact cameras (**Figure 4-1**), on the other hand, are known for having fixed lenses, a smaller sensor size, and an electronic viewfinder. Mirrorless cameras are a new hybrid category (**Figure 4-2**); these cameras have viewfinders that are similar to those on compact cameras, but they have interchangeable lenses and a sensor size that is often similar to that of digital SLR cameras.

The viewfinder type and sensor size are the two primary factors that determine the size and weight of a camera. Compact cameras are therefore the smallest, whereas mirrorless cameras are a little larger depending on the sensor size, and digital SLR cameras are the largest. **Table 4-1** summarizes the characteristics of each camera type.

**Table 4-1** Summary of Camera Types

|  | COMPACT CAMERA | MIRRORLESS CAMERA | DIGITAL SLR CAMERA |
|---|---|---|---|
| **VIEWFINDER** | Electronic | Electronic | Optical |
| **LENS FLEXIBILITY** | Fixed | Interchangeable | Interchangeable |
| **SENSOR SIZE** | Small | Intermediate to large | Large |

Although you can find additional, minor differences that vary depending on the camera brand or model, the three aspects most likely to impact your photography are the viewfinder type, the lens flexibility, and the sensor size. Let's explore what these mean in practice and how they might impact your photography style. After that, we'll discuss other, more minor differences among the three camera types.

**FIGURE 4-1**
Compact camera

## NOTABLE EXCEPTIONS

The Sony *Single-Lens Translucent (SLT)* cameras have a mirror that's stationary, as opposed to being able to flip up, and therefore do not have an optical viewfinder. Some entry-level SLR cameras might also have fixed lenses, and some high-end compact-style cameras can have sensors that are nearly as large as an SLR's, but these are the exceptions rather than the rule.

As you'll learn in this chapter, SLR cameras are usually much more expensive than mirrorless and compact cameras, mostly as a consequence of these three differences. Also, unlike with compact cameras, which usually don't require external accessories, purchasing a mirrorless or SLR camera is only part of your overall cost. You might have to buy additional lenses, an external flash, and other accessories, which can end up costing more than the camera itself.

**FIGURE 4-2**
Mirrorless camera

**FIGURE 4-3**
SLR camera

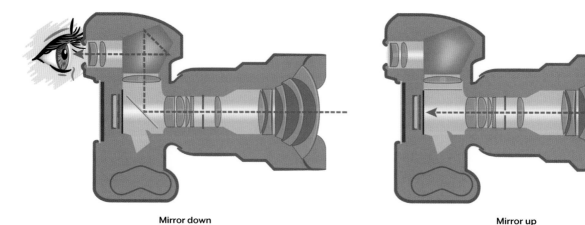

Mirror down                                    Mirror up

**FIGURE 4-4**
How the viewfinder works in an SLR camera

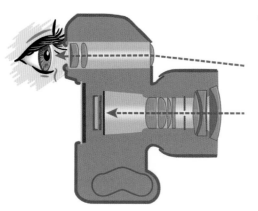

**FIGURE 4-5**
Compact camera with a viewfinder

## VIEWFINDER MECHANISM

Unlike with compact and mirrorless cameras, with an SLR camera, the light you see through the viewfinder is the same light that reaches your camera's sensor. When you press the shutter button on an SLR, the mirror flips up, and the light that was formerly being routed to your eye instead gets sent straight to the camera sensor, as shown in **FIGURE 4-4**. The flipping up of the mirror is also what makes the characteristic clicking or snapping sound that we've come to associate with SLR cameras.

On the other hand, the viewfinder mechanism in early compact cameras used a version of an optical viewfinder that tried to estimate what light would reach the sensor, making it potentially less accurate (as illustrated by the upper dashed line in **FIGURE 4-5**).

Modern compact and mirrorless cameras therefore use what's called an *electronic viewfinder (EVF)*, which attempts to re-create what an SLR viewfinder would see using the electronic image from the sensor.

The need for a prism and mirror is one of the reasons SLR cameras cost more to manufacture (other than sensor size). However, in practice, the sensor size and the ability to change lenses will likely make more of a difference to your photography, so you may want to prioritize those factors when purchasing your camera. This is especially true since even SLR camera owners often choose to use the *rear LCD screen* instead of the viewfinder if a "live view" mode is supported. The rear LCD screen is typically available with all three camera types, and when used in conjunction with a live histogram, it allows you to see exactly how the image will be recorded. On the other hand, if your work requires seeing exactly the same light as what will hit the camera's sensor, you should certainly opt for an SLR.

## SINGLE-LENS REFLEX (SLR)

The mirror flipping is what gives single-lens reflex (SLR) cameras their name. "Single-lens" refers to the fact that the same lens is used to produce the image in the viewfinder and to capture that image at the sensor, and "reflex" refers to the mirror reflecting light to the viewfinder (the Latin root verb, reflectere, means "to bend back"). However, this terminology can be a little confusing because SLR cameras can actually use more than just a "single lens," despite what the name might state.

### FIXED VS. INTERCHANGEABLE LENSES

The fact that you can change out lenses on mirrorless and SLR cameras (**FIGURE 4-6**) is likely the most noticeable difference between these two camera types and compact cameras. Although many compact cameras, especially the high-end variety, can use lens adaptors, the original lens still remains on the camera.

**FIGURE 4-6**
Example set of diverse interchangeable lenses

You may be wondering why a camera would need more than one lens. It's difficult, if not impossible, to design a single lens that can capture all types of scenes without noticeably sacrificing quality and portability. It's therefore better to use special-purpose lenses to achieve the various styles you want.

In practice, the ability to use different lenses allows you to do the following:

- **Use wider lens apertures** (lower f/stops) to enable a shallower depth of field, better low-light performance, or both.

- **Use specialized lenses**, such as ultra-wide-angle lenses (**FIGURE 4-7**), macro lenses (**FIGURE 4-8**), fisheye lenses, and extreme telephoto lenses, to give you more creative options.

- **Achieve better image quality**, primarily because you can use a lens more specifically designed for the task at hand.

For example, as you learned in Chapter 3, you can use a wide aperture (such as f/2.0 or less) to create a smooth, out-of-focus background and isolate your subject in portraits. Alternatively, you can use an ultra-wide-angle lens designed to minimize distortion to prevent straight lines from appearing curved in architectural photography. Neither of these scenarios would be possible with the vast majority of compact cameras.

**FIGURE 4-7**
Ultra-wide angle of view made possible with a special-purpose lens on a camera with interchangeable lenses

**FIGURE 4-8**
Shallow depth-of-field macro shot made possible with a special-purpose lens on a camera with interchangeable lenses

However, using more than one lens also has the following disadvantages:

- You need to carry more lenses with you if you plan on shooting a range of different styles and subjects, which decreases the portability of your camera system.

- You need to change lenses every time you want to change shooting styles, which can interrupt your shooting rhythm.

- You might introduce dust onto your camera's sensor each time you have to change lenses, which can reduce image quality and be difficult to remove. See the Appendix for more on camera sensor cleaning.

Of course, to negate any potential inconvenience, you could always stick with one all-around lens for your SLR. In addition, the built-in lens on a high-end compact camera can sometimes produce higher-quality images than a stock or entry-level SLR lens, and it's often more versatile. However, if you're willing to spend a lot more money, you'll find that compact camera lenses rarely hold their own against high-end SLR lenses.

## CAMERA SENSOR SIZE

In general, compact cameras have much smaller camera sensors than mirrorless and SLR cameras, resulting in much smaller pixels at the same resolution, as shown in **FIGURE 4-9**. This is a less commonly known difference between camera types, but it's the one that will make the most noticeable impact on image quality.

**FIGURE 4-9**
Differences in camera sensor size

Compact camera pixels

SLR camera pixels

So what does a camera's sensor size mean in practice?

- **Cost** Larger sensors are much more expensive to make and usually require correspondingly more expensive lenses. This is the biggest reason SLR and mirrorless cameras cost so much more than compact cameras.

- **Weight and size** Larger sensors require much heavier and larger camera lenses and camera bodies, because the lens needs to capture and project light over a larger sensor area. Other than reducing portability, this can also be a disadvantage because the size of your camera and lens makes you look more conspicuous, making candid shots more difficult to take.

- **Depth of field** Larger sensors create a shallower depth of field given the same aperture setting. For example, a lens at f/4.0 on a compact camera likely won't create a blurred background in a portrait, whereas f/4.0 on a mirrorless or SLR camera will likely create a smooth, creamy background (depending on subject distance). This can be an advantage for portraits but a disadvantage for landscapes.

**Figure 4-10**
High dynamic range made possible with a large sensor

**Figure 4-11**
Clean image at a high ISO speed
made possible with a large sensor

- **Image noise**  For the same number of megapixels, larger sensors have much larger pixels (as illustrated in **Figure 4-9**). This increased light-gathering area means that these pixels will be more sensitive to tiny amounts of light, resulting in less image noise. Thus, an SLR or mirrorless camera can produce an image with less noise with a much higher ISO setting than can a compact camera (**Figure 4-11**).

- **Dynamic range**  Another consequence of having physically larger pixels is that mirrorless and SLR cameras can usually capture a greater range of light to dark without having the pixels become solid white or black (**Figure 4-10**), respectively (in other words, these cameras have a higher *dynamic range*). Using an SLR, you can reduce the chance of blown highlights in the sky or other bright objects, and you can preserve more details in the deep shadows.

The key here is that a different sensor size is just one of many trade-offs you'll need to consider when deciding what kind of camera to buy. One sensor size isn't necessarily better than another, so be sure to consider how the pros and cons of each will fit into your intended shooting style.

## ADVANTAGES OF EACH CAMERA TYPE

In addition to what we discussed so far, each camera type can have other advantages, depending on the specific brand or model.

Compact cameras offer the following advantages:

- Live-view rear LCD (although most newer SLRs also have this feature)
- Greater range of pre-programmed creative modes
- No mirror/shutter mechanism that can fail after ~10–100K shots

On the other hand, SLR cameras have these advantages:

- Faster camera autofocus
- Much less *shutter lag*, or delay between pressing the shutter and starting the exposure
- Higher maximum frame rate
- RAW file format support (most high-end compact cameras also have this)
- Ability to take exposures longer than 15–30 seconds (using manual or bulb mode)
- Complete manual exposure control
- Ability to use an external flash unit (many high-end compact cameras also have this)
- Manual zoom control (by twisting the lens as opposed to using an electronic button)
- Greater range of ISO speed settings
- Ability to upgrade just the camera body and keep all your lenses

However, many of these differences in advantages result from the fact that photographers are willing to spend a lot more on an SLR than on a compact camera; they aren't necessarily inherent to each camera type. For example, if you spend enough on a high-end compact camera, you can often attain many of the features typically found on SLR cameras.

In sum, choosing among camera types comes down to flexibility and the potential for higher image quality versus portability and simplicity. This choice often isn't a matter of which is right for a given person but rather which is better for a given shooting environment and intended application.

Compact cameras are much smaller, lighter, less expensive, and less conspicuous, but SLR cameras allow for a shallower depth of field, a greater range of subject styles, and potentially higher image quality. Mirrorless cameras, on the other hand, have some of the size benefits of compact cameras but also have the image-quality benefits of SLR cameras if the sensor size is comparable. Compact cameras are probably better for learning photography because they cost less, simplify the shooting process, and are a good all-around option for capturing many types of scenes out of the box. SLR and mirrorless cameras are much better suited to specific applications, especially when cost or size and weight are less important.

Costs aside, many people prefer to own more than one type of camera. This way, they can take their compact camera to parties and on long hikes, but have an SLR or mirrorless camera available when they need to capture indoor subjects in low light or for landscape or event photography.

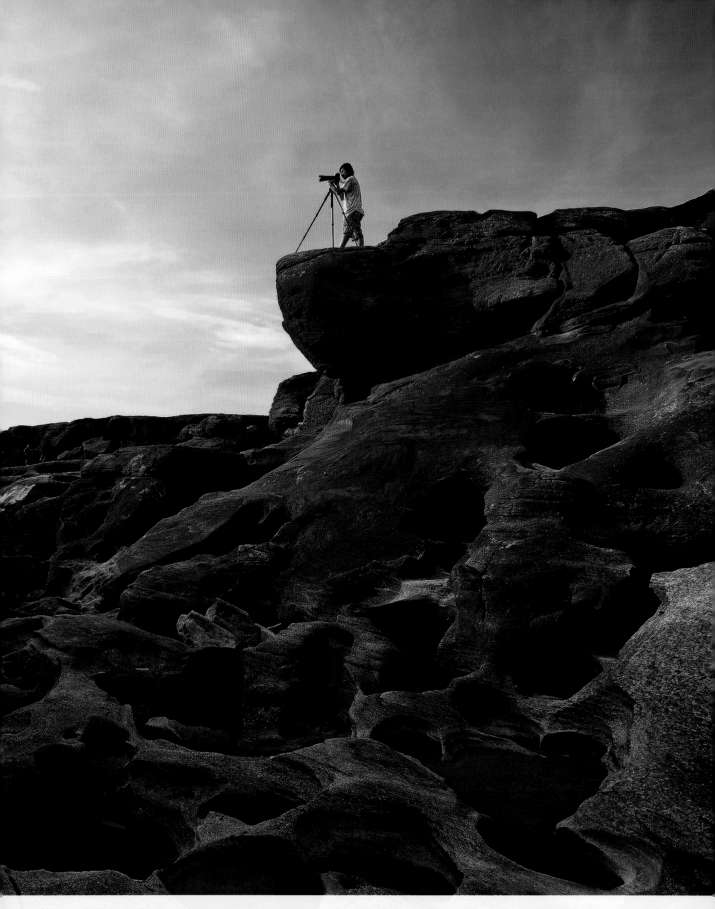

# CAMERA TRIPODS

A camera tripod can make a huge difference in the sharpness and overall quality of photos. It enables photos to be taken with less light or with a greater depth of field, in addition to enabling several specialty techniques. A camera tripod's function is to hold the camera in a precise position. This gives you a sharp picture that might otherwise appear blurry due to camera shake. But how can you tell when you should and shouldn't be using a tripod? When is a photo taken with a handheld camera likely to become blurred?

## WHEN TO USE A TRIPOD

Your intended shutter speed typically determines whether you need to use a tripod. Fast shutter speeds can usually be taken handheld without appearing blurred, but for slower shutter speeds you'll want to use a tripod for best results. To estimate how fast the exposure needs to be to avoid a tripod, you can use the one-over-focal-length rule you learned in Chapter 3, which states that for a 35 mm camera, the exposure time needs to be at least as fast as one over the focal length in seconds. In other words, when you're using a 100 mm focal length on a 35 mm camera, the exposure time needs to be at most 1/100 second long to avoid blurring. For digital cameras with cropped sensors, you need to convert to a 35 mm equivalent focal length.

This rule depends on focal length because zooming in on your subject magnifies camera movement, as illustrated by the laser pointer analogy in Chapter 3.

Keep in mind that this rule is just for rough guidance. The exact camera shutter speed where camera shake affects your images will depend on the sharpness of your lens, the resolution of your camera, the distance to your subject, and how steady you hold the camera. In other words: if in doubt, always use a tripod.

Finally, camera lenses with image stabilization (IS) or vibration reduction (VR) may enable you to take handheld photographs with shutter speeds that are anywhere from two to eight times longer than you'd otherwise be able to hold steady for. However, IS and VR do not always help when the subject is moving—but then again, neither do tripods.

## OTHER REASONS TO USE A TRIPOD

Just because you can hold the camera steady enough to take a sharp photo using a given shutter speed doesn't necessarily mean that you should not use a tripod. A tripod can allow you to use an even slower shutter speed than would otherwise be possible, and in exchange you can then optimize your aperture or ISO setting. For example, with a slower shutter speed, you could use a smaller aperture to achieve more depth of field or a lower ISO to reduce image noise.

In addition, the following specialty techniques may require using a tripod:

- Taking a series of photos at different angles to produce a digital panorama
- Taking a series of photos at different exposures for a high-dynamic-range (HDR) photo
- Taking a series of time-lapse photographs to produce an animation
- Taking a series of photos to produce a composite image, such as selectively including people in a crowd or combining portions lit by daylight with those at dusk
- Whenever you want to precisely control your composition

## MAIN CONSIDERATIONS FOR CHOOSING A TRIPOD

Even though a tripod performs a pretty basic function, choosing the best tripod often involves many competing factors. You'll need to identify the optimal combination of trade-offs for your needs.

The top considerations are usually its stability, weight, and ease of use:

- **Stability**  Important factors that can influence sturdiness include the number of tripod leg sections, the material and thickness of the leg units, and the length of the legs and whether a center column is needed to reach eye level. Ultimately, though, the only way to gauge the sturdiness of a tripod is to try it out. Tap or apply weight to the top to see if it vibrates or sways and take a few test photos.
- **Weight**  This determines whether you take the tripod along with you on a hike or even on a shorter stroll through town. Having a lighter tripod can mean that you'll end up using it more often—or at least make using it more enjoyable since it will be easier to carry around. However, tripod weight, sturdiness, and price are closely related; just make sure you're not sacrificing too much sturdiness in exchange for portability, or vice versa. If you want a lightweight, sturdy tripod, you'll end up paying a lot more than for a heavier

tripod that's just as sturdy or a lightweight tripod that isn't as sturdy. Also, tripods that don't extend as high may weigh a little less and therefore be more portable, but they might not be as versatile as a result.

- **Ease of use**  What's the point of having a tripod if it stays in the closet because you find it too cumbersome, or if you miss the shot because it takes you too long to set it up? A tripod should be quick and easy to position. Ease of use depends on the type of tripod head (which we'll discuss shortly) and how you can position the leg sections. We usually extend or contract tripod leg sections using a locking mechanism, either with lever locks (**Figure 4-12**) or twist locks (**Figure 4-13**). Lever locks, also called clip locks, tend to be much quicker to use, although some types can be tough to grip when you're wearing gloves. Twist locks are usually a little more compact and streamlined because they do not have external clips or latches. They also sometimes require two hands to extend or contract each leg section independently.

**Figure 4-12**
Lever locks

**Figure 4-13**
Twist locks

## OTHER CONSIDERATIONS

Other, more minor considerations when choosing a tripod include the following:

- **Number of tripod leg sections**  Each tripod leg can typically be extended using two to four concentric leg sections. In general, more leg sections means reduced stability, but having more sections can reduce the size of the tripod when fully contracted and in your camera bag. Note that more leg sections can also mean that it takes longer to position or fully extend your tripod.

- **Maximum tripod height**  This is especially important if you're tall, since you could end up having to crouch if the tripod isn't tall enough. Make sure that the tripod's max height specification does not include having to extend its center column (**Figure 4-14**), because this can make the camera much less steady. Even without the center column, the higher you extend your tripod, the less stable it will be. On the other hand, you might not want to take your photos at eye level most of the time since this can make for an ordinary-looking perspective.

**Figure 4-14**
The center column of the tripod extends to increase its maximum height (at the expense of stability).

- **Minimum tripod height** This is primarily important for photographers who take a lot of macro photographs of subjects on the ground or those who like to use extreme vantage points in their photographs (**FIGURE 4-15**).

- **Contracted tripod height** This is important for photographers who need to fit their tripod in a backpack, suitcase, or other enclosed space. Tripods with more leg sections are generally more compact when fully contracted, but more compact tripods either don't extend as far or aren't as sturdy.

- **Aluminum vs. carbon fiber** The two most common types of tripod material are aluminum and carbon fiber. Aluminum tripods are generally much cheaper than carbon fiber models, but they're also heavier for the same amount of stability, not to mention uncomfortably cold to handle with your bare hands in the winter. Carbon fiber tripods are generally also better at dampening vibrations. The best tripod material for damping vibrations is actually good old-fashioned wood, but it's just too heavy and impractical for typical use.

**FIGURE 4-15**
Example of a tripod being used from a low vantage point. The center column may limit the minimum height if not removable.

## TRIPOD HEADS

Although many tripods already come with a tripod head, you might consider purchasing something that better suits your shooting style. The two most common types of tripod heads are pan-tilt (**FIGURE 4-16**) and ball heads (**FIGURE 4-17**).

*Pan-tilt heads* are great because you can independently control each of the camera's two axes of rotation: left/right (yaw) and up/down (pitch). This can be very useful once you've already taken great care to level the tripod but need to shift the composition slightly. However, for moving subjects, this can also be a disadvantage because you will need to adjust at least two camera settings before you can fully recompose the shot.

*Ball heads* are great because you can quickly point the camera freely in nearly any direction before locking it into position. They are typically also a little more compact than equivalent

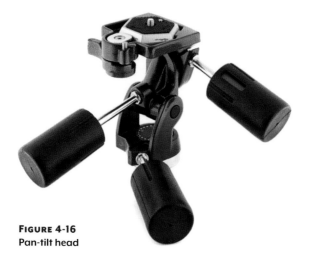

**FIGURE 4-16**
Pan-tilt head

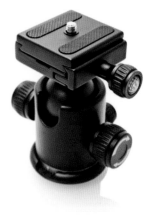

**FIGURE 4-17**
Ball head

pan-tilt heads. However, the advantage of free motion can also be a disadvantage because your composition might no longer be level when you unlock the camera's position, even if all you want to change is its left/right angle. To get around this problem, some ball heads come with a rotation-only ability. They can also be more susceptible to damage because small scratches or dryness of the rotation ball can cause it to grind or move in uneven jumps.

Be on the lookout for whether your tripod head creeps or slips under heavy weight. This is a surprisingly common problem, especially for long exposures with heavier SLR cameras. To test this, attach a big lens to your SLR camera and face it horizontally on your tripod. Take an exposure of around 30 seconds, if possible, and see whether your image has slight motion blur when viewed at 100 percent. Pay particular attention to creeping when the tripod head is rotated so you can check how it holds up in portrait orientation.

The *strength-to-weight ratio* is another important tripod head consideration. This describes the rated load weight of the tripod head (how much equipment it can hold without creeping or slipping) compared to the weight of the tripod head itself. Higher ratios make for a much lighter overall tripod/head combination.

A tripod head with a built-in bubble (**FIGURE 4-18**) or spirit level can also be an extremely helpful feature, especially when your tripod legs aren't equally extended on uneven ground.

**FIGURE 4-18**
Bubble level

Finally, regardless of which type of tripod head you choose, a quick-release mechanism makes a big difference in how quickly you can attach or remove your camera. A *quick-release mechanism* lets your camera attach to the tripod head using a latch, instead of requiring the camera to be screwed into place. With most photographers, the choice isn't about whether to use quick release, but about which quick release standard to adopt. Two common options are the Arca-Swiss and Manfrotto styles.

## TRIPOD LENS COLLARS

Most commonly used with large telephoto lenses, a *lens collar* is an attachment that fits around the lens somewhere near its base or midsection, allowing the tripod head to attach directly to the collar itself instead of the camera body (**FIGURE 4-19**).

This causes the camera and lens to rest at a location much closer to their center of mass. Much less rotational stress, or torque, is therefore placed on the tripod head, greatly increasing the amount of weight that your tripod head can sustain without creeping or slipping. A lens collar can also make the tripod and head less susceptible to vibrations.

So if your lens came with a collar, use it! Otherwise, you might consider purchasing one that fits your lens.

**FIGURE 4-19**
Tripod lens collar on a heavy telephoto zoom lens

## TIPS FOR TAKING SHARP PHOTOS WITH TRIPODS

How you use your tripod can be just as important as the type of tripod you're using. Here is list of tips for achieving the sharpest possible photos with your tripod:

- Hang a camera bag from the center column for added stability, especially in the wind. (Make sure that this camera bag does not swing appreciably, which would be counterproductive.)

- Raise the center column only after all of the tripod's leg sections have been fully extended, and then only if absolutely necessary. The center column wobbles much more easily than the tripod's base.

- Remove the center column to shave off some weight.

- Extend your tripod only to the minimum height required for a given photograph.

- Spread the legs to their widest standard position whenever possible.

- Shield the tripod's base from the wind whenever possible.

- Extend only the thickest leg sections necessary to reach a given tripod height.

- Set your tripod up on a sturdy surface, such as rock or concrete, rather than dirt, sand, or grass. For indoor use, tile or hardwood floor is much better than a rug or carpet.

- Use add-on spikes at the ends of the tripod legs if you have no other choice but to set up your tripod on carpet or grass.

**FIGURE 4-20**
Tabletop or mini tripod

## TABLETOP AND MINI TRIPODS

You can use a *tabletop* or *mini tripod* with a compact camera, as shown in **FIGURE 4-20**. This type of tripod can be quite portable and even carried in your pocket. As you can imagine, this portability often comes at the expense of versatility. Because a tabletop or mini tripod can only change your camera's up/down (pitch) and left/right (yaw) orientation, it won't help you change your camera's height. This means that finding the best surface to place the tripod becomes more important with a tabletop/mini tripod, because you need this surface to be at a level that gives you the desired vantage height.

However, photos taken at eye level often appear too ordinary, because that's the perspective we're most used to seeing. Photos taken above or below this height are therefore often perceived as more interesting. A tabletop/mini tripod can force you to try a different perspective with your photos.

## CAMERA MONOPODS

A *monopod* is a tripod with only one leg and is most commonly used to hold up heavy cameras and lenses, such as large telephoto lenses for sports and wildlife photography. In addition, monopods can increase "handheld-ability" for situations where longer shutter speeds are needed but carrying a full tripod might be too cumbersome.

You can use a monopod to more easily photograph a moving subject in a way that creates a blurred background while keeping the moving subject reasonably sharp, as shown in **FIGURE 4-21**.

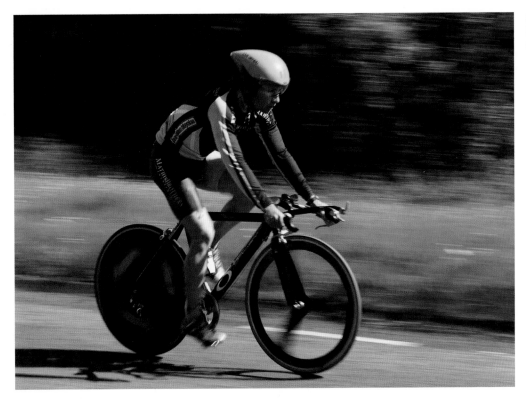

**FIGURE 4-21**
Monopod used to track a moving subject

This technique works by rotating the monopod along its axis, causing the camera to pan in only one direction.

## SUMMARY

In this chapter, we explored the various categories of cameras, along with key differences that are likely to influence your photography, such as the type of viewfinder, the sensor size, and whether the camera supports interchangeable lenses. You also learned when a camera tripod is necessary, along with how to choose and make the most of your camera tripod.

In Chapter 5, we'll explore different filter options and when to use them.

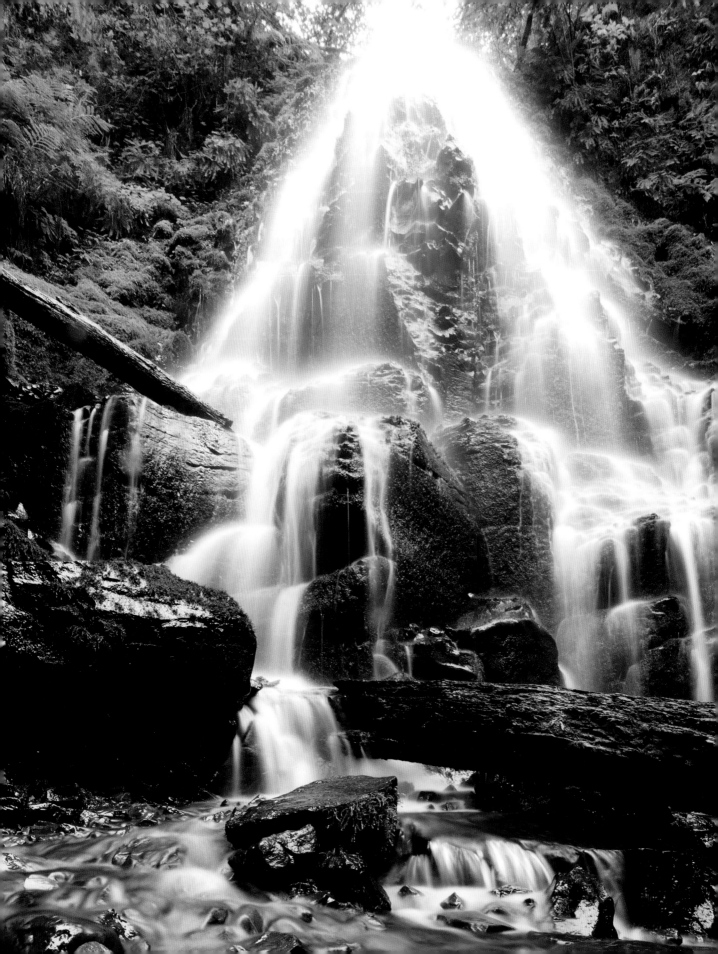

# 5

# Lens Filters

**THIS CHAPTER GIVES AN OVERVIEW** of filter choices as well as the various options and usage scenarios for these filters. You start by learning about polarizing filters and how they control reflections and color saturation. Then you learn how to use neutral density (ND) filters to intentionally create very long exposures. Finally, you see how you can use graduated neutral density (GND) filters to manage dramatic lighting when working with expansive scenes.

# UNDERSTANDING LENS FILTERS

Although it's possible to edit digital images later in post-processing, camera lens filters—the physical pieces of glass that affect light passing through the lens—are just as important to digital photography as they are to film photography. This chapter concentrates on filter options that create effects that are difficult or impossible to reproduce in digital editing, such as using polarizing filters to reduce glare and see through reflections on the water. Even the simple UV/haze filter, which just provides protection for the front of the lens while minimally influencing image quality, is an important part of any photographer's camera bag.

Polarizing filters can increase color saturation and decrease reflections. They're one of the only lens filters whose effects cannot be replicated using digital photo editing. They are indispensable tools that should be in every photographer's camera bag. They are among the most commonly used filters in digital photography, which also include, UV/haze, neutral density, graduated neutral density, and color filters. **TABLE 5-1** lists some of these filters and their uses.

**TABLE 5-1**  Common Filter Types and Their Uses

| FILTER TYPE | PRIMARY USE | COMMON SUBJECT MATTER |
|---|---|---|
| Linear and circular polarizers | Reduce glare. Increase saturation. | Sky, water, and foliage in landscapes. Reflective surfaces including glass, windows, and water. |
| Neutral density (ND) | Enable longer exposures. Enable shallower depth of field. | Water (for example, waterfalls/rivers) and other moving subjects. Subjects under bright light. |
| Graduated neutral density (GND) | Control light gradients. Reduce vignetting. | Dramatically-lit landscapes. |
| UV/haze | Improve clarity with film. Provide lens protection. | Hazy, sunny scenes with film. Any shooting environment where protecting the front of the lens is important. |
| Warming/cooling | Change white balance. | Landscapes, underwater, and special lighting conditions. |

# UV AND HAZE FILTERS

The original purpose of ultraviolet (UV) filters was to block or absorb ultraviolet light. Especially with film cameras, UV filters reduce haze and improve contrast by minimizing the amount of UV light that reaches the film.

The problem with UV light is that even though it is not visible to the human eye, it is detected by the camera. On a hazy day, the UV light is often uniformly distributed and therefore adversely affects the camera's exposure by reducing contrast.

Nowadays, UV filters are primarily used to protect the front element of a camera lens (see **Figure 5-1**). Because UV filters are clear, they offer a layer of protection over the lens and coatings without noticeably affecting an image. Digital camera sensors are not as sensitive to UV light as film is and may incorporate native UV filtration, so external UV filtration is often no longer necessary.

The drawback to UV filters is that they have the potential to degrade image quality by increasing lens flare, adding a color tint, or reducing contrast. Multicoated UV filters can dramatically reduce the chance of flare. Keeping your filter clean minimizes any reduction in image quality, although micro-abrasions due to cleaning can affect sharpness and contrast. Pristine, high-quality UV filters will not introduce many of these issues, whereas lower-quality, poorly maintained filters might do more to degrade image quality than they are worth.

**Figure 5-1**
**Broken UV filter with lens intact**

For digital cameras, it is up to you to decide whether the advantage of a UV filter (for protection) outweighs the potential reduction in image quality. For very expensive SLR lenses, the increased protection is often the determining factor: it is much easier to replace a filter than to replace or repair a lens. For less expensive lenses, protection and image quality are much less of a factor.

Another consideration is that the use of a UV filter might increase the resale value of the lens by helping to keep the front lens element in mint condition. A UV filter could also be deemed to increase image quality because it can be routinely and cheaply replaced whenever it adversely affects image quality. The wear and tear that the filter absorbs from normal use protects the lens and coatings from seemingly innocuous practices such as cleaning.

# COLOR FILTERS

Cooling and warming filters change the white balance of light reaching the camera's sensor. These can be used to correct or create color casts, such as shifting the balance of artificial light or adding warmth to a cloudy day to give the appearance of sunset lighting.

These filters have become much less important with digital cameras because most automatically adjust for white balance; plus, color can be adjusted afterward when photos are taken using the RAW file format. On the other hand, some situations might still necessitate using color filters, such as the unusual lighting shown in **Figure 5-2** or underwater photography.

◀ **Figure 5-2**
Example of unusual lighting that calls for the use of color filters

▲ **Figure 5-3**
Visible filter vignetting

This image's orange color cast is from the monochromatic sodium street lamps; with this type of light source, virtually no amount of white balance correction can restore full color—at least not without introducing huge amounts of image noise in some color channels. In this case, a cooling filter or specialized streetlight filter could be used to restore color based on other light sources.

## PROBLEMS WITH USING LENS FILTERS

Filters should only be used when necessary because they can also adversely affect an image. Because they introduce an additional piece of glass between your camera's sensor and the subject, they have the potential to reduce image quality. This usually comes in the form of either a slight color tint, a reduction in local or overall image contrast, or ghosting and increased lens flare caused by light reflecting off the inside of the filter. Filters might also introduce physical *vignetting* (light fall-off or blackening at the edges of the image) if their opaque edge gets in the way of light entering the lens.

**FIGURE 5-3** was created by stacking a polarizing filter on top of a UV filter while also using a wide-angle lens, causing the edges of the outermost filter to get in the way of the image. Stacking filters therefore has the potential to make all of the aforementioned problems much worse.

# CHOOSING A FILTER SIZE

Lens filters generally come in two varieties: front filters and screw-on filters. *Front filters* are more flexible because they can be used on virtually any lens diameter; however, they can also be more cumbersome to use because they might need to be held in front of the lens. Fortunately, filter holder kits are available that can improve this process. *Screw-on filters*, on the other hand, can provide an air-tight seal when needed for protection, and they cannot accidentally move relative to the lens while you're composing a shot. The main disadvantage is that a given screw-on filter will only work with a specific lens size.

The size of a screw-on filter is expressed in terms of its diameter, which corresponds to the diameter usually listed on the top or front of your camera lens (see **Figure 5-4**). This diameter is listed in millimeters and usually ranges from about 46 to 82 mm for digital SLR cameras. Step-up or step-down adapters can enable a given filter size to be used on a lens with a smaller or larger diameter, respectively. However, step-down filter adapters could introduce substantial vignetting (because the filter might block light at the edges of the lens), whereas step-up adapters mean that your filter is much larger (and potentially more cumbersome) than is required.

The height of the filter edges may also be important. Ultra-thin and other special filters are designed so that they can be used on wide-angle lenses without vignetting. On the other hand, these may also be much more expensive and often do not have threads on the outside to accept another filter (or sometimes even the lens cap).

**Figure 5-4**
Example of a filter diameter specification (circled in red)

# POLARIZING FILTERS

*Polarizing filters*, also known as *polarizers*, are perhaps the most important filter for landscape photography. Placed in front of your camera lens, polarizers work by reducing the amount of reflected light that passes through your camera's lens at certain angles. Similar to polarizing sunglasses, polarizers make skies appear deeper blue, reduce glare and reflections off water and other surfaces, and reduce the contrast between land and sky.

Note that in **Figure 5-5** the sky has become a much darker blue and the foliage and rocks have acquired slightly more color saturation.

Polarizing filters should be used with care because they can adversely affect the photo. Polarizers dramatically reduce the amount of light reaching the camera's sensor, often by two to three f-stops (1/4 to 1/8 the amount of light). Because compensating for this light loss often requires a slower shutter speed, the risk of creating a blurred handheld image goes up dramatically. Polarizing filters might therefore limit opportunities with action shots.

Using a polarizer on a wide-angle lens can produce uneven or substantially darkened skies that look unrealistic. For example, in the photo on the right in **Figure 5-5**, the sky could be considered unusually uneven and dark toward the top.

**FIGURE 5-5**
Two separate hand-
held photos taken
seconds apart

No polarizer

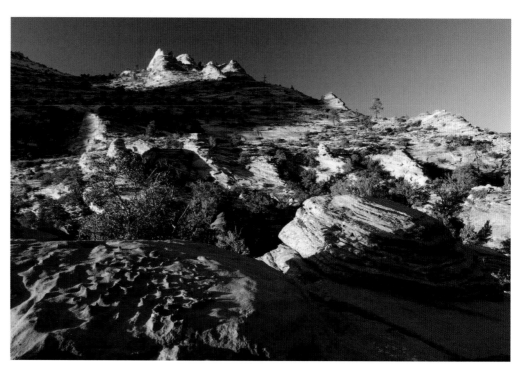

Polarizer at its maximum effect

## LINEAR AND CIRCULAR POLARIZERS

Another option is to use either a circular or linear polarizing filter. The *circular polarizer* is designed so that the camera's metering and autofocus systems can still function, and it's the recommended type for most photographers.

On the other hand, *linear polarizers* are much less expensive, but they cannot be used with cameras that have through-the-lens (TTL) metering and autofocus, thus excluding nearly all digital SLR cameras. You could, of course, forgo metering and autofocus to save money with these linear polarizers, but that is rarely desirable.

## USING POLARIZERS

Developing an intuition for how a polarizer might impact a photo often requires extensive experimentation. This section aims to accelerate that process by demonstrating how and why polarizing filters can help—and in some cases harm—different types of scenes.

Polarizers filter out sunlight that has been directly reflected toward the camera at specific angles, as shown in **FIGURE 5-6**. This filtration is beneficial because the remaining light is often more diffuse and colorful, but it also requires a longer exposure time (since light has been discarded). The angle at which light is filtered is controlled by rotating the polarizer itself, up to 180 degrees, and the strength of this effect can be controlled by changing the camera's line of sight relative to the sun. The effect as you rotate the filter is visible through your camera's viewfinder or liquid crystal display (LCD).

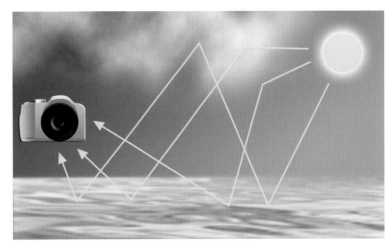

**With a polarizing filter**

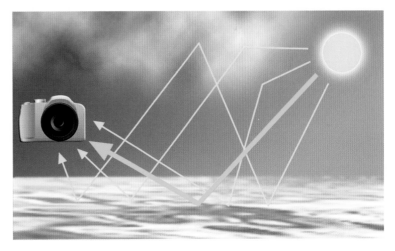

**Without a polarizing filter**

**FIGURE 5-6**
Illustration of diffuse (thin arrows) versus directly reflected (thick arrow) light reaching the camera with and without a polarizing filter

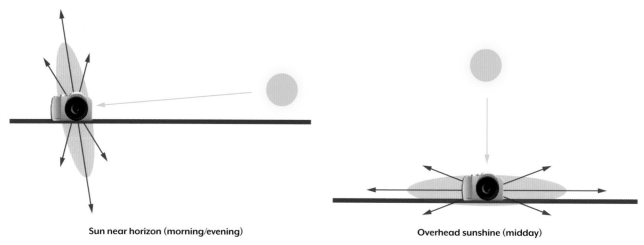

Sun near horizon (morning/evening)                    Overhead sunshine (midday)

**FIGURE 5-7**
The red disks represent the directions of maximum polarizing capability. The green lines represent the ground/horizon.

To maximize the effect of a polarizing filter, your line of sight should be perpendicular to the direction of the sun, as shown in **FIGURE 5-7**.

A good way to visualize this is to aim your pointer finger at the sun while holding your thumb straight up. Wherever your thumb points to when you rotate your hand (while still pointing at the sun) is where the polarizer can have the strongest impact.

Once you've found a good camera angle, rotate the filter to toggle the strength of the polarizer effect. If your camera is aimed in the direction of your thumb (or red lines in **FIGURE 5-7**), you'll see the most variation in polarizer effect as your rotate the filter. The best way to get a feel for this is to rotate the filter while looking through the camera's viewfinder (or rear LCD), but you can also consult the box below for specifics on how this process works.

 **FILTER ROTATION ANGLE**

At one extreme, you can rotate your filter so that the direction of maximum polarization is perpendicular to the direction of the sun (as illustrated in **FIGURE 5-7**). In that case, the polarizing effect will be as pronounced as possible. If you then rotate your filter just a little (say by 10–20 degrees), you can shift the angle of maximum effect slightly toward or away from the sun, but in this case the polarizing effect won't be as pronounced as before. As this angle gets progressively closer to the direction into or away from the sun, the polarizing effect will appear progressively less pronounced. Finally, once the filter has been rotated a full 90 degrees (to the other extreme), no polarizing effect will be visible. Any more rotation than this, and the polarizing effect increases again and the cycle repeats.

Because a polarizer's effect varies with the angle of incoming light from your scene, results can appear uneven when a wide-angle lens is used. Some parts of the scene might be directly in the sun, whereas other parts might be in a direction that is at a right angle to the sun's direction. In that case, one side of the photo would show a stronger polarizer effect than the other side. **FIGURE 5-8** illustrates this uneven effect.

**FIGURE 5-8**
Hearst Castle in San Simeon, California

In **Figure 5-8**, the sun is near the horizon, so the strip of sky directly overhead is most influenced by the polarizer (causing it to appear darker), whereas the upper-left and lower-right regions (nearer the horizon) are much less impacted. If a telephoto lens had been used to photograph just the tower, then the sky would have appeared much more even.

Although using a wide-angle lens certainly isn't ideal, rotating the polarizing filter can sometimes make the effect appear more realistic. One approach is to ensure that the most pronounced polarization coincides with the image's edge or corner. This way, the change in polarization will look more like a natural gradient across the sky, such as how the sky might appear during twilight.

## COLOR SATURATION

One of the first characteristics you're likely to notice with polarizers is how they increase color saturation, as shown in **Figure 5-9**.

Because polarizers reduce direct reflections, a greater fraction of the subject's light becomes diffuse, resulting in a more colorful representation. Generally, when you use a polarizer, foliage will become a brighter green, skies will be a deeper blue, and flowers will appear more intense.

However, saturation doesn't increase uniformly. Its effect depends on whether a particular object is at an optimal angle to the sun and whether this object is highly reflective. In general, you'll get more saturation with more reflective objects when using a polarizer. Clear, sunny days are also much more heavily influenced by polarizers than overcast or rainy days.

For example, in **Figure 5-5**, the effect on the stone and foliage is subtle, but the sky becomes a noticeably darker blue. Take care not to overdo this effect; unusually dark midday skies or overly vibrant foliage can easily make photos appear unrealistic.

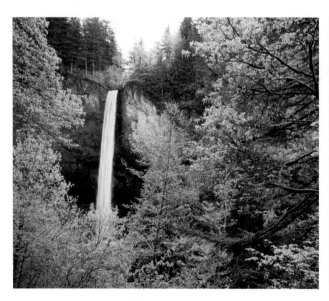

Without polarizer
    With polarizer

**Figure 5-9**
How polarizers affect color saturation

# REMOVING REFLECTIONS

A polarizing filter can be an extremely powerful tool for removing reflections and isolating objects that are wet, underwater, or behind a window. In **FIGURE 5-10**, a polarizer enables the photographer to select between subjects that are reflected from or are underneath the water's surface.

No polarizer

Removing reflections with a polarizer.

**FIGURE 5-10**
Examples of reflections with and without a polarizing filter (photo courtesy of Rick Lee-Morlang at *www.flickr .com/80464756@N00*)

You can see how the polarizer was unable to remove reflections entirely, although it did a pretty good job. Removing reflections completely isn't possible, but polarizers are usually able to make reflections imperceptible, unless they're relatively intense. Unfortunately, the one exception is reflections on metal surfaces, which often happen to be the brightest and least desirable type of reflection.

You can also use a polarizer to remove unwanted reflections when taking a photo through windows or other transparent barriers like glass cases. However, polarizers can sometimes create an unrealistic-looking rainbow or ripple effect on windows that are uneven, have been tinted, or are treated with coatings. A good example is *birefringence*, which appears when a polarized photo is taken through an airplane window (see **FIGURE 5-11**).

**FIGURE 5-11**
An example of birefringence (photo courtesy of Ryan O'Hara at *www .rpophoto.com*)

## CONTRAST AND GLARE

Polarizers often reduce image contrast. This can make it easier to capture scenes with a broad dynamic range, such as trying to balance a bright sky with relatively unreflective land. A polarizer can therefore sometimes reduce the need for using a graduated neutral density filter or high dynamic range in post-production.

However, less glare and contrast can be undesirable, as you can see in **FIGURE 5-12**. Here, the artistic intent was to highlight the curving road by portraying it in stark contrast to its surroundings. You can see that using a polarizer actually detracts from this goal. But in most other situations, a decrease in glare is desirable and generally creates a more pleasing photo. For instance, in the same winding road example, the light doesn't appear as harsh and reflective on the rocks to the far right when a polarizer is used.

In other situations, polarizers can instead increase contrast. For example, in **FIGURE 5-13**, the polarizer increased contrast by filtering the light reflecting from the haze and sea spray.

Without a polarizing filter

With a polarizing filter

**FIGURE 5-12**
Effect of reduced contrast due to a polarizer

Without a polarizing filter

With a polarizing filter

**FIGURE 5-13**
Polarizers can also increase contrast (photos courtesy of Mike Baird at *www.bairdphotos.com*)

The increase in contrast appears most pronounced in the hills and the puffy clouds directly overhead. In general, using a polarizer on clouds and skies will almost always increase contrast unless the subject itself is highly reflective.

## DISADVANTAGES OF USING POLARIZERS

Although polarizing filters can be very useful, they have their disadvantages. Not only are polarizers some of the most expensive types of filters, but they can also be cumbersome to work with. As you learned, they require the camera to be pointed at a right angle to the sun for maximum effect and can take longer to compose with since they need to be rotated. Often, they can make the exposure require using two to three more stops (meaning four to eight times more light) than normal. They can also be difficult to visualize when you're using the camera's viewfinder, and you have to keep the filter perfectly clean to avoid reducing image quality.

What's more, you shouldn't use polarizers with stitched panoramic photos or wide-angle shots, such as the one in **FIGURE 5-14**.

Keep in mind that polarizers can take away from a photograph where reflections are essential. For example, when you use a polarizer on sunsets and rainbows, the colorful, reflected light may disappear.

 **TECHNICAL NOTE**

Polarizers can sometimes enhance the color and contrast of a rainbow by darkening background clouds, but only if the filter has been rotated just right. Furthermore, including both ends of a rainbow usually requires a wide-angle lens, in which case the scene and rainbow may appear uneven.

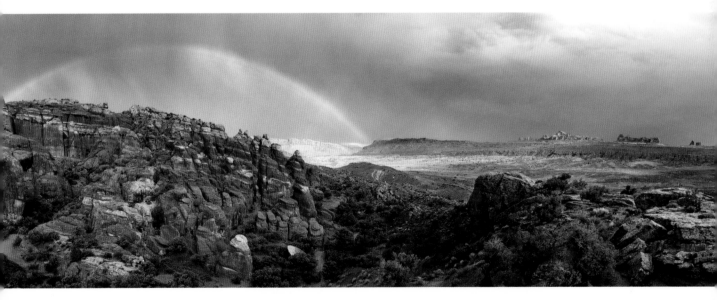

**FIGURE 5-14**
This panorama would have appeared uneven with a polarizer, and the rainbow could have even disappeared at some positions. (Photos courtesy of Arches National Park in Utah, USA.)

## POLARIZER TIPS

Here are some tips to keep in mind for using polarizing filters:

- **Substitute for neutral density filters**  A polarizing filter can sometimes be used when a longer exposure is needed. This can enable an exposure time that is two to three stops (four to eight times) longer than otherwise possible, which is often sufficient for shots of water or waterfalls.

- **Preview using polarized sunglasses**  Wearing untinted polarized sunglasses can be a helpful way to visualize how your scene will be captured in a photograph. Just be sure to take them off when looking through the camera's viewfinder, because the combined effect can prevent you from being able to see the image.

- **Choose thin filters on wide-angle lenses**  A polarizer can sometimes create visible darkening in the corners of the image (vignetting) when used on a wide-angle lens. To avoid this, you'll likely need to opt for the more expensive "thin" variety.

## NEUTRAL DENSITY FILTERS

A *neutral density (ND) filter* is nothing more than a semitransparent piece of glass placed in front of your lens. It reduces the amount of light entering the camera, enabling a longer exposure time than otherwise possible. This can emphasize motion, or it can make an otherwise tumultuous scene appear surreal and quiescent (see **FIGURE 5-15**). Alternatively, an ND filter also enables larger apertures, which can produce a shallower depth of field or achieve a sharper photo, without overexposing bright areas of a scene.

**FIGURE 5-15**
Examples of pretty results you can achieve with an ND filter. Multi-second exposures from Columbia River Gorge (left) and Olympic National Park (right).

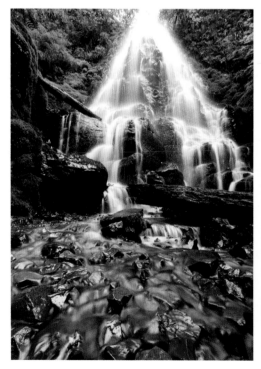
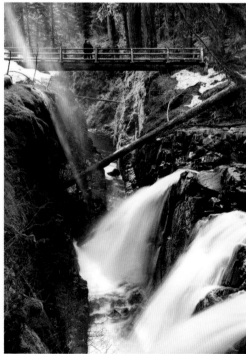

What makes this filter special, however, is that it obstructs a precisely controlled fraction of incoming light and does so uniformly; it doesn't block specific angles the way a polarizer does, thereby not altering image contrast or color saturation. The obstruction also aims to be equal across the visible spectrum, thereby not introducing a color cast (although this isn't always the case). This last characteristic also happens to be why it's called a "neutral density filter."

ND filters are also some of the easiest filters to use, and their effect cannot be fully replicated digitally—at least not with a single shot and not without risking clipped highlights.

You can use ND filters when a sufficiently long exposure time is not attainable at the lowest ISO setting, like in the following situations:

- To convey motion (for example, smoothing water movement in waves or waterfalls, as in **Figure 5-16**)
- To make moving objects, such as people or cars, less apparent or invisible with long exposures
- To achieve a shallower depth of field in very bright light using a wider aperture
- To reduce diffraction and thereby sharpness by enabling a wider aperture

**Figure 5-16**
Using an ND filter and long exposure to create a smoothed water effect

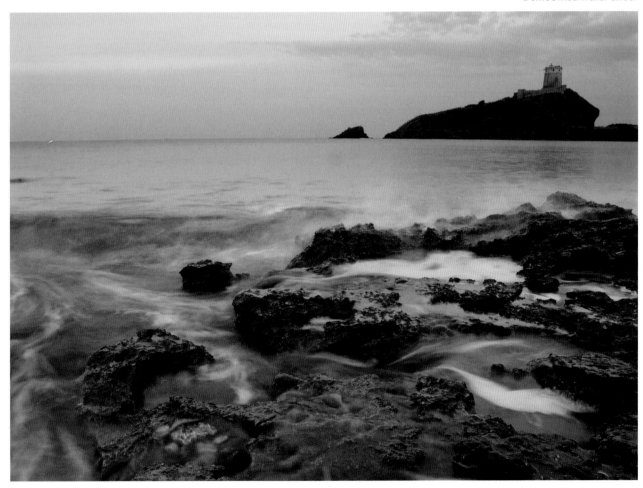

Use ND filters only when absolutely necessary because they attenuate light that could otherwise give you more creative control over the appearance of your image. This includes using a shorter exposure to freeze action, using a smaller aperture to increase depth of field, or setting a lower ISO setting to reduce image noise. Some lower-quality ND filters can also add a slight color cast to an image.

Understanding how much light a given ND filter blocks can be difficult because manufacturers don't necessarily standardize their specifications. **TABLE 5-2** illustrates how the strength specification varies across several ND filter companies.

**TABLE 5-2**  Amount of Light Reduction by ND Filter Type

| F-STOPS | FRACTION | HOYA, B+W AND COKIN | LEE, TIFFEN | LEICA |
|---------|----------|---------------------|-------------|-------|
| 1 | 1/2 | ND2, ND2X | 0.3 ND | 1X |
| 2 | 1/4 | ND4, ND4X | 0.6 ND | 4X |
| 3 | 1/8 | ND8, ND8X | 0.9 ND | 8X |
| 4 | 1/16 | ND16, ND16X | 1.2 ND | 16X |
| 5 | 1/32 | ND32, ND32X | 1.5 ND | 32X |
| 6 | 1/64 | ND64, ND64X | 1.8 ND | 64X |

Often, you won't need more than a few f-stops to achieve the desired effect, so most photographers just keep one or two different ND filters on hand (see **FIGURE 5-17** for an example). Extreme light reduction can enable very long exposures, even during broad daylight.

Even though ND filters might appear gray or even opaque to your eyes, this isn't how your photo will appear, because the camera's metering automatically compensates by letting in more light. However, the viewfinder will still appear very dark, so photographers often compose their image prior to placing the filter in front of the lens.

ND filters are specified by their light-reducing ability, where stronger filters appear as darker shades of gray. Some common specifications are summarized in **TABLE 5-3**.

Many other intermediate strengths exist, but high precision typically isn't needed with ND filters. You can often instead adjust the aperture, ISO, or shutter speed by one stop without substantially changing the image.

**FIGURE 5-17**
Example of a screw-on ND filter

**TABLE 5-3** ND Filter Strength

| FILTER STRENGTH (IN F-STOPS) | LIGHT REDUCTION | DENSITY | COMMON USES |
| --- | --- | --- | --- |
| 2 | 4× | 0.6 ND | Modest increases in exposure time, such as photographing waterfalls. |
| 3 | 8× | 0.9 ND | |
| 10 | 1,000× | 3.0 ND | Extreme increases in exposure time, such as blurring in broad daylight. |
| 13 | 10,000× | 4.0 ND | |
| 20 | 1,000,000× | 6.0 ND | |

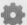 **TECHNICAL NOTE**

Recall that each "stop" of light reduction corresponds with a halving of light. A given filter strength therefore passes only 1/2 strength of the initial incoming light, where "strength" is the filter strength in stops. For example, a 3-stop ND filter only passes 1/8 the incoming light—that is, $1/2^3 = 1/(2 \times 2 \times 2) = 1/8$.

## EXTENDING EXPOSURE TIME

Neutral density filters can be used to create any combination of the following: a longer exposure time or a shallower depth of field. We'll start with longer exposure times, which is by far the most common application.

Longer exposure times can achieve a wide variety of artistic effects, including softening the appearance of turbulent water, blurring waves of blowing grass, and emphasizing motion within a crowd of people. For a full discussion of these and other examples, see Chapter 9.

Let's focus on the waterfall example shown in **FIGURE 5-18**. Without a filter, you would need to use the smallest aperture and the lowest ISO speed available. With a waterfall under soft daylight like this, f/22 and ISO 100 might yield an exposure of 1/10 second. Unfortunately, not only is this duration insufficient, but the f-stop also has to be increased to the point of reducing sharpness due to diffraction.

You can address both of these problems using an ND filter, but the extent of the improvement depends on how you choose to allocate its effect. With a 5-stop ND filter, for example, the same settings would yield a 32× longer exposure time, giving the water a much silkier appearance. To avoid the reduced sharpness, you could use a more reasonable f-stop, such as f/16, with the same filter and then shoot with a 16× (4-stop) exposure time; the water won't appear as silky as it does at f/22, but it will still appear smooth.

For an ND filter to take full effect, multisecond exposures are usually a must. These can render clouds as streaks in the sky, blur people in motion beyond recognition, and make waves appear as a uniform, low-lying mist, as shown in **FIGURE 5-19**. However, this depends on the nature of the motion, the amount of subject magnification, and the desired effect. The key to getting the desired effect is lots of experimentation.

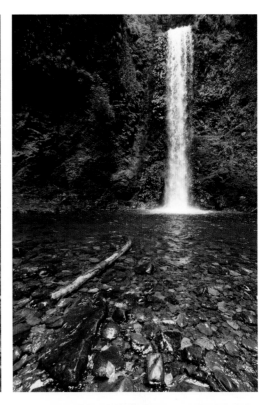

▶ **Figure 5-18**
Exposure times of
2 seconds (left) and
1/10 second (right),
Columbia River Gorge,
Oregon, USA

▼ **Figure 5-19**
Using an ND filter to
achieve an exposure
time of 60 seconds
(photo courtesy of
Colin J. Southern)

During daylight, achieving the effect shown in **FIGURE 5-18** usually requires having a 10-stop or greater ND filter strength, which blocks all but a staggering 1/1000 of incoming light. Try revisiting the exposure settings from some of your past images to see what ND filter strengths would be needed to achieve multisecond exposures.

## SHALLOWER DEPTH OF FIELD

Although photographers primarily use ND filters to achieve longer exposures, they also use them to enable a shallower depth of field in very bright light. For example, most SLR cameras have a maximum shutter speed of 1/4000 second, so a subject in direct sunlight might therefore require an f-stop greater than about f/4.0 (at ISO100). With a 2-stop ND filter, you could reduce this to f/2.0, yielding a dramatic improvement in background blur and subject isolation, like in **FIGURE 5-20**.

**FIGURE 5-20**
Example of a situation where an ND filter could help (depending on the camera's maximum shutter speed)

On the other hand, requiring a shallower depth of field under bright light is rare, and you can usually benefit more from photographing the subject under dimmer (and likely less harsh) lighting. Achieving a sufficiently shallow depth of field is also unlikely to require anything stronger than a 2- or 3-stop ND filter.

## DIGITAL ND EFFECTS

Although ND filters cannot be replicated digitally, certain scenes and exposure times can be adequately emulated by employing a technique called *image averaging*. This works by combining several separate photos in a way that simulates a single, longer exposure.

**FIGURE 5-21**
Single photo

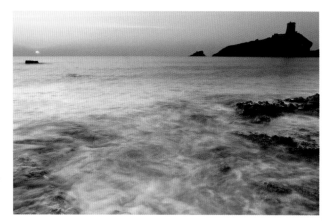

**FIGURE 5-22**
Four averaged photos

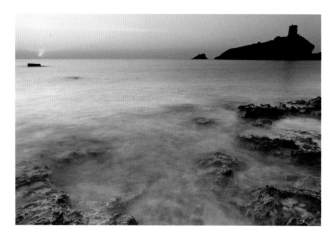

**FIGURE 5-23**
Sixteen averaged photos

In **FIGURE 5-21**, note how the water appears only slightly blurred using a single photograph.

When four photos are averaged (**FIGURE 5-22**), there is substantially more motion blur, but the effect isn't as smooth as it would have been with a single exposure.

In general, better results are achieved when more photos are averaged and the exposure time of each photo is long compared to the interval between them.

**FIGURE 5-23** required about 16 averaged shots to adequately mimic an ND filter, in part because each individual exposure was so brief.

Perhaps the biggest problem with averaging photos in this way is that moving objects aren't always rendered as continuous streaks, no matter how many photos are averaged, as shown in **FIGURE 5-24**.

Photos containing people, the sun, the stars, or other moving objects are all particularly susceptible to appearing as a series of discrete objects as opposed to a single continuous streak.

## VARIATIONS ON ND FILTERS

Here are some points to keep in mind about using ND filters:

- **Filter-mounting systems** Because ND filters have the same effect regardless of how they're shifted or rotated, using a filter-mounting system isn't as critical. However, filter-mounting systems still have some

**FIGURE 5-24**
Sun from Figure 5-23 appears to make discrete jumps across sky

advantages, including quicker insertion and removal, as well as freeing up a hand from holding the ND filter in place.

- **Step-up and step-down adapters**  These adapters prevent you from having to purchase a different screw-on filter size for each lens diameter (usually listed as 77 mm, 72 mm, and so on). You could then just purchase an ND filter that fits your largest lens and use what's called a *step-up adapter* to have this same ND filter fit on any smaller lenses.

- **Variable ND filters and stacking**  A variable ND filter is a single filter that employs a mechanism for adjusting the density strength without having to switch filters, but at a cost—they're usually much more expensive than purchasing a few separate filters. Therefore, many photographers with a smaller budget just stack multiple ND filters when they need to reproduce the light-reducing ability of a single stronger (but unavailable) filter.

- **Substitutes**  Depending on their size, graduated ND (GND) filters (see next section) can sometimes be used as ND filters if the darker region is large enough to cover the entire lens. Alternatively, polarizing filters can function as 2- to 3-stop ND filters, but only if you also want the polarized look and only when this filter is rotated for maximum effect. Some photographers don't purchase 2- or 3-stop ND filters for this reason, instead opting for stronger varieties, such as a 10-stop filter.

- **Filter color casts**  Some cheaper ND filters can introduce a color cast. Fortunately, you can usually correct this by adjusting the photo's white balance in post-processing. However, in extreme cases, cheaper filters can introduce color casts that don't correlate with white balance settings, making color cast removal much more difficult.

# GRADUATED NEUTRAL DENSITY FILTERS

*Graduated neutral density (GND) filters*, or *grad filters*, restrict the amount of light across an image in a smooth, geometric pattern. They're called graduated neutral density filters because they have a graduated blend, from clear to neutrally colored gray, and the effective density of this gray increases, thereby blocking more light. These are sometimes also called *split filters* because they split how they treat different areas of a scene. Scenes that are ideally suited for GND filters are those with simple lighting geometries, such as a linear blend from dark to light, which is commonly encountered in landscape photography, as shown in **FIGURE 5-25**.

GND filter

Final scene

**FIGURE 5-25**
The structure of a GND filter (above) and the effect it produces (below)

Prior to digital cameras, GND filters were essential for capturing dramatically lit landscapes. You can mimic a GND filter effect with digital cameras by taking two separate exposures and blending them using a linear gradient in Photoshop. This two-shot technique is often not possible for fast-moving subject matter or in changing light, although a single exposure developed twice from the RAW file or a "graduated filter" in RAW development software could possibly mimic the effect. A benefit of using a GND is being able to see how the final image will look immediately through the viewfinder or LCD.

## WHY USE GND FILTERS?

As we look around a scene, our eyes adjust to varying brightness levels. A standard camera, on the other hand, captures the entire scene using the same exposure. This can cause bright and dark regions to appear washed out and void of detail, respectively, unlike how they appear in person. Without a GND filter, the photographer therefore has to choose whether to expose for the bright or dark portions of their scene, or something in between. **FIGURE 5-26** demonstrates how a typical landscape scene appears when exposed for the bright sky without a GND filter. Note the loss of detail throughout the darker, lower half of the image.

Although photographic filters are often looked down upon as artificial enhancements, GND filters can actually help you capture a photo that more closely mimics how a scene appears in person, as shown in **FIGURE 5-27**.

**FIGURE 5-26**
Standard exposure

**FIGURE 5-27**
Graduated neutral density filter applied

In this way, graduated neutral density filters are essential tools for capturing scenes where the light intensity varies substantially across the image frame. They're perhaps a hidden secret of successful landscape photographers. These filters have been used for over a hundred years, but nowadays the GND effect can also be applied digitally, either during RAW development or in subsequent photo editing. In either case, knowing how to make the most of GND filters can have a huge impact on the quality of your photographs, as demonstrated in **FIGURES 5-27** and **5-28**.

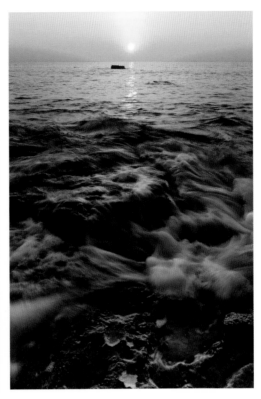

**FIGURE 5-28**
Original scene (left), and the same scene with a GND filter applied (right)

## HOW GND FILTERS WORK

GND filters work by obstructing progressively more light toward one side of the filter and can be used in virtually any situation where brightness changes uniformly in one direction—either at a sharp boundary such as a horizon or more gradually across the entire image. In general, wider angles of view encompass a correspondingly greater range of brightness and are more likely to benefit from a GND filter.

GND filters affect two aspects of a photograph:

- **Dynamic range** You are able to capture scenes whose range of brightness exceeds the capabilities of your camera. This is the most commonly understood application.

- **Local contrast** Even though GND filters usually decrease the contrast between extreme light and dark regions, the contrast within each region actually increases, thereby improving the appearance of color and detail. This is because extreme tones are brought closer to the midtones, which are where a camera's tonal curve has the most contrast (and where our eyes are most sensitive to tonal differences). This is perhaps a less commonly known benefit, but it can yield the greatest improvement.

The second advantage is why many photographers often apply GND filters even when the scene's dynamic range fits within the capabilities of the camera. This might include giving clouds more definition, for example, or making them appear more ominous by darkening them relative to everything else. The applications are amazingly diverse.

## CHOOSING A GND FILTER STRENGTH

The effect of a given GND filter is determined by two properties:

- **Filter strength** The difference between how much light is reduced at one side of the gradient compared to the other. **FIGURE 5-29** shows the difference between strong and weak GND filters.

- **Rate of transition** The rate at which the darkest side of the filter transitions into the clear side.

Of these two, the filter strength is perhaps the most important consideration, and it's expressed using similar terminology to that used for ND filters. For example, "0.6 ND grad" refers to a graduated filter that lets in 2 f-stops less light (1/4) at one side of the blend versus the other, whereas "0.9 ND grad" lets in 3 f-stops less light (1/8) at one side.

**TABLE 5-4** lists the most commonly used strength specifications.

Recall that each additional "stop" of strength blocks twice as much light.

To estimate what strength you need, you can point your camera at the darker half of the scene, take an exposure reading, and then point your camera at the lighter half and take a second exposure reading. The difference between these two exposures is the maximum strength you'll need to use, although you'll likely want something weaker for a more realistic-looking photo. Most landscape photos need no more than a 1–3 f-stop blend, which compensates for the typical reflectivity difference between the sky and land or sea, but even if it doesn't, a greater differential risks making the photo appear unrealistic.

For example, if you place your camera in aperture priority mode, and the camera's metering estimates shutter speeds of 1/100th second for the sky and 1/25th second for the ground, then you won't want anything stronger than a 2-stop GND filter. However, as you'll quickly realize, this isn't strictly a numbers game; the optimal strength is also highly dependent on the subject matter and the look you're trying to achieve.

The most versatile strength is perhaps the 2-stop variety. Anything weaker is often too subtle, and anything stronger may appear unrealistic. In either case, it's often not difficult to reproduce the results of a 1- or 3-stop GND filter in post-processing by starting with an existing 2-stop GND photo.

**TABLE 5-4** GND Filter Strength

| STRENGTH (IN F-STOPS) | BRAND-SPECIFIC TERMINOLOGY: | | |
| | HOYA, B+W & COKIN | LEE, TIFFEN | LEICA |
| --- | --- | --- | --- |
| 1 | ND2, ND2X | 0.3 ND | 2X |
| 2 | ND4, ND4X | 0.6 ND | 4X |
| 3 | ND8, ND8X | 0.9 ND | 8X |

**FIGURE 5-29**
GND filter strengths

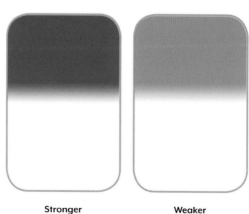

Stronger          Weaker

## CHOOSING AN OPTIMAL RATE OF TRANSITION

The second important quality is how quickly the GND filter blends from light to dark. A *soft edge* is used to describe a gradual blend, whereas a *hard edge* describes a more abrupt blend. These should be selected based on how quickly the light changes across the scene. A sharp division between dark land and bright sky would necessitate a harder-edge GND filter, for example. Other patterns exist, such as radial GNDs, which can enhance or reduce light fall-off toward the lens's edges and thus affect vignetting. **FIGURE 5-30** shows what these patterns look like.

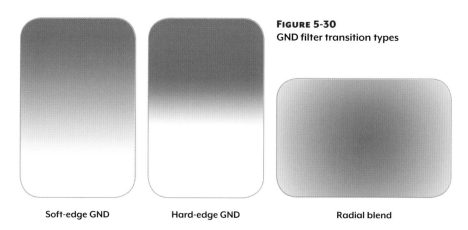

**FIGURE 5-30**
GND filter transition types

Soft-edge GND          Hard-edge GND                    Radial blend

The blend should be placed very carefully, and this usually requires a tripod. The soft-edge filters are generally more flexible and forgiving of placement. On the other hand, a soft edge may produce excessive darkening or brightening near where the blend occurs if the scene's light transitions faster than the filter gradient. You should also be aware that vertical objects extending across the blend may appear unrealistically dark, such as those in **FIGURE 5-31**.

Although subtle and likely imperceptible, the rock columns in **FIGURE 5-30** become darker at their top compared to below the blend. With other photos, such as those in **FIGURE 5-33**, the effect can be more substantial and likely unacceptable. This unrealistic darkening effect is unavoidable and is always present to some degree when GND filters are used without subsequent digital correction.

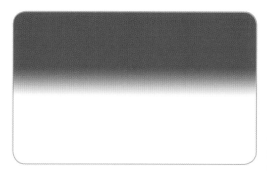
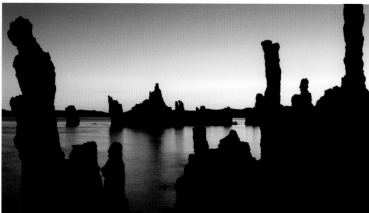

**FIGURE 5-31**
Location of GND blend (left) and the final photo (right)

A problem with the *soft* and *hard edge* terminology is that it is not standardized from one brand to another. One company's "soft edge" can sometimes have a blend that is nearly as abrupt as another company's "hard edge." It is best to actually look at the filter to judge the blend. Most manufacturers will show an example of the blend on their website.

In general, wide-angle lenses require harder gradients, primarily because brightness varies more abruptly when a broader range is squeezed into the image frame. Softer transitions are often much more forgiving when they aren't optimally positioned, but their location is also much more difficult to identify in the camera's viewfinder. **Figure 5-32** illustrates the rate of transition.

**Figure 5-32**
Softer edge to
harder edge

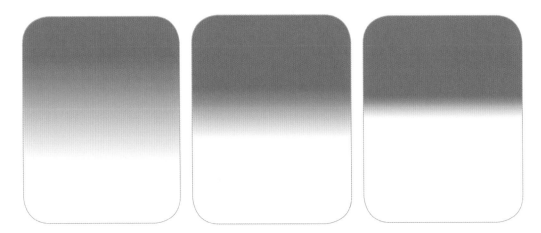

## HOW TO USE A GRADUATED ND FILTER

Although you can clearly see the GND transition region when looking at the filter on its own, it's often far from obvious when you're looking through the camera's viewfinder. The depth of field preview button can help, but you ultimately need to know what artifacts to look out for.

Of the three GND filter characteristics under your control (the position, the strength, and the rate of transition), you can control only the position for a given filter, though you can adjust all three if you're applying the grad filter digitally. **Figure 5-33** illustrates how each of these three GND filter characteristics influences the image.

- **Position** Optimal placement of the transition region is usually close to the horizon, although you can achieve more realistic-looking results by placing it slightly lower. Note that placing it too high can create a bright strip above the horizon, whereas placing it too low can make the distant land appear unrealistically dark. Pay particular attention to objects that extend above the horizon, such as trees and mountains.

- **Strength** Bringing the bright and dark regions into balance can be of great benefit, but this is easily overdone. Try to avoid violating the scene's tonal hierarchy. For example, if the sky was brighter than the ground, it's almost always a good idea to keep it that way in your photo if you want to achieve a realistic-looking result.

**Figure 5-35**
Example of a digital GND filter in Adobe Photoshop

A physical filter is a little more restricting because you have to choose from certain pre-made types. The resulting image also already has the gradient applied, so it can be much more difficult to correct for misplacement.

On the other hand, physical GND filters often produce higher-quality results. A physical GND works by darkening the brighter regions, whereas a digital GND filter works by brightening the darker regions. The physical GND filter will therefore require a much longer exposure, resulting in dramatically less noise within the (previously) darker regions.

You could always get around this limitation of digital GND filters by just taking two separate exposures (and combining these in image-editing software), but this technique can be problematic with dynamic subjects. Furthermore, using multiple exposures requires a tripod and a remote release device because the camera might move during or between exposures.

## OTHER CONSIDERATIONS FOR PHYSICAL GND FILTERS

If you choose to stick with physical GND filters, they can be much easier to use if you find the right filter system. GND filters can typically be mounted one of three ways:

- **Standard screw-on mechanism**  This type is used for most other filters, including UV and polarizing filters. However, a screw-on mechanism can make it extremely difficult to adjust the location of the GND transition.

- **Free-floating/handheld**  This type is often quick and easy to use, but you usually cannot keep the gradient in the same location for different shots, and this also ties up the use of one hand. It also makes performing small adjustments much more difficult.

- **Filter holder**  This type usually includes an adapter ring that screws onto the front of the camera. The square GND filter can then slide into this holder, as shown in **FIGURE 5-36**, permitting fine control over the placement of the transition. The Lee filter holder system is the most commonly used.

Specialty gradient types and image quality may also be important considerations:

- **Reverse grad filters**  These are a variation of GND filters. Instead of an even blend from clear to gray, these special-purpose filters blend from clear to dark gray to lighter gray. This can sometimes be helpful with sunsets and sunrises, because the filter further darkens the otherwise bright strip near the horizon. On the other hand, you can almost always instead just darken this part later on in post-processing.

- **Image quality**  Any time you place an additional glass element between your subject and your camera's sensor, you run the risk of decreasing image quality. Although this usually isn't a problem, filters that have smudges, deposits, micro-abrasions, or other defects can all reduce the sharpness and contrast of your photos. In addition, many GND filters aren't "multicoated," which may make them more susceptible to lens flare (especially considering that these are often used with harsh or dramatic lighting).

**FIGURE 5-36**
Example of a filter holder system

## ALTERNATIVES TO USING GND FILTERS

Of course, using GND filters is just one among many approaches to dealing with difficult lighting. Other common techniques include the following:

- **Shadow/highlight recovery**  This technique can be applied in photo editing and is a great alternative to GND filters whenever the brightness doesn't vary uniformly in one direction and the total dynamic range isn't too extreme.

- **Waiting for better lighting**  If you find that you're requiring a 3-stop or greater filter strength, consider instead just taking your photograph at a different time of day.

- **High dynamic range**  Whenever the preceding approaches aren't practical, another popular technique is to merge several exposures into a single high dynamic range (HDR) image using Photoshop, Lightroom, or another software package.

## SUMMARY

In this chapter, you were introduced to some of the most common types of lens filters, how they work, and how you can use them to gain more control over your images. You learned how to use polarizing filters to control reflections and color saturation. You then saw how neutral density filters can be used to intentionally create long exposures, which can emphasize motion, or enable larger apertures for a sharper image. Finally, you learned how to maximize graduated neutral density filters to manage dramatic lighting when working outdoors.

In the next chapter, you'll learn techniques for using on-camera and off-camera flash to control the appearance of a subject.

# 6

# Using Flash to Enhance Subject Illumination

**IN THIS CHAPTER, WE'LL EXPLORE** how on-camera flash and off-camera flash affect the appearance of a subject. Then we'll explore how to control flash intensity to accommodate ambient lighting. Note that this chapter focuses on on-camera and off-camera mobile flash, as opposed to studio flash, which we'll explore in more detail in Chapter 8 when we discuss portrait-lighting techniques.

# HOW FLASH AFFECTS SUBJECT APPEARANCE

A camera flash can broaden the scope and enhance the appearance of your photographic subjects. However, flash is also one of the most confusing and misused of all photographic tools. In fact, the best flash photo is often the one where you cannot tell a flash was used. In this section, you'll learn how the flash affects your light and resulting exposure, with a focus on mobile on-camera and off-camera flash.

Before proceeding further, be sure you have read Chapter 1 so that you are familiar with aperture, ISO, and shutter speed.

## WHAT MAKES FLASH LIGHTING DIFFERENT?

Flash photography is fundamentally different from normal camera exposure because your subject is being lit by two light sources: your flash, which you have some control over, and the ambient light, which is likely beyond your control. Although this concept may seem simple, its consequences are not always obvious.

For example, you can vary the appearance of a subject by controlling the intensity, position, and distribution of light from a flash. But when you're working with ambient light, you can only affect the appearance of a subject by changing lens settings. And unlike with ambient-light photography, you can't see how your flash will affect the scene prior to and during the exposure, since a flash emits light for milliseconds or less.

It's therefore critical to develop a good intuition for how the position and distribution of your flash influences the appearance of your subject. We'll begin by exploring the qualitative aspects of flash photography, and then we'll concentrate on how to use camera settings to achieve the desired flash exposure.

## LIGHT DISTRIBUTION: USING BOUNCED FLASH AND DIFFUSERS

For a given subject, the distribution of the light source determines how much contrast this subject will have. *Contrast* describes the brightness difference between the lightest and darkest portions of a subject. When light is more localized, one side of the subject receives intense direct light, while the opposing side appears almost black because it receives only what light has bounced off the walls, ceiling, and floor. **FIGURE 6-1** shows an example of localized light on a subject, which results in high contrast.

**FIGURE 6-1**
High contrast

Localized
light source

When light is more distributed, shadows and highlights appear softer and less intense because the light is hitting the subject (in this case, the sphere) from a wider angle. **FIGURE 6-2** shows an example of this.

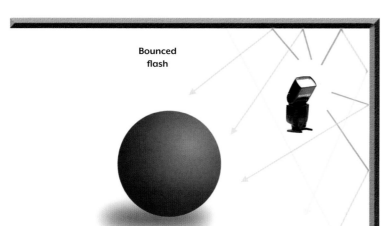

**FIGURE 6-2**
Low contrast

Bounced flash

Photographers use the term *soft light* to describe light that scatters substantially or originates from a large area and the term *hard light* to describe more concentrated and directional light. Softer light therefore results in lower contrast, whereas harder light results in higher contrast.

In practice, photographs of people appear more appealing if captured using less contrast. Higher contrast tends to over-exaggerate facial features and skin texture by casting deep shadows across the face, an effect that is less flattering.

The dilemma in portrait photography is that a camera flash is, by its very nature, a localized light source and therefore often produces too much contrast in the subject. A good photographer knows how to make their flash appear as if it originated from a much larger and more evenly distributed source. You can achieve this using either a flash diffuser or a bounced flash.

Although it may seem counterintuitive, aiming your flash away from your subjects can actually enhance their appearance by causing the incident light to originate from a greater area. This is why photographers take portraits with a flash that first bounces off a large umbrella, which is called *bounced flash*.

However, bouncing a flash greatly reduces its intensity, so you'll need to have a much stronger flash to achieve the same exposure. Additionally, bouncing a flash is often unrealistic for outdoor photography when you're not in a contained environment.

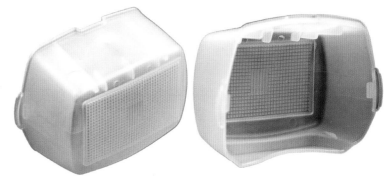

Similarly, you can use a *flash diffuser*, shown in **FIGURE 6-3**, which is a piece of translucent plastic that fastens over your flash to scatter outgoing light.

**FIGURE 6-3**
Flash diffuser

For outdoor photos, flash diffusers make very little difference, but for indoor photography, they can soften the lighting because some of the scattered light from your flash will first bounce off other objects before hitting your subject. However, just as with a bounced flash, you may need to use stronger flash when using a flash diffuser.

## LIGHT POSITION: ON-CAMERA AND OFF-CAMERA FLASH

The position of the light source relative to the viewer also affects the appearance of your subject. Whereas the localization of light affects contrast, light source position affects the visibility of a subject's shadows and highlights.

For example, **FIGURE 6-4** shows how head-on lighting affects the subject.

As you can see, the side of the subject that receives all the light is also the side of the subject the camera sees, resulting in barely visible shadows. The subject appears flat and harshly lit as a result.

On the other hand, off-camera flash results in a more three-dimensional subject, as you can see in **FIGURE 6-5**.

Overall, subjects look best when the light source is neither head-on, as with on-camera flash, nor directly overhead, as is often the case with indoor lighting. In real-world photographs, using an on-camera flash can give a "deer in the headlights" appearance to subjects. Placing the flash to one side can also greatly reduce the chance of direct reflections off glasses or other flat surfaces, which is usually a telltale sign of using a flash and therefore undesirable. In **FIGURE 6-6**, off-camera flash has successfully avoided direct reflections on the lenses of the baby's glasses.

However, it's usually unrealistic to expect access to off-camera flash, unless you're in a studio or have a sophisticated setup, which you might for a big event like a wedding.

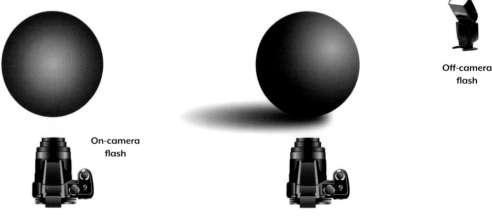

Off-camera flash

On-camera flash

**FIGURE 6-4**
With head-on lighting, the subject appears flat.

**FIGURE 6-5**
With off-camera lighting, the subject is more three-dimensional.

The best and easiest way to achieve the look of an off-camera flash using an on-camera flash is to bounce the flash off an object, such as a wall or ceiling, as discussed previously. Another option is to use a *flash bracket*, shown in **FIGURE 6-7**, which increases the distance between the flash unit and the front of your camera.

Although you can use flash brackets to create substantial off-angle lighting for close-range photos, the lighting will appear increasingly like an on-camera flash the farther you are from your subject. One advantage of flash brackets is that they noticeably reduce red-eye with close-proximity portraits. Their biggest disadvantage is size, because they need to extend far above or to the side of your camera body to achieve their effect.

For full off-camera flash control, you'll want a portable unit that can be triggered remotely, as shown on the right in **FIGURE 6-7**. This can either be placed in a fixed location or carried around by a camera assistant if you're at a dynamic event such as a wedding.

**FIGURE 6-6**
Flash portraiture with eyeglasses

**FIGURE 6-7**
Two options for off-camera flash

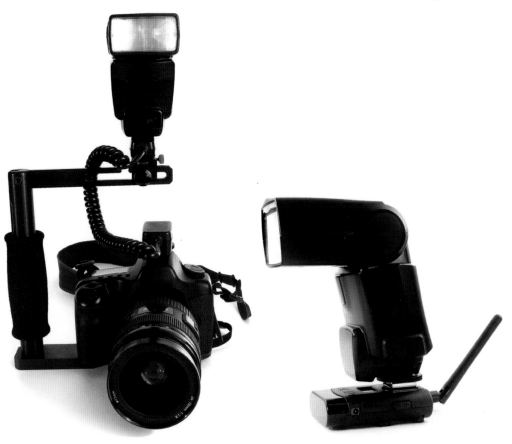

Flash bracket                    Remotely triggered off-camera flash

## DEALING WITH MULTIPLE LIGHT SOURCES: FILL FLASH

A common misconception is that we only use flash when it's dark. On the contrary, we can use flash to enhance the appearance of subjects in harsh outdoor lighting, such as afternoon sunlight on a clear day. A good example is a fill flash, which is most useful as a secondary light source under bright ambient lighting, such as when your subject is backlit, or when the lighting has too much contrast.

The term *fill flash* describes a flash that contributes more to ambient light than it does to exposure. It gets its name because it effectively fills in the shadows of your subject without changing the overall exposure significantly, as in **Figure 6-8**.

To use a fill flash, you need to force your flash to fire, because most cameras in automatic mode won't fire a flash unless the scene is dimly lit. To get around this, you can manually activate fill flash on compact and SLR cameras when there is plenty of ambient light. Just pay close attention to the charge on your camera's battery because flash can deplete it much more rapidly than normal.

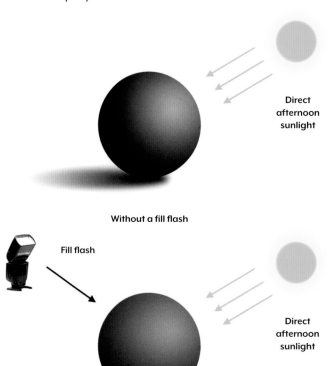

**FIGURE 6-8**
Using fill flash to reduce harsh shadows from strong lighting

Direct afternoon sunlight

Without a fill flash

Fill flash

Direct afternoon sunlight

With a fill flash

## RED-EYE REDUCTION

A big problem with camera flashes is unnatural red eyes in subjects, caused by glare from the subject's pupils. The red color is due to the high density of blood vessels directly behind the pupil at the back of the eye. Red eye can be most distracting when the subject is looking directly into the camera lens (as in **FIGURE 6-9**), or when pupils are fully dilated in dim ambient light. It is also much more prominent with hard lighting.

You can sometimes use a *red-eye reduction mode*, which sends a series of smaller flashes before the exposure so that the subject's pupils are contracted during the actual flash. Although reducing pupil area doesn't eliminate red eye entirely (smaller pupils still reflect some light), it makes it much less prominent. You can also contract the pupil naturally by taking the photo where it is brighter or by increasing the amount of ambient light.

Another technique used during post-processing is *digital red-eye removal*, which usually works by using image-editing software to select the red portion of the eye and remove the coloration so that the pupil appears more natural. If the subject's eye is extremely dilated and far away, this may also include changing the red hue to match the person's natural eye color found in the iris. However, this technique should only be used as a last resort because it does not address the underlying cause of red-eye. Also, it's difficult to perform so that the eye looks natural in a detailed print. For example, subjects could easily end up appearing to have either unnaturally dilated pupils or no pupils at all.

In summary, the only ways you can eliminate red-eye entirely are to have the subject look away from the camera; to use a flash bracket, an off-camera flash, or a bounced flash; or to avoid using a flash altogether.

**FIGURE 6-9**
Example of red-eye caused by flash

## FLASH WHITE BALANCE

When using flash, you need to be aware of how it affects the color balance of your image. Cameras use a process called *white balance* to adjust colors so objects that appear white in person are rendered white in the image, for example. This process requires determining the *color temperature* of a light source, which refers to the relative warmth or coolness of white light. It's also important to know the *color tint* of your source, which refers to any remaining magenta or green color casts.

Most flash units emit light that has a color spectrum resembling daylight. If your ambient light differs from this substantially, an undesirable color shift will result (as in **FIGURE 6-10**) because most cameras automatically set their white balance to match the flash, if it's used. The tint is most apparent with artificial lighting, as well as when balanced ratios between light from flash and ambient sources (1:4 to 4:1) make light from both sources clearly distinguishable.

**FIGURE 6-10**
Localized color tint
caused by a flash in the
foreground but ambient
light in the background

A flash can also create a *color cast*, which is what happens when any light bouncing off a colored surface, such as a wall painted orange or green, casts a color different from ambient light onto a subject. However, if ambient light is bouncing off those same colored surfaces, this color cast may already exist without the flash; therefore, the addition of a flash will not introduce any additional color casts.

Alternatively, you can intentionally modify the flash's white balance to achieve a given effect. Some flash diffusers have a subtle warming effect, for example, to better match indoor incandescent lighting or to give the appearance of more flattering or evocative light from a sunset.

## EXTERNAL VS. INTERNAL FLASH UNITS

Most cameras have a flash unit built into the camera body called an *internal flash*. Although an internal flash can be adequate as a low-intensity fill flash with nearby subjects, it often also risks casting a shadow on the subjects due to large lenses. If professional results are important in a broader range of conditions, you'll likely want an *external flash* unit , shown in **FIGURE 6-11**, that affixes to the top of your camera along a metal connector called a *hot shoe mount*.

Even though an in-camera flash has enough intensity to directly illuminate a nearby subject, an external flash can often be aimed in more directions and has enough power to bounce off a distant wall or ceiling and still adequately illuminate the subject. An added benefit is that external flash units are usually easier to modify with diffusers, brackets, reflectors, color filters, and other add-ons. Furthermore, because external flashes are a little farther from your lens's line of sight, they can reduce red-eye, reduce the risk of lens shadows, and slightly improve light quality.

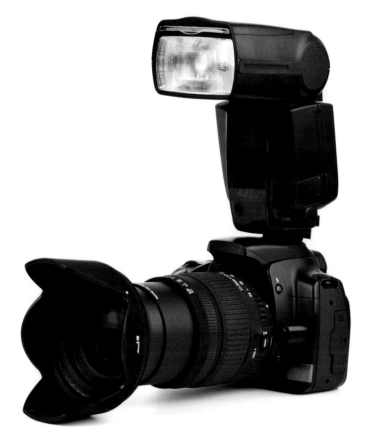

**FIGURE 6-11**
Camera with an external flash mounted atop the hot shoe mount

# CONTROLLING YOUR FLASH EXPOSURE

Now that you know how a camera's flash can influence a subject's appearance, you're ready to learn how to achieve the desired flash exposure using your camera settings.

## UNDERSTANDING FLASH EXPOSURE

As you learned previously, *flash exposure* involves two light sources: your flash and ambient light. In this section, we focus on how to achieve the desired mix between light from your flash and light from ambient sources, while also having the right amount of total light (from all sources) to achieve a properly exposed image.

Your camera's flash actually consists of two overlaid exposures: one for ambient light, which happens throughout the exposure duration, and the other for flash, which happens only during the flash pulse. **FIGURE 6-12** illustrates how this exposure process works.

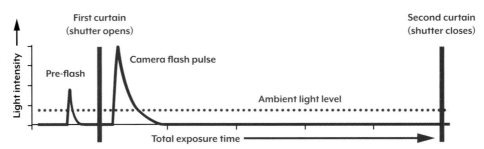

**FIGURE 6-12**
Illustration shown roughly to scale for a 1/200th second exposure with a 4:1 flash ratio. Flash shown for first curtain sync. Much older flash units do not emit a pre-flash.

In this graph, the green line represents the light pulse that contributes to the flash exposure, whereas the blue lines for the first and second curtain represent the start and end of the exposure for ambient light, respectively. Newer SLR cameras also fire a pre-flash to estimate how bright the actual flash needs to be. The pre-flash exposure occurs in the split second between when you press the shutter button and when the shutter opens.

As you can see in **FIGURE 6-12**, a flash pulse is usually very brief compared to the exposure time, which means that the amount of flash captured by your camera is independent of your shutter speed. On the other hand, aperture and ISO speed still affect flash and ambient light equally.

## FLASH RATIO

The *flash ratio* describes the ratio between light from the flash and ambient light. Because the shutter speed doesn't affect the amount of light captured from your flash but does affect ambient light, you can use this fact to control the flash ratio. For a given amount of ambient light, you can use the length of the exposure and flash intensity to adjust the mix of flash and ambient light, as detailed in **TABLE 6-1**.

**TABLE 6-1** How Different Settings Affect Flash Ratio

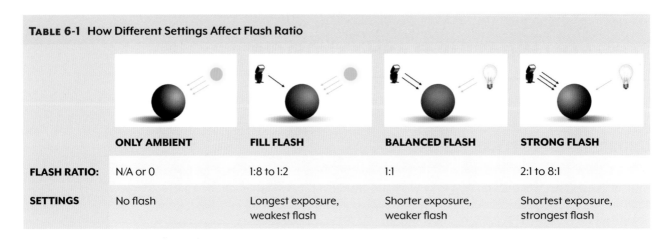

|  | ONLY AMBIENT | FILL FLASH | BALANCED FLASH | STRONG FLASH |
|---|---|---|---|---|
| **FLASH RATIO:** | N/A or 0 | 1:8 to 1:2 | 1:1 | 2:1 to 8:1 |
| **SETTINGS** | No flash | Longest exposure, weakest flash | Shorter exposure, weaker flash | Shortest exposure, strongest flash |

On the far left of **TABLE 6-1**, you can see the flash ratio of ordinary ambient light photography, and on the far right, you can see the flash ratio of photography using mostly light from the flash. In reality, there's always some amount of ambient light, so an infinite flash ratio is just a theoretical limit.

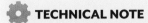
Note that not all flash ratios are attainable with a given flash unit or ambient light intensity. For example, if ambient light is extremely intense, or if your flash is far from your subject, it's unlikely that the internal flash of a compact camera could achieve flash ratios approaching 10:1. At the other extreme, using a subtle 1:8 fill flash might be impractical if there's very little ambient light and your lens doesn't have a large maximum aperture (or if you are unable to use a high ISO speed or capture the photo using a tripod).

Flash ratios of 1:2 or greater are where the topics in this section become most important, including the flash position and its apparent light area, because this is where the flash starts to appear quite harsh unless carefully controlled. On the other hand, you can often use an on-camera flash to get flash ratios of less than 1:2 and achieve excellent results.

Whenever possible, most photographers use their flash as a fill flash when starting out, because this is the simplest type of flash photography and doesn't require knowing how to use an off-camera flash.

## FLASH EXPOSURE MODES

Let's consider one of the most difficult tasks in flash photography: understanding how different camera and flash-metering modes affect an overall exposure. Some modes assume you only want a fill flash, while others virtually ignore ambient light and assume that your camera's flash will be the dominant source of illumination.

Fortunately, all cameras use their flash as either the primary light source or as a fill flash. So the key is knowing when and why your camera uses its flash in each way. To understand this, take a look at **TABLE 6-2**, which summarizes the most common camera modes and their flash ratios.

**TABLE 6-2** Common Flash Modes

| CAMERA MODE | FLASH RATIO |
| --- | --- |
| Auto □ | 1:1 or greater if dim; otherwise, flash doesn't fire |
| Program (P) | Fill flash if bright; otherwise, greater than 1:1 |
| Aperture Priority (Av) Shutter Priority (Tv) | Fill flash |
| Manual (M) | Whatever flash ratio is necessary |

In *Auto mode* (□), the flash turns on only if the shutter speed would otherwise drop below what is deemed "handhold-able," which is usually about 1/60 second. The flash ratio then increases progressively as light hitting the subject gets dimmer, but the shutter speed remains at 1/60 second. This mode therefore functions to maintain handheld sharpness first and foremost, regardless of whether that causes the flash to harshly light the subject.

*Program (P) mode* is similar to Auto mode, except you can also force a flash in situations where the subject is well lit, in which case the flash will act as a fill flash. Most cameras intelligently decrease their fill flash as ambient light increases (called *auto fill reduction mode* in Canon models). The fill flash ratio may therefore be anywhere from 1:1 (in dim light) to 1:4 (in bright light). For situations where the shutter speed is longer than 1/60 second, flash in Program mode acts just as it would in Auto mode. Overall, Program mode is useful when you want the automation benefits of Auto mode, but also want to use your flash as a fill flash.

*Aperture Priority (Av)* and *Shutter Priority (Tv)* modes have a different behavior. Just as with Program mode, you usually have to force your flash to turn on, which results in the camera using the flash as a fill flash. However, unlike with the Auto and Program modes, the flash ratio never increases beyond about 1:1, and exposures are as long as necessary; this is also called *slow sync*.

In Shutter Priority mode, the flash ratio may also increase if the necessary f-stop is smaller than what's available with your lens. Flash control in these modes is more flexible than in Auto or Program mode, but more control also means fewer safeguards, so you can easily end up with a blurred long exposure if you're not careful.

In *Manual (M) mode*, the camera exposes ambient light based on how you set the aperture, shutter speed, and ISO. It then calculates flash exposure based on whatever remaining light is necessary to illuminate the subject. Manual mode therefore enables a much broader range of flash ratios than the other modes.

In all modes, the relevant setting in your viewfinder will blink if a flash exposure is not possible using that setting. This results when an aperture is outside the range available with your lens or a shutter speed is faster than what your flash system supports (for example, *X-sync speed*, which is usually 1/200 to 1/500 second).

## FLASH EXPOSURE COMPENSATION

To set the proper flash ratio on your camera, you'll need to figure out the right combination of ordinary exposure compensation (EC) and flash exposure compensation (FEC). Recall from Chapter 1 that when you activate EC, the final exposure target gets compensated by the EC value, which allows for manual corrections if a metering mode is consistently under- or overexposing.

*Flash exposure compensation (FEC)* works much like regular EC, by telling the camera to take whatever flash intensity it was going to use and to override that by the FEC setting. The big difference is that whereas EC may affect the exposures for both flash and ambient light simultaneously (depending on camera model), FEC only affects flash intensity.

With current Canon and Sony cameras, EC only affects ambient exposure, whereas with Nikon cameras, EC simultaneously affects flash intensity and ambient exposure by default. However, recent Nikon cameras (such as the D4, D800, and later) can work either way via

a custom function. Sony cameras also have this custom function, but they default to the same behavior as Canon cameras.

Each type of flash control has clear advantages and disadvantages. When EC affects both flash output and ambient exposure, you can easily adjust the flash ratio without affecting the overall exposure; for example, a +1 FEC and –1 EC setting will leave the overall exposure unchanged.

For cameras where EC affects only ambient exposure, EC and FEC effectively become independent controls over ambient and flash metering, but these cameras can also make it more difficult to use both EC and FEC to change the flash ratio without also changing the overall exposure. If you happen to have a camera that controls flash intensity and ambient exposure independently, you'll learn how to use these settings to control the flash ratio next.

## CHANGING THE FLASH RATIO

**TABLE 6-3** provides reference settings to change the flash ratio if it was originally 1:1. (Note that EC settings are listed as a range because they can only be set in 1/2- to 1/3-stop increments.)

**TABLE 6-3  How to Change the Flash Ratio by Adjusting FEC and EC**

| FLASH RATIO: | 1:8 | 1:4 | 1:2 | 1:1 | 2:1 | 4:1 | 8:1 |
|---|---|---|---|---|---|---|---|
| FEC SETTING: | –3 | –2 | –1 | 0 | +1 | +2 | +3 |
| EC SETTING: | +2/3 to +1 | +2/3 | +1/3 to +1/2 | 0 | –1/2 to –2/3 | –1 1/3 | –2 to –2 1/3 |

Note that the FEC value is straightforward: it's just equal to the number of stops you intend to increase or decrease the flash ratio by. On the other hand, the EC setting is far from straightforward: it depends not only on how much you want to change the flash ratio by but also on the original flash ratio—and it's rarely an integer.

Although this flash ratio table is not something you would necessarily use in the field, it can help you develop a better intuition for roughly what EC values are needed in different situations. For example, positive EC and negative FEC values are typically used when you want a fill flash, whereas negative EC and positive FEC values are typically used when you want a strong (usually off-camera) flash that overpowers the ambient light.

The exact FEC/EC combination is also much less important with low flash ratios. For example, with a 1:4 fill flash, the FEC setting can vary substantially without noticeably affecting the overall exposure. However, if your flash is the primary source of lighting, then a full-stop FEC is substantial and will likely overexpose the image by nearly a stop.

 **TECHNICAL NOTE ON EC VALUES**

As an example of why EC is much more complicated than FEC, let's walk through what happens when you change the flash ratio from 1:1 to 2:1. You will first want to dial in +1 FEC, because that's the easiest part. However, if only FEC is increased by +1, then the amount of light from the flash doubles while the ambient light remains the same, thereby increasing the overall exposure. You therefore need to dial in a negative EC to compensate for this so that the exposure is unchanged.

But how much EC? Because the original flash ratio was 1:1, the total amount of light using +1 FEC is now 150 percent of what it was before. You therefore need to use an EC value that reduces the total amount of light by a factor of 2/3 (150% × 2/3 = 100%). Because each negative EC halves the amount of light, you know this EC value has to be between 0 and –1, but the exact value isn't something you can readily calculate in your head. It's equal to $\log_2(2/3)$, which comes out to –0.58.

The following EC and FEC adjustments can be used to quickly increase or decrease the flash ratio without changing overall exposure:

- **How to increase the flash ratio:** Dial in a positive flash exposure compensation while simultaneously entering a negative exposure compensation. Assuming a default 1:1 flash ratio, to achieve a 2:1 flash ratio, you need an FEC value of +1 and a corresponding EC value of –1/2 to –2/3.

- **How to decrease the flash ratio:** Dial in a negative flash exposure compensation while simultaneously entering a positive exposure compensation, but not exceeding +1. Assuming a default 1:1 flash ratio, to achieve a 1:2 flash ratio, you need an FEC value of –1 and a corresponding EC value of about +1/3 to +1/2.

Finally, it's important to note that FEC is not always used to change the flash ratio. You can also use it to override errors by your camera's flash-metering system. We discuss how and why this might happen in the next section.

## THROUGH-THE-LENS FLASH METERING

Most current SLR flash systems employ some form of *through-the-lens (TTL) metering*, which works by bouncing one or more tiny pre-flash pulses off the subject immediately before the exposure begins, as depicted in **FIGURE 6-13**. This is used to estimate what flash intensity is needed during the actual exposure.

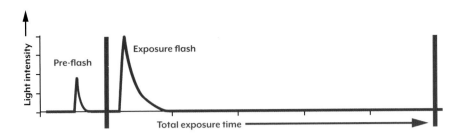

Just after the exposure begins, the flash unit starts emitting its flash pulse. Your camera then measures how much of this flash has reflected back in real time, and it quenches (stops) the flash once the necessary amount of light has been emitted. Depending on the camera mode, the flash will be quenched once it either balances ambient light (fill flash) or adds whatever light is necessary to expose the subject (greater than 1:1 flash ratio).

However, a lot can go wrong during this process. Because a flash exposure is actually two sequential exposures, both ambient light metering and flash metering have to be correct for proper exposure. We'll therefore deal with each source of metering error separately.

## AMBIENT LIGHT METERING

Ambient light metering is the first to occur and determines the combination of aperture, ISO, and shutter speed. This is quite important because it controls the overall exposure and is the basis for the subsequent flash metering.

Recall that in-camera metering goes awry primarily because it can only measure reflected and not incident light (see "Camera Metering" on page 10).

If your subject is light and reflective, like the Dalmatian on the beach in **FIGURE 6-14**, then your camera will mistakenly assume that this apparent brightness is caused by lots of incident light, as opposed to the subject's high reflectance. This causes your camera to overestimate the amount of ambient light, thus underexposing the subject. Similarly, a dark and unreflective subject often results in an overexposure. Furthermore, situations with high- or low-key lighting can also throw off your camera's metering (see "Image Histograms" on page 26).

> NOTE: *White wedding dresses and black tuxedos are perfect examples of highly reflective and unreflective subjects, respectively, that can throw off your camera's exposure—which is unfortunate because weddings are often where flash photography and accurate exposures are most important.*

If you suspect your camera's ambient light metering will be incorrect, you can dial in a positive or negative exposure compensation (EC) to fix ambient light metering and improve flash metering at the same time.

**FIGURE 6-14**
Reflective subject

## FLASH METERING

*Flash metering* is based on the results from both the pre-flash and ambient light metering. If your TTL flash-metering system emits an incorrect amount of flash, not only will your overall exposure be off, but the flash ratio will be off as well, thereby affecting the appearance of your subject.

The biggest causes for flash error are the distance to your subject, the distribution of ambient light, and your subject's reflective properties. The subject distance is important because it strongly influences how much flash will hit and bounce back from this subject.

Even with proper flash exposure, if your subject distance varies, expect regions closer to the camera to appear much brighter than regions that are farther, as shown in **FIGURE 6-15**.

**FIGURE 6-15**
Light fall-off is so rapid that objects 2 times as far away receive 1/4 the amount of flash.

Complex lighting situations can also be problematic as shown in **Figure 6-16**. If ambient light illuminates your subject differently than the background or other objects, the flash might mistakenly try to balance light hitting the overall scene (or some other object), as opposed to light that only hits your subject.

Additionally, because flash metering occurs after your camera meters for ambient light, it is important not to use the auto-exposure (AE) lock setting , discussed in Chapter 1, when using the focus and recompose technique. If it's available, you should instead use *flash exposure lock (FEL)*.

The particular reflective properties of objects in your photo can also throw off flash metering. This might include flash glare and other hard reflections from mirrors, metal, marble, glass, or other similar objects. These objects might also create additional unintended sources of hard light, which can cast more shadows on your subject.

There are also subtle differences among how manufacturers' metering systems work and their naming conventions. For Canon EOS digital, you will likely have either E-TTL or E-TTL II; for Nikon digital, it will be D-TTL or i-TTL; and for Sony, it will likely be P-TTL and ADI. However, many of their flash-metering algorithms are complicated and proprietary, and differences often only arise in situations with uneven ambient lighting. Therefore, the best approach is to experiment with a new flash system before using it for critical photos so you can get a better feel for when metering errors might occur.

**Figure 6-16**
**Example of complex, uneven ambient light**

## CONTROLLING MOTION BLUR

First and second curtain syncs are flash exposure settings you can use to control how a subject's motion blur is perceived. Because a flash pulse is usually much shorter than the exposure time, a flash photo of a moving object is actually composed of both a blurred portion, caused by the slower ambient light exposure, and a sharper portion, caused by the much faster flash pulse. These are overlaid to create the final flash photograph. **FIGURE 6-17** illustrates this process in detail.

**FIGURE 6-17**
First and second curtain sync

First and second curtain syncs control whether the blurred portion trails behind or in front of the subject's flash image, respectively, by synchronizing the flash pulse with the beginning (*first curtain*) or end (*second curtain*) of the exposure.

Again, the best approach is to experiment with a new flash system before using it for critical photos so you can get a better feel for when metering errors might occur.

With first curtain sync, most of the ambient light is captured after the flash pulse, causing the blurred portion to streak in front of the sharper flash image. This can give moving objects the appearance of traveling in the opposite direction of their actual motion. **FIGURE 6-18** shows an example; the swan has motion streaks, making it appear as though it's rapidly swimming backward, and the snow appears to be falling upward.

Note how the blurred streak from the forward-moving swan appears in front of instead of behind it. The start of the blur on the left corresponds with the end of the exposure, whereas the swan itself corresponds with the start of the exposure when the first curtain flash gets fired. The blurred streaks below the snowflakes also give the appearance of upward motion.

For these reasons, photographers usually avoid first-curtain sync when capturing subjects in motion, unless the exposure time is kept short enough that no streaks are visible. On the other hand, you can use second-curtain sync to exaggerate subject motion, because the light streaks appear behind the moving subject.

However, most cameras do not use second-curtain sync by default, because it can make timing the shot more difficult. Second-curtain sync introduces much more of a delay between when you press the shutter button and when the flash fires, and the delay increases for longer exposure times. You therefore need to anticipate where the subject will be at the end of the exposure, as opposed to when the shutter button is pressed. This can be very tricky to time correctly for exposures of a second or more or for really fast-moving subjects.

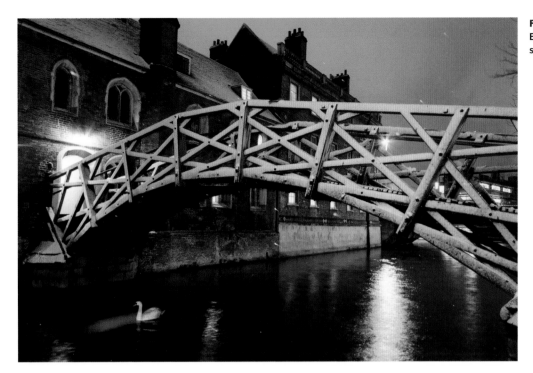

**FIGURE 6-18**
Example of first-curtain sync with motion

## SUMMARY

In this chapter, you were introduced to flash photography by learning how the intensity, position, and distribution of the flash affect the appearance of your subject. You then put that knowledge into practice by using EC and FEC to control flash exposure and achieve the desired mix between light from your flash and ambient sources.

In the next chapter, you'll learn techniques for working with natural light and weather conditions.

# 7

# Working with Natural Light and Weather

**PAYING MORE ATTENTION TO LIGHT** is perhaps the single most important step you can take to improve your photography. In this chapter, you'll learn techniques to maximize natural light at any time of the day. We'll also discuss how to work with other weather conditions that can affect your lighting, such as fog, mist, or haze.

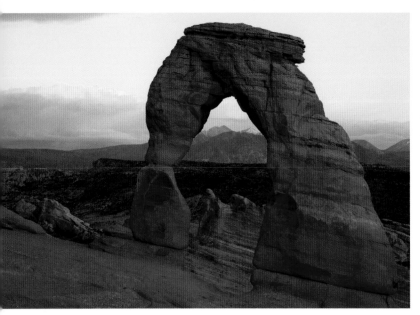

**FIGURE 7-1**
Flat natural light

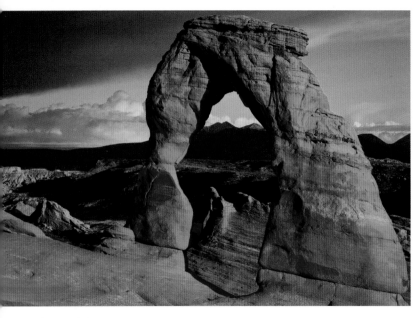

**FIGURE 7-2**
Warm, low-angle natural light

# HOW TIME OF DAY AND CLOUDS AFFECT LIGHT

In landscape photography, having good natural lighting can be even more important than the choice of subject itself. Different types of natural light can illuminate the subject very differently, even though the source is always the sun, as demonstrated in **FIGURES 7-1** and **7-2**. To achieve the right light for your subject, you'll need to utilize the unique qualities of the particular time of day and the weather.

Notice how different the subject appears in **FIGURES 7-1** and **7-2**, even though the composition is identical in each. Although there are no strict rules when it comes to lighting, landscapes are generally considered more evocative when illuminated by warm light at a low angle, as in **FIGURE 7-2**, which therefore exhibits more texture, depth, tonal range, and color saturation. **FIGURE 7-1**, on the other hand, lacks these qualities and is therefore referred to as having *flat* lighting.

# COMPONENTS OF ILLUMINATION

Even though all natural light originates from the sun, a subject's *illumination* is actually made up of several components: direct light, diffused light, and reflected light. These are represented by the colored arrows in **FIGURES 7-3** through **7-6**, where direct light is represented by the yellow arrows, diffused light by the blue arrows, and reflected light by the green arrows.

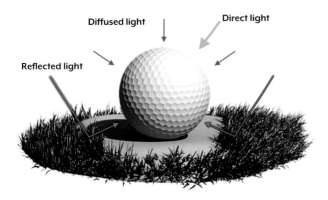

**FIGURE 7-3**
All components of natural light

**FIGURE 7-4**
Only direct sunlight (warmer, high contrast)

**FIGURE 7-5**
Only diffuse skylight (cooler, low contrast)

**FIGURE 7-6**
Only bounced light (takes on the qualities of the surfaces it is reflected from)

Depending on the time of day, the relative contribution of each light component changes as the sun moves from its apex toward the horizon. This results in illumination with different qualities of white balance and contrast. **TABLE 7-1** summarizes how light quality changes as the day progresses from astronomical high noon (when the sun is at its highest) to sunset (or in reverse to sunrise).

**TABLE 7-1** Light Quality at Different Times of Day

| TIME OF DAY | CONTRAST | COLORS | DIRECTION OF SUN |
|---|---|---|---|
| 1. Midday | Highest | Neutral white | Near vertical |
| 2. Evening and midmorning | High | Slightly warm | Mid to low |
| 3. Golden hour and sunrise/sunset | Medium | Warm to fiery | Near horizon |
| 4. Twilight, dawn, and dusk | Low | Cool pastel | Below horizon |

Three factors influence how natural light renders a subject: time of day, light direction, and weather. We'll first explore the time of day under clear skies and then move on to specific weather conditions. The direction of light and how to control it will be discussed in Chapter 8, which is on portrait lighting.

- **Time of day** Further from high noon, the sun dips closer to the horizon. The lower the sun is on the horizon, the lower the contrast. This is because sunlight is diffused through more atmosphere and also is often bounced off the ground toward the subject. The atmosphere also filters more of the sun's blue light, resulting in warmer light overall.

- **Light direction** With landscape photography, you typically don't have control over the direction of light for a given composition and time of day, so this will be discussed in Chapter 8. However, you might choose a different camera direction because light is striking your subject from a more desirable angle. For example, you could aim your camera either toward the sun for backlit silhouettes that emphasis shape over texture, perpendicular to a low-lying sun to emphasize texture with long sideways shadows, or away from the sun to better illuminate the foreground and hide shadows behind objects.

- **Weather** The type and extent of cloud cover are the other strong influences on natural lighting variation. Cloud cover primarily influences lighting because it changes the balance between direct sunlight and diffuse skylight, which in turn affects the apparent contrast and color temperature of the light source.

**FIGURE 7-7**
Example of midday sunshine

## MIDDAY SUNLIGHT

Midday lighting on a clear day is primarily composed of direct, downward sunlight, as shown in **FIGURES 7-7** and **7-8**. Such light has little chance to scatter and diffuse through the atmosphere or to bounce off the ground and illuminate the subject indirectly. This results in the hardest and most neutrally colored lighting of any time of day—and it's typically the least desirable type of natural light.

Due to these drawbacks, photographers often put their cameras away, potentially missing unique opportunities. For example, water may appear more transparent, as you can see in **FIGURE 7-8**, because light penetrates deeper and direct reflections off the surface are less likely. Alternatively, other types of photographs are more about capturing a particular event, as opposed to achieving an image with optimal lighting, and thus photographers will want to continue using their camera to capture photos during midday lighting.

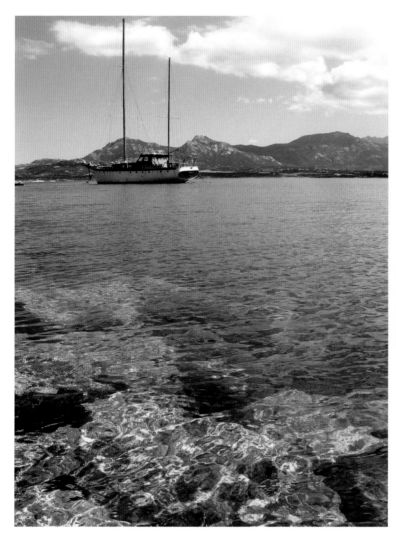

**FIGURE 7-8**
Photographs taken at midday

When working with midday sunshine, you'll notice that color saturation is typically lower and that downward shadows generally don't produce flattering portraits or render subjects as three-dimensional. To overcome this, many photographers use polarizing filters liberally to manage contrast, since this is often when a polarizer is most impactful. However, at this time of day, these filters can also more easily make the sky appear unnaturally dark and blue. If shadows appear harsh and colors aren't sufficiently saturated, try converting to black-and-white because grayscale depictions of a scene might benefit from the high contrast of midday light.

## MIDMORNING AND EVENING

Midmorning and evening light is slightly warmer than midday light, and it begins to cast noticeable shadows at an angle. The result of these angular shadows is that subjects often appear to have more depth. The lighting is usually much more predictable than at sunset and sunrise, primarily because it is relatively independent of the effect of surrounding mountains, the location of the cloud line, and other horizon-line obstructions.

**FIGURES 7-9** and **7-10** show examples of the kind of light you'll typically see in the midmorning or evening.

**FIGURE 7-9**
Example of midmorning or evening light

**FIGURE 7-10**
Photographs taken in the evening (left) and midmorning (right)

Notice how both photos in **Figure 7-10** retain shadows but that these shadows aren't so dark that color and detail are compromised. In the photo on the left, the lower angle of light caused one side of the tower to be more illuminated and helped highlight horizontal symmetry. In the photo on the right, color saturation is improved substantially compared to how this boat would have appeared with midday lighting.

Clear midmorning and evening light perhaps provides the most compromise of any lighting scenario: it's not as neutrally colored as midday light, but also not as warm or intense as a sunset or sunrise. It's less harsh and originates from a better angle than midday light, but it also isn't as soft and diffuse as twilight or overcast lighting. These qualities make it a good all-around time of day for photography, but they simultaneously risk making your photos appear too ordinary, because you cannot use exaggerated lighting traits to emphasize features in your subjects.

Even though midmorning and evening light doesn't necessarily provide any exaggerated qualities in your subjects, this can work to your advantage. For many subjects, this middle-of-the-road lighting can be just right. For example, sometimes you might want a little more contrast and less warmth than at sunset, or conversely, a little less contrast and more warmth than during midday.

## GOLDEN HOUR

The hour just after sunrise, or just before sunset, called the *golden hour*, is typically regarded as having the most desirable light for photography. It is characterized by horizontal light that casts long shadows and gives subjects a warm glow, as shown in **Figure 7-11**.

Sunsets and sunrises make for exciting and highly varied lighting, primarily because the lighting is heavily influenced by subtleties in the weather. Clouds are rendered with sunlight that reflects off them from underneath—as

**Figure 7-11**
**Example of golden hour light**

opposed to sunlight that's diffused through them from above—potentially causing the sky to light up with a soft, warm light, as you can see in **Figure 7-12**.

Sunrises and sunsets are often spectacularly vibrant in person, but this doesn't always translate well into an image. To take full advantage of this light, make sure your camera's automatic white balance doesn't counteract an otherwise warm-looking scene, or that the color saturation isn't overly conservative to minimize the risk of color clipping. Ironically, the time when lighting is the most dramatic is also when your camera is most likely to produce an image you're not expecting. Try taking several photos, or use partial or spot metering to compensate for anticipated errors with your camera's default metering mode.

Although sunsets and sunrises are identical to each other in theory, weather patterns often cause them to be different. Because of that, many photographers prefer one situation over the other. Some find it easier to photograph during sunset instead of sunrise because light quality builds steadily prior to a sunset, as shown in **Figure 7-13**, thus giving the photographer more time to prepare.

▶ **FIGURE 7-12**
Photographs taken at golden hour

▼ **FIGURE 7-13**
Photograph taken during sunset

Others prefer to shoot during sunrises, where the light often starts at its best and gradually fades. Being awake and on location for a sunrise may be impractical, depending on where you are and the time of year. The advantages of sunrise photography are that the scene is usually void of potentially distracting crowds and there can be a low-lying mist or dew on foliage. Sunrises often also have a calm, quiescent quality—particularly with scenes involving water—that isn't present during sunsets.

## TWILIGHT, DAWN, AND DUSK

At dawn and dusk, which are typically described as the half hour before sunrise and after sunset, respectively, the sky is bright but there's no direct sunlight. The primary source of light effectively becomes the entire sky, with one side appearing warm and reddish and the other a cool blue or purple. This can produce wonderfully soft, multicolored lighting that gives a calm, peaceful mood to subjects, as shown in **FIGURE 7-14**.

**FIGURE 7-14**
**Example of twilight or dusk light**

Perhaps the biggest disadvantage of working with twilight is the lack of contrast and ambient light. Handheld shots are rarely possible, and achieving a sufficient sense of depth may require more attention to composition. Cameras often overexpose twilight scenes when automatic exposure is used—potentially washing out otherwise delicate colors because twilight almost never contains fully white objects.

If you're lucky, a phenomenon called *alpenglow* may appear (see **FIGURE 7-15**). This is the red or pinkish glow in the sky farthest from the setting sun. Alpenglow can be a helpful effect for extending the sky's warmth well beyond sunset.

**FIGURE 7-15**
**A photograph that captures alpenglow**

**FIGURE 7-16**
Example of overcast light

## SHADE AND OVERCAST SUNLIGHT

Shade and overcast light typically have a cool, soft appearance, because the light source is spread across the entire sky and doesn't include any direct sunlight. Textures therefore appear more subtle, and reflections on smooth surfaces are more diffuse and subdued. The color of light is also more heavily influenced by bounced light from nearby objects. For example, subjects shaded by foliage can be tinted green, as you can see in **FIGURE 7-16**.

Many photographers shy away from this type of lighting, in part because of how low-contrast and bluish this light can appear. However, doing so can be a mistake. Depending on the degree of cloud cover, bright overcast light can be ideal for outdoor portraits and wildlife as long as the cool white balance is corrected (see **FIGURE 7-17**). It doesn't cast harsh shadows across the subject's face. Bright overcast light can also enhance close-up photography—such as with flowers—because the appearance and saturation of colors usually improve. Alternatively, low-contrast light can be better when the subject itself is high contrast, such as a subject containing both dark and light colors.

**FIGURE 7-17**
Photos taken during overcast light

A common trick is to keep gray skies out of a photo, unless the clouds are particularly moody and highly textured. Because shadows play much less of a role, achieving sufficient depth may be difficult—just as during twilight—but you don't have the appealing pastel lighting to help compensate. Images straight out of the camera often appear bluish, so adjusting the white balance afterward is encouraged. Liberal use of contrast tools in post-processing can be helpful if you want to use the full tonal range in a print.

In **FIGURE 7-17**, the image on the right avoids harsh reflections off all the shiny surfaces and benefits from improved color saturation. The image on the left avoids harsh shadows on an otherwise dark face and benefits from contrast enhancement in post-processing.

## OTHER WEATHER CONDITIONS

Weather is effectively just a massive filter that lies between the sun and your subject. At one extreme, light can be relatively warm and highly localized, such as sunlight from a clear sky. At the other extreme, light can be cooler and envelop the subject, such as diffuse sunlight through a densely overcast sky. The thickness and extent of cloud cover is what determines how weather will affect your images.

When the sky is partly cloudy, you can effectively use it to paint your scene with light—if you are willing to wait for whenever you feel is just the right moment (see **FIGURE 7-18**). Partial cloud cover can be an excellent and often overlooked opportunity, especially during the middle of the day.

**FIGURE 7-18**
**Taking advantage of selective light from partly cloudy skies**

**FIGURE 7-19**
Evening light during
stormy skies

Stormy weather can produce extremely high-contrast light because rain clears the air of haze and dust. Sunsets after a storm are often the most dramatic, in part because the sky can become much darker than the land, providing a nice high-contrast backdrop for front-lit subjects, as shown in **FIGURE 7-19**. This is also when rainbows are most likely to appear.

Other scenarios include fog, mist, and haze, which we'll discuss next. These situations greatly decrease contrast—just as during an overcast day—and they do so progressively for more distant objects.

## FOG, MIST, AND HAZE

Photography in fog, mist, or haze can give a wonderfully moody and atmospheric feel to your subjects. However, it's also very easy to end up with photos that look washed out and flat.

Fog usually forms in the mid-to-late evening and often lasts until early the next morning. It is also much more likely to form near the surface of water that is slightly warmer than the surrounding air. Although the focus of the examples here is primarily on fog, the photographic concepts apply similarly to mist and haze.

Photography in the fog is very different from photography in clear weather. Scenes are no longer necessarily clear and defined, and they are often deprived of contrast and color saturation, as **FIGURE 7-20** shows.

In essence, fog is a natural soft box: it scatters light sources so that their light originates from a much broader area. Compared to localized light sources, such as a street lamp or light from the sun on a clear day (as illustrated in **FIGURE 7-21**), light filtered through fog dramatically reduces contrast (as illustrated in **FIGURE 7-22**).

Scenes in the fog are dimly lit, often requiring long exposure times. In addition, fog makes the air more reflective, which can trick your camera's light meter into decreasing the exposure. Just as with photography in the snow, fog usually requires dialing in positive exposure compensation.

In exchange for these potential disadvantages, fog can be a powerful and valuable tool for emphasizing the depth, lighting, and shape of your subjects. These traits can make scenes feel mysterious and uniquely moody—an often elusive but sought-after prize for photographers. The trick is knowing how to make use of the fog's unique characteristics without also having those characteristics detract from your subject.

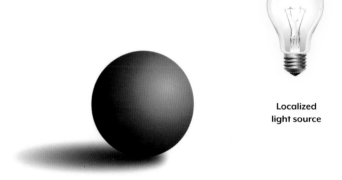

Localized
light source

**FIGURE 7-21**
A lamp or the sun on a clear day (high contrast)

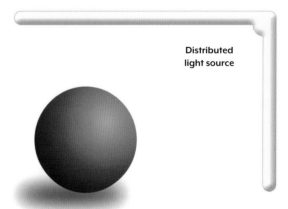

Distributed
light source

**FIGURE 7-22**
Light in the fog, haze or mist (low contrast)

## EMPHASIZING DEPTH

As objects become progressively farther from your camera, not only do they become smaller, but they also lose contrast—sometimes quite dramatically, as depicted in **FIGURE 7-23**.

This can be a blessing and a curse: it exaggerates the difference between near and far objects, but also makes distant objects difficult to photograph on their own. A dramatic lighthouse that you expected would be the focal point of a composition, for example, may appear faded and desaturated because it's far enough away that the haze has scattered its reflected light.

The example in **FIGURE 7-24** shows at least four layers of trees that cascade back toward the distant bridge. Notice how both color saturation and contrast drop dramatically with each successive layer. The farthest layer, near the bridge, is reduced to a soft silhouette, whereas the closest layer has nearly full color and contrast.

Although there are no steadfast rules about photographing in the fog, it's often helpful to have at least some of your subject close to the camera. This way, a portion of your image can contain high contrast and color, hinting at what everything else would look like without the fog. Layering adds some tonal diversity to the scene.

**FIGURE 7-23**
Southwest coast of
Sardinia in the haze

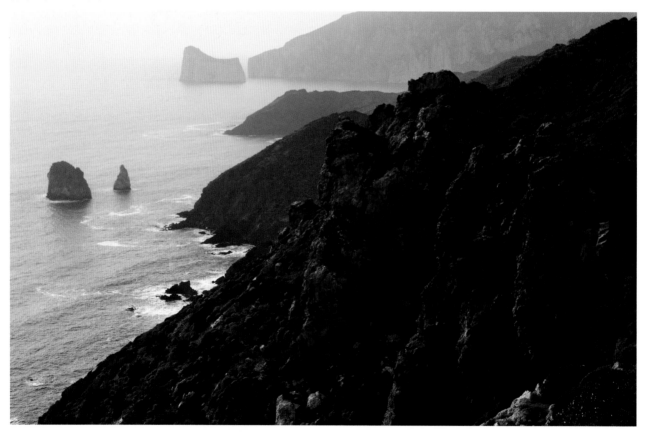

**Figure 7-24**
Mathematical Bridge in Queens' College, Cambridge, UK

## EMPHASIZING LIGHT

The water droplets in fog or mist make light scatter a lot more than it would otherwise. This greatly softens the light but also makes visible light streaks from concentrated or directional light sources, as shown in **Figures 7-25** and **7-26**. A classic example of this phenomenon is when a photo is taken in a forest during an early morning mist; if the camera faces incoming light, the trees cast a shadow and create rays that streak down in the heavy morning air.

In the example in **Figure 7-25**, light streaks are clearly visible from an open window and near the bridge where a large tree partially obstructs an orange lamp. The visibility of light streaks is often highly sensitive to camera position, though; for example, when the camera was moved just a few feet back, the streaks from the window were no longer visible.

The trick to making light rays most pronounced is planning your vantage point. Light rays will be most apparent if your camera is located where the light source is barely obstructed from your point of view. This "off-angle" perspective ensures that the scattered light will be both bright and well separated from the surrounding shadow.

On the other hand, if the fog is very dense or the light source is extremely intense and concentrated, the light rays will be clearly visible independent of the vantage point.

The example in **FIGURE 7-26** was taken in air that was not visibly foggy, but the light sources were extremely intense and concentrated. The diffused light was brighter relative to the sky because the image was taken after sunset.

**FIGURE 7-25**
View of King's College
Bridge from Queens'
College, Cambridge, UK

**FIGURE 7-26**
Spires above the
entrance to King's
College, Cambridge
during BBC lighting of
King's Chapel for the
boys' choir

## SHAPES AND SILHOUETTES

Fog can emphasize the shape of subjects because it downplays their texture and contrast. Often, the subject can even be reduced to nothing more than a simple silhouette, as you can see in **Figure 7-27**.

Here, the swan's outline has been defined because the low-lying fog has washed out nearly all of the background. The bright fog background contrasts starkly with the darker silhouetted swan.

Expose based on the fog—not the subject—if you want the subject to appear as a silhouette. Another option is to use negative exposure compensation to ensure that subjects do not turn out too bright.

You will also need to pay careful attention to the relative position of objects in your scene to be sure outlines of objects don't unintentionally overlap. In the example in **Figure 7-28**, the closest object—a cast iron gate—stands out much more than it would otherwise against this tangled backdrop of tree limbs. Behind this gate, each tree silhouette is visible as if layered because the branches become progressively fainter the farther they are from the camera.

▲ **Figure 7-27**
Swan at night on the River Cam, Cambridge, UK

▶ **Figure 7-28**
Rear gate entrance to Trinity College, Cambridge, UK

**FIGURE 7-29**
Mount Rainier breaking through the clouds, Washington, USA

## PHOTOGRAPHING FROM WITHOUT

You may have heard the saying "it's difficult to photograph a forest from within." This is because it can be hard to get a sense of scale by photographing a cluster of trees. You have to go outside the forest to see its boundaries and gain perspective.

In the same way, getting outside of the fog can be helpful. This way, you can capture the unique atmospheric effects of fog or haze without the contrast-reducing disadvantages. Fog, from a distance, is really nothing more than low-lying clouds (see **FIGURE 7-29**).

## TIMING THE FOG FOR MAXIMAL IMPACT

Just as with photographing in weather and clouds, timing when to take a photo in the fog can make a big difference with how the light appears. Depending on the type of fog, it can move in clumps and vary in thickness and density with time. These differences can be difficult to notice if they happen slowly because our eyes adjust to the changing contrast. In **FIGURE 7-30**, notice how the bridge scene changed in just six minutes.

**FIGURE 7-30**
First photograph (top)
and a photograph six
minutes later (bottom)

**Figure 7-31**
Shorter exposure time (1 second)

**Figure 7-32**
Longer exposure (30 seconds)

Fog can dramatically change the appearance of a subject, depending on where it is located and how dense it is in that location. When you're photographing foggy scenes, the texture of the fog is an important consideration. Even if you time the photograph for when there is an interesting distribution, the fog might not retain its texture if the exposure time is too long. In general, the shutter speed needs to be less than a second in order to prevent the fog's texture from changing shape or smoothing out, as shown in **Figure 7-31**.

You might be able to get away with longer exposure times when the fog is moving slowly or when your subject is not magnified much. **Figure 7-32** shows an example of such a scene.

Although the shorter exposure time does a much better job of freezing the fog's motion, it also has a substantial impact on the amount of image noise when viewed at 100 percent. Noise can be a common problem with fog photography, because fog is most likely to occur in the late evening through to the early morning when light is low, and it greatly reduces the amount of light reaching your camera after reflecting off the subject. Compensating for the dim light requires increasing the ISO or lengthening the exposure; therefore, freezing the motion of the fog might not be possible if you also want to avoid noise.

## BEWARE OF CONDENSATION

If water is condensing out of the air, such as in shooting conditions similar to **Figure 7-33**, you can be assured that water is also going to condense on the surface of your lens and possibly inside your camera. If your camera is at a similar temperature to the air and the fog isn't too dense, you might not notice any condensation at all. On the other hand, if you previously had your camera indoors and it is warmer outside, expect substantial condensation.

**FIGURE 7-33**
Sunset above the clouds on Mount Baldy, Los Angeles, California, USA

To minimize condensation caused by going from indoors to outdoors, place your equipment in a plastic bag and ensure it is sealed airtight before going out. You can then take the sealed bag outdoors, wait until the items in the bag have adjusted to the temperature, and then open the bag. For large camera lenses with many elements, this can take 30 minutes or more if the temperature difference between indoors and outdoors is significant.

Unfortunately, sometimes a little condensation is unavoidable. Make sure to bring a lens cloth to wipe the lens.

## SUMMARY

This chapter summarized the various ways that weather and time of day can influence the lighting in your photographs. You learned how the warmth, direction, and contrast of light are generally considered beneficial during the golden hour, but also that any lighting scenario presents unique creative opportunities. You also explored various specialty techniques for making the most of photos taken in the fog, mist, or haze. Taken as a whole, this chapter should form the very core of your photographic intuition—a universal skill set that's independent of camera type.

In the next chapter, we'll begin to explore what happens when you have control over the size, position, and intensity of your light sources in portrait photography.

# 8

# Introduction to Portrait Lighting

**GOOD LIGHTING IS A CRITICAL COMPONENT** of portraiture. It's also easily identifiable, even by the casual observer. However, despite this apparent simplicity, knowing how to use light to achieve a desired look requires a deeper understanding. In this chapter, you'll first learn how a single light source can affect your subjects. Then you'll see how adding a second light source can refine that control.

Note that this chapter utilizes both 3D rendered portraits (courtesy of Nikola Dechev) and actual subject portraits in a studio setting. Where applicable, we chose to use rendered images to more clearly illustrate subtle lighting differences than would otherwise be possible with an actual model or mannequin. Such rendered images are especially important when the subject's expression needs to remain identical even when light placement and size need to vary substantially.

Also note that the real-life photos aim to accentuate the effect of lighting and do not necessarily reflect ideal lighting conditions or subject appearance. Furthermore, such photos would also typically be touched up in editing software afterward, depending on artistic intent. Touch-ups might include improving skin texture, skin reflections, deep shadows, and so on. However, editing was not performed on the images in this chapter in order to demostate how lighting affects all subject traits, regardless of whether these effects are desirable.

# USING A SINGLE LIGHT SOURCE

The primary source of illumination is usually called the *main* or *key light*. Although additional lights may be added to enhance a portrait, key lighting is considered independently. This is great if you're trying to learn portrait lighting, because it means you can ease into the process one light at a time. When you decide to include additional lights, everything you'll learn here still applies.

Only two traits control the appearance of light on a subject: its color and distribution. For this chapter, I assume you want the light to appear natural and match daylight, so we'll focus on *distribution*, which refers to the positioning and intensity of light relative to a subject. For a given light source, we can separate distribution into two easily manageable characteristics: direction and apparent size. *Direction* refers to where the light is coming from, and it controls the location of shadows and highlights on the subject. *Apparent size* refers to how large a light source appears from the perspective of the subject, and it controls the amount of contrast.

**FIGURE 8-1**
Unflattering portrait lighting

As you'll soon learn, **FIGURE 8-1** shows a less flattering portrait because the direction and size of the light source cast harsh, unrealistic upward shadows, as compared to **FIGURE 8-2**, which demonstrates more traditional portrait lighting.

Although these characteristics are simple and controllable, different combinations can create a wide array of effects on the subject. Lighting can become more predictable when you develop an intuition for each quality.

## HARD VS. SOFT LIGHT

When photographers describe "light quality" or refer to light being "hard" or "soft," they're actually referring to the apparent size of the light source. This relationship is perhaps the most common cause of poor portrait lighting. **TABLE 8-1** details the characteristics and common causes of hard light versus soft light.

**FIGURE 8-2**
Better portrait lighting

**TABLE 8-1  Characteristics and Common Causes of Hard vs. Soft Light**

|  | HARDER LIGHT | SOFTER LIGHT |
| --- | --- | --- |
| **LIGHT SIZE** | Smaller | Larger |
| **SHADOWS/HIGHLIGHTS** | Abrupt | Gradual |
| **TYPES OF SUNLIGHT** | Direct | Overcast, shade |
| **TYPES OF FLASH** | Direct | Bounced, diffuse |

As you can see from the table, the type of sunlight, flash, and studio lighting can all influence the hardness or softness of light. Although too much of anything can be harmful, portraits usually benefit from softer lighting, as you can see progressively illustrated in **FIGURES 8-3** through **8-5**.

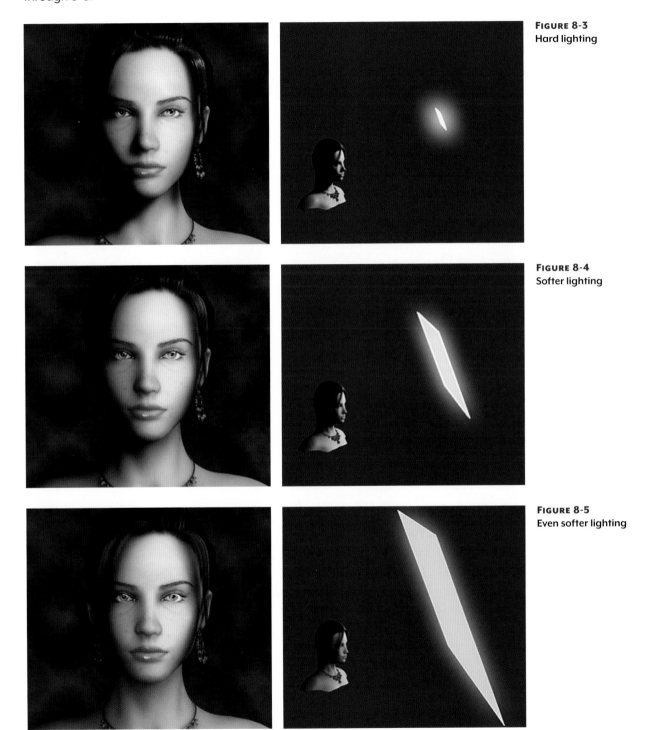

**FIGURE 8-3**
Hard lighting

**FIGURE 8-4**
Softer lighting

**FIGURE 8-5**
Even softer lighting

The larger and smaller light sources are termed *soft* and *hard*, respectively, because of how they render the edges of shadows and highlights. A larger light source effectively "wraps" light around the subject; any given region of the subject is therefore more likely to receive at least some direct lighting, resulting in softer shadows. With a smaller light source, a given region of the subject usually receives either all or none of the direct light, producing much deeper shadows. Also note how light size is equally transformative to the highlight transitions: the harder the light, the brighter and more abrupt the hair reflections in these figures.

Light size doesn't just control the appearance of large-scale tones; it also affects the visibility of texture, as shown in **FIGURES 8-6** and **8-7**. Pores, blemishes, wrinkles, and other facial details all become more pronounced with hard light. Hard light also increases the likelihood of harsh direct reflections.

**FIGURE 8-6**
Harder light emphasizes texture.

**FIGURE 8-7**
Softer light blends texture.

The most important trick for achieving softer light is to understand that direct light is hard, but that whenever this light bounces off or travels through objects, it becomes diffused and softer. Photographers use this concept to make the most of otherwise harsh light. Here are some tips for making hard light softer:

- **Use a diffuser.** Place a larger translucent object between your subject and the light source. This might include using a lamp shade or hanging a white sheet or curtain over an open window that receives direct light.

- **Use bounced or reflected light.** Place your subject so that they receive only bounced or reflected light. This might include moving them a little farther from an open window (just outside the direct rays) or aiming your flash at a nearby wall or ceiling.

In either case, because you'll end up with a lot less light, the subject might require a longer exposure time or a brighter flash.

At the other extreme, a light source can be too soft, although this is a much less common situation. Some might consider photos taken in the shade as appearing too flat, for example, because indirect light scatters in from everywhere. Such light is effectively very large and can erase all shadows. Other examples of very soft light include portraits in the fog or outside on a fully overcast day.

Just how soft is "too soft" really depends on the look you're trying to achieve, as whether lighting is considered soft is relative and can vary depending on the photographer or application—unless the lighting is at an extreme. For example, even though **FIGURE 8-5** uses very soft lighting, many might consider the result to be a desirable look for glamour portraits. This chapter therefore refers to light as being either "softer" or "harder" compared to a reference instead of trying to set a standard for what is considered "soft" or "hard" light in general.

## DISTANCE AND APPARENT LIGHT SIZE

We've established light size correlates with the hardness or softness of light, but it's not really the physical size of the light source that matters, just its *apparent* size, from the perspective of the subject. The combination of distance and size is what ultimately determines apparent size, because a small light that's very close can easily appear larger from the subject's perspective than a large light that's far away.

In general, moving a light closer makes it softer, because this light strikes the subject from a broader range of angles, even if the light itself remains unchanged. Similarly, the opposite is also true: direct sunshine is hard light even though the sun is physically enormous. The sun is so distant that its light reaches us from effectively one direction.

Moving a light closer also brightens the subject. If this is your primary source of light, then the look of your portrait might not change much, other than perhaps becoming a little softer, but the exposure time or flash intensity can be decreased to compensate for this. However, if much of your subject's light was previously ambient, then moving a light source closer can decrease the influence of other light sources (for example, ambient light). This has the potential to make the overall light harder because more of it will come from one location.

**FIGURES 8-8** and **8-9** show how the distance of a light source affects a subject's appearance. Note how the closer light source brightens the subject relative to the background while softening the lighting on the subject a little.

Closer light sources also illuminate the subject more unevenly, because different parts of the subject will become relatively closer or farther from the light. For example, the far side of the subject might only be 5 percent farther from a distant light source than the near side of the subject, but that relative distance could become 50 percent when the light source is moved up close. This would cause the far side of the subject to become much darker relative to the other parts of the subject.

**FIGURE 8-8**
Subject appearance
with farther light source

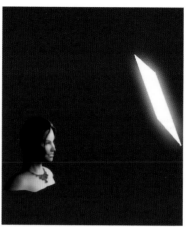

**FIGURE 8-9**
Subject appearance
with closer light source

However, this uneven lighting can also be used to your advantage. A light source placed closer to the subject might be able to achieve better subject/background separation because the subject will become much brighter relative to the background. On the other hand, this can also create more separation than desired if the background and subject are already well separated.

## LIGHTING DIRECTION

Finding the right lighting direction requires the photographer to strike a balance among several potentially competing considerations. Typically, this includes both portraying a sense of depth and depicting facial features in a pleasing manner.

### SENSE OF DEPTH

Creating a sense of depth is a key part of capturing realistic-looking portraits, since it helps give a two-dimensional image a more three-dimensional feel. However, our sense of depth doesn't work very well unless light is striking our subject from the right direction. **FIGURE 8-10** show how various lighting directions affect perception of depth of a sphere.

Note how the upper-side lighting generally makes the shape appear more three dimensional than either front or side lighting. This same principle holds true for portraits, but fortunately the irregular geometry of a face can still appear three-dimensional with a wider range of lighting directions.

In addition to a person's head as a whole, individual facial features can have unique shadows and highlights. These differences deserve special consideration. For example, this might mean preventing a subject's nose from casting a long shadow to avoid making it seem larger than it is, or you might choose to soften the shadows underneath the subject's eyes to make them look less tired. Upper-side lighting, or lighting from the upper left or upper right, could cause these and other undesirable effects if not carefully positioned.

## REMBRANDT LIGHTING

One classical way to achieve both a sense of depth and a flattering appearance is to place the light so that it creates a triangle of illumination on the cheek farthest from the light source. This style is often called *Rembrandt lighting*, and we'll refer to this shape as the *key triangle*.

**FIGURE 8-11** shows an example of the key triangle you should aim for if a Rembrandt lighting style is desired.

You can use the key triangle as a guide to help restrict the lighting to a narrower range of angles. When the key triangle deviates from this shape, you may need to make some adjustments (shown in **FIGURE 8-12**). For example, when the key triangle is too wide, this means the light is too close to the subject's forward direction, and it likely isn't creating a sufficient appearance of depth since most shadows are hidden from the camera's perspective.

If a key triangle is too narrow, it means the light is too far to the side of the subject, which could cause the nose to appear bigger by having it cast a longer shadow or leave a substantial portion of the face in shadow. However, this is perhaps the least adhered to of all the key triangle guidelines.

**FIGURE 8-11**
Illustration of how the key triangle might appear on a subject

**FIGURE 8-12**
Examples of how the subject appears if
the light source is vertically or horizontally
displaced compared to Rembrandt lighting

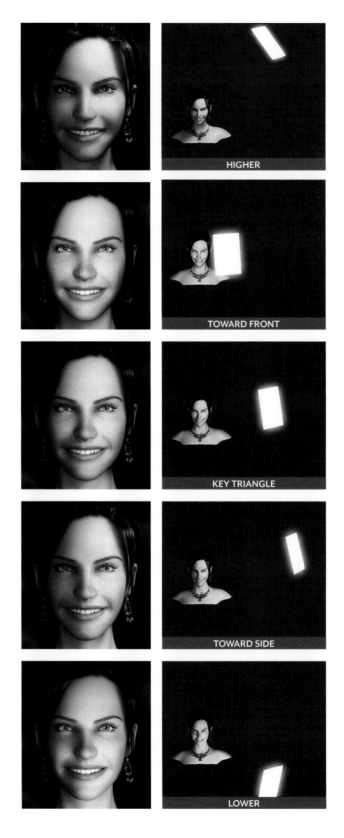

A key triangle that is too short can indicate that the light is too high or low, so the light is likely causing shadows underneath the eyes or a lack of shadow definition along the jaw line, respectively. Lighting from below is often used for unsightly creatures in movies or to create a frightening face when telling a scary story (like when you hold a flashlight under your chin).

Keep in mind that the exact appearance of the key triangle will vary greatly depending on the subject's facial structure and expression, so this is only a rough guide.

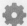 **TECHNICAL NOTE**

*Loop lighting* is another popular (and more commonly used) portrait style that is similar to Rembrandt lighting. It is based on the appearance of the shadow underneath the subject's nose, which produces a "looped" diagonal shadow that doesn't fully extend to the shadows on the far side of the face.

As with any rule, there are exceptions. For example, a side-view portrait might not need a key triangle to convey a sense of depth if additional shadows have become visible on the side of the face (such as in **FIGURE 8-12**).

Furthermore, Rembrandt lighting is just one style among many, and each subject is a little different. For example, you might want to forego Rembrandt lighting and choose hard side-lighting to accentuate a man's facial hair or to convey symmetry by only illuminating half the face. The key is knowing how to use light to emphasize depth, shape, or texture, depending on your artistic intent. *Short lighting* and *broad lighting* are two other common lighting styles. These are used when the subject's face is at an angle to the camera. Short lighting illuminates the full face and leaves the near side of the head in shadow, whereas broad lighting illuminates the near side of the head and face but leaves the far side of the face in shadow, as shown respectively in **FIGURES 8-13** and **8-14**.

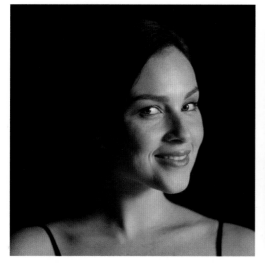

**FIGURE 8-13**
Short lighting

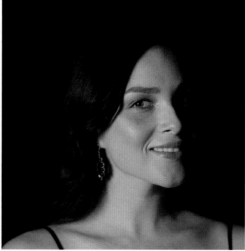

**FIGURE 8-14**
Broad lighting

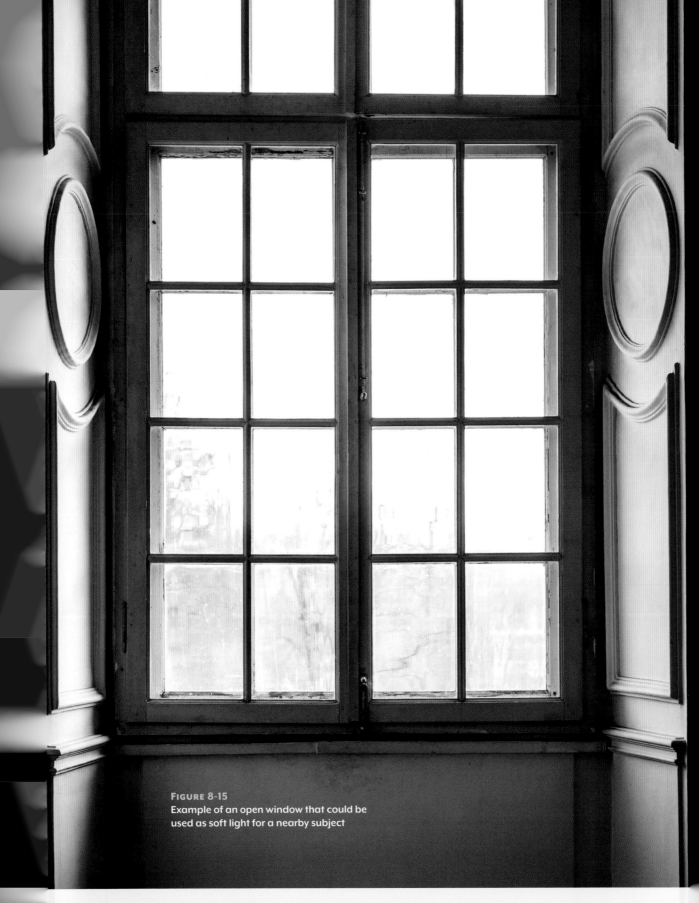

**FIGURE 8-15**
Example of an open window that could be used as soft light for a nearby subject

In sum, the usual goal of portrait lighting is to achieve softer light. This is almost always more flattering because it makes a subject's features appear smooth and the skin texture appear softer. Achieving softer light requires making the apparent size of the light source bigger. This can be done by employing any of the following methods:

- Moving the light closer

- Increasing the light's physical size

- Bouncing or diffusing the light

Sometimes it's possible to make the apparent light size larger using available light. For example, you can often achieve light quality that is similar to expensive equipment by photographing subjects in indirect sunlight, such as the light near large, open windows (see **FIGURE 8-15**).

The choice of lighting direction is definitely more subjective than just using hard or soft light. Two lighting orientations are usually considered undesirable: lighting from underneath and directly from the front. The former doesn't appear natural, and the latter destroys the portrait's sense of depth. In any case, you'll generally want to portray your subject in a flattering light, but each subject is unique and may require a different treatment.

Regardless of the choices, the key is to envision your artistic intent at the start and then to adjust your lighting setup to achieve that goal.

# FILL LIGHTING

Adding a second light source—usually called a *fill light* or *fill flash*—can greatly improve portrait lighting. It reduces the depth of shadows and softens the appearance of facial features, as you can see in **FIGURE 8-16**. Best of all, a fill light is easy to create using a simple on-camera flash or a reflector. However, a second light source can just as easily harm portraits. Controlling the location and intensity of the fill light can help you produce the portrait appearance you want.

 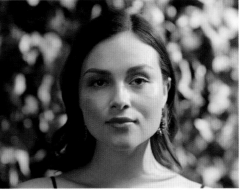

**FIGURE 8-16**
Harsh overhead sunlight (left), sunlight with a fill flash (right)

## ADDING A SECOND LIGHT SOURCE

As you just learned, with a single light source, the most important considerations are its direction and apparent size. Although size and direction have the same effect with a second light, they aren't typically controlled the same way as the main light. Instead, we usually adjust the relative illumination of the secondary light compared to the main light. This controls how much the second light will fill in the shadows that the main light creates, and this is precisely why a secondary light is usually referred to as the fill light or fill flash.

For example, **FIGURES 8-17** and **8-18** illustrate the principle of using a fill flash to fill in the shadows created by a direct sunlight.

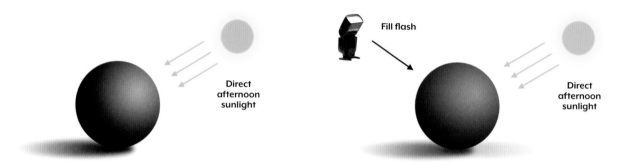

**FIGURE 8-17**
Harsh overhead sunlight

**FIGURE 8-18**
Using a fill flash to balance out an otherwise harshly lit subject

Perhaps the most common lighting scenario in outdoor portraiture is to use an on-camera flash as the fill light and to use sunlight as the main light. In the studio, you could also use a second flash or ambient light as the fill light and use a flash as the main light. There are many possibilities. The key is knowing how to control the qualities of your fill light, regardless of what source is being used to create it.

## FLASH AND FILL LIGHT RATIOS

The terms *flash ratio* and *fill light ratio* describe the relative proportion of light coming from the main and secondary light sources, which effectively determines the overall contrast. For example, a value of 1:4 means that the fill light is one-quarter the intensity of the main light. More balanced ratios produce weaker shadows. **FIGURE 8-19** shows how different fill light ratios influence the appearance of a subject.

Portraits typically appear more pleasing with a flash ratio near 1:2. At this ratio, the fill light is strong enough to produce subtle shadows, but not so strong that it eliminates shadows entirely, which could make the subject appear flat.

However, you should always be wary of rules in photography. In fact, less fill light is a popular choice for dark, *low-key* portraits with well-defined shadows. Similarly, more fill light might be necessary to render a brighter, *high-key* style, or just to provide a softer appearance (such as styles used for photographing babies). When in doubt, though, the 1:2 ratio is a safe starting point.

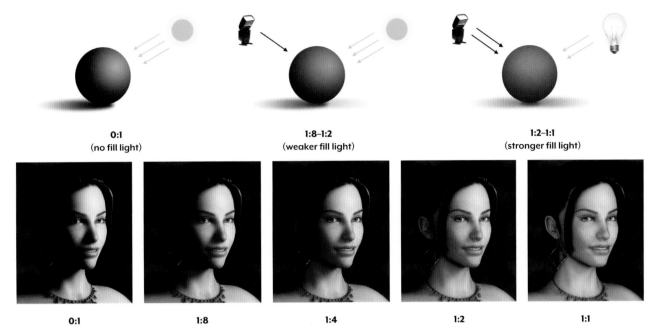

| 0:1 (no fill light) | | 1:8–1:2 (weaker fill light) | | 1:2–1:1 (stronger fill light) |
|---|---|---|---|---|
| 0:1 | 1:8 | 1:4 | 1:2 | 1:1 |

**FIGURE 8-19**
Fill light ratio and subject appearance

The terminology can be a little confusing, because a fill light ratio refers to the ratio between the secondary and primary sources of light, whereas the flash ratio refers to the ratio between the light from the flash and the ambient light. To make matters worse, sometimes the ratio describes the total light (ambient + flash) compared to the flash alone. It's helpful to remember that, although the numbers in the ratio are sometimes reversed, the smaller number always refers to the fill light.

## FILL LIGHT LOCATION

Unlike with the main light source, the simplest location for a fill light is near the camera's line of sight (*on-axis*), but not so close that it appears in your image. In that position, any shadows cast by the fill light won't be visible from the camera's perspective, even if these shadows appear hard due to the small size of the source. Unlike with the main light source, where the goal is often to add pleasing shadows and dimensionality, the goal with fill lighting is to soften the main light without the viewer knowing this has happened. Perhaps the easiest way to achieve this type of fill light is to use a built-in or on-camera flash, as shown in **FIGURE 8-20**.

On the other hand, an on-axis fill light doesn't give you any control over where it's located and has a higher chance of producing direct reflections, which you want to avoid. To get around this, many photographers use a fill light that strikes the subject from a direction that partially opposes the main light (*off-axis*), as shown in **FIGURE 8-21**. This targets main-light shadows more efficiently than on-axis fill lighting—even if the fill light ratio remains unchanged—and is less likely to affect the overall exposure.

Off-camera
flash

On-camera
flash

**FIGURE 8-20**
On-axis fill light (shadows fall behind the subject)

**FIGURE 8-21**
Off-axis fill light (shadows fall across the subject)

Off-axis fills have their own disadvantages, with the worst being that you have to worry about the appearance of shadows from the fill light. These need to be made sufficiently soft; otherwise, they can cause unrealistic-looking double shadows. To minimize the risk of double shadows, the apparent size of the fill light should be as large as possible.

The second shadow to the right of the subject's nose in **FIGURE 8-22** is caused by off-axis fill lighting that is too hard. The on-axis fill light in **FIGURE 8-24** avoids producing double shadows, even though it is just as hard as in **FIGURE 8-22**. The fill light in **FIGURE 8-24** still doesn't eliminate the shadows as thoroughly as in **FIGURE 8-23**, though, even though it uses the same 1:1 fill light ratio.

Keep in mind that off-axis fill lighting requires a more complex lighting arrangement, and it is therefore usually reserved for portraits in a studio. An off-axis fill light isn't technically a true fill light either, because it does not lighten all shadows visible to the camera—just those from its direction. For example, in **FIGURE 8-23**, the off-axis light is unable to reduce the shadows behind the hair on the upper left.

**FIGURE 8-22**
Harder off-axis fill light

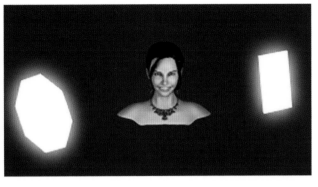

**FIGURE 8-23**
Softer off-axis fill light

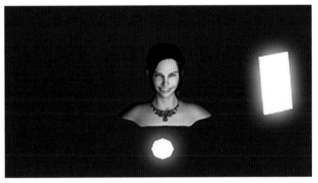

**FIGURE 8-24**
Harder on-axis fill light

## FILL FLASH CAMERA SETTINGS

Many people only use flash when their scene has insufficient light for a handheld photo-graph. Doing so misses out on what may be a more useful function: fill flash. It might seem counterintuitive, but flash is most useful in portraiture when there is plenty of sunlight. Most cameras default to using their flash as a fill flash when the subject is *well lit*, but only if you force the flash to fire.

Cameras usually default to a flash ratio near 1:1, but this can be substantially off because it relies on your camera's metering system. As you learned in Chapter 6, you can fine-tune this ratio using flash exposure compensation (FEC), which modifies the amount of flash your camera would otherwise emit while leaving the other exposure settings unchanged.

>  **TECHNICAL NOTE**
>
> ***Well lit*** means that your camera doesn't deem camera shake a threat, which usually translates into having an exposure time that is faster than about 1/60 second.

## OTHER CONSIDERATIONS FOR FILL LIGHTING

Other important fill light techniques and considerations include natural fill lighting, reflectors, subject/background separation, and ambient light, as described here:

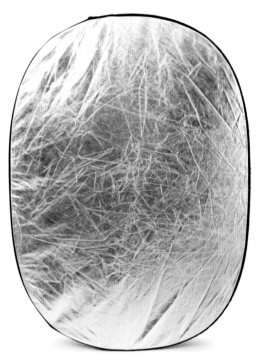

**Figure 8-25**
Handheld light reflector

- **Natural fill lighting** Thus far we've focused on scenarios where natural light is the main light source and then the camera's flash is used as the fill light. These roles could easily be reversed. For natural fill lighting, the source of natural light usually needs to be soft, such as on an overcast day or when the subject is in the shade. You also typically need an off-camera or bounced flash in order for this to produce optimal results.

- **Reflectors** Reflectors make a single light source illuminate a subject from a second direction. The reflection is always dimmer than the main light, so reflectors are most commonly used for fill light. An added benefit is that this light can have the same white balance as the main light. A disadvantage is that reflectors often don't provide enough light. The intensity depends on the reflectivity of the reflector's surface and its distance from the subject. To increase illumination, reflectors are usually placed as close to the subject as possible, just outside the image frame. Reflectors vary in size and color, but a common one is depicted in **FIGURE 8-25**. It has a silver foil surface.

- **Subject/background separation** With natural light portraits, a fill flash can help create additional subject/background separation, when the flash is placed closer to the subject than the background. You can control the strength of this effect by moving the flash closer to your subject and/or moving your subject farther from the background.

- **Ambient light** All scenes have some amount of fill light that comes from ambient light, even if no fill light has been added. For example, light from the main source bounces off walls and other objects and collectively acts as a fill light. This is why shadows are never fully black and the actual amount of fill light is usually a little higher than that provided by your fill flash. However, studio lighting can still achieve very high contrast, such as in **FIGURE 8-26**, because ambient light can be more carefully controlled.

Overall, the most important fill light choices are location of the light and the fill ratio. You'll need to decide whether to place the fill near your camera's line of sight (on-axis) or off to the side (off-axis). On-axis fill is easier since you don't have to worry about how shadows appear, but off-axis fill provides more flexibility with placement and with control over the appearance of reflections.

You'll also need to consider the relative strength of your fill light compared to the main light. A good starting point is typically one part fill light for every two parts main light (a 1:2 ratio), but this also depends on where your fill light is located.

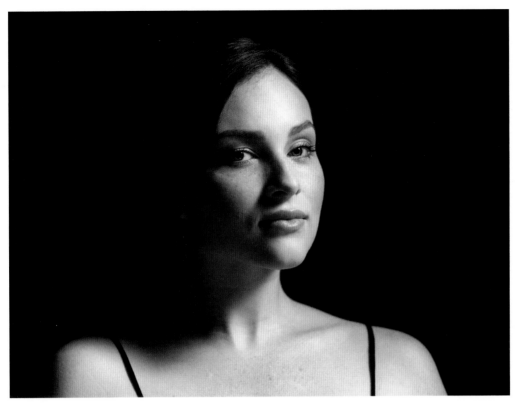

**FIGURE 8-26**
Low ambient light

## SUMMARY

This chapter reviewed the fundamentals of portrait lighting with one and two light sources. You learned why the distribution of light around your subject is key and that this distribution is controlled by the apparent size of your lights and their direction relative to the subject. You also learned that portraits are generally more pleasing with softer lighting, which you can enhance by diffusing, reflecting, or bouncing your light to effectively increase its size.

In the next chapter, we'll explore various tips and techniques to help you achieve better results with your photography.

# 9

# Other Shooting Techniques

**IN THIS FINAL CHAPTER,** you'll learn techniques for reducing camera shake with handheld shots and how to make the most of lighting when using a tripod is not possible. You'll also learn tips for using camera shutter speed creatively. Specifically, you'll learn to manipulate exposure settings to convey motion, freeze action, isolate subjects, and smooth water. Then you'll learn the inner workings of autofocus sensors to achieve more predictable results. Finally, you'll learn about composition and how to use the rule of thirds to improve your shots.

# REDUCING CAMERA SHAKE

Blurry photos can be a problem when you're taking handheld shots. The cause is *camera shake*, which is especially common for those of us who are unfortunate enough to have unsteady hands (see **FIGURE 9-1**). Although it cannot be eliminated entirely, there are steps you can take to greatly reduce its impact.

**FIGURE 9-1**
Blurry photo from camera shake (left), photo without camera shake (right)

Camera shake is more visible when your shutter speed is slow compared to the unintended motion of the camera. Therefore, you can reduce the impact of camera shake by either increasing the shutter speed or reducing camera motion. Many who are new to photography don't appreciate the importance of using fast shutter speeds or a tripod, but experienced photographers sometimes overestimate their impact. More often than not, it is your shooting technique—not high-end lenses or high megapixel cameras—that ultimately limits the resolution of a photograph.

While either increasing shutter speed or reducing camera motion can be a great help, the most effective solution is to take both into consideration. Even the steadiest hands cannot hold a camera perfectly stable during a several-second exposure, and fast shutter speeds are unlikely to perfectly freeze motion when a telephoto lens is held by a photographer with shaky hands. Also, increasing the shutter speed helps freeze a moving subject, whereas reducing camera motion does not.

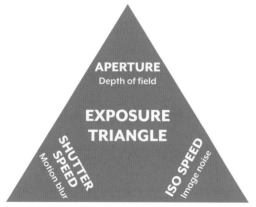

**FIGURE 9-2**
The exposure triangle from Chapter 1

## INCREASING SHUTTER SPEED

The three ways to increase your shutter speed are to optimize exposure settings, avoid unintentional overexposure, and improve the lighting.

- **Optimizing exposure settings** Make sure you're making the best tradeoffs with the camera exposure triangle (see **FIGURE 9-2**). Use the highest ISO speed and/or the lowest f-stop possible. Consider using a shallower depth of field to open the aperture and allow a faster shutter speed. If you use your camera in automatic mode, then it's likely already doing whatever it can to increase the shutter speed.

- **Avoiding unintentional overexposure** A common cause of blurred shots is the camera's metering system choosing a longer exposure time than is necessary. Dark subject matter and uneven light can trick your camera into overexposure.

- **Improving the lighting**  If you're using a compact camera with a built-in flash, try getting closer to your subject so that they'll be more brightly illuminated. If you're shooting people without a flash, try relocating the subject closer to the light source(s) or wait for the light to improve. If you're in a studio setting with controlled lighting, try including an additional light source.

After making the most of exposure, you may also need to employ techniques for holding the camera to further improve sharpness.

## IMPROVING YOUR HANDHELD TECHNIQUE

Although increasing the shutter speed is often the easiest technique to implement, how you take handheld photographs can often make a great difference. Methods for improving your handheld technique include bracing yourself and your camera, optimizing your camera grip, using better shutter-button technique, and taking multiple shots in rapid succession, as detailed next:

- **Bracing yourself and your camera**  Steadying yourself and your camera might include leaning up against a wall, kneeling or sitting, or using the viewfinder instead of the rear LCD—the camera gets braced against your face. Holding your camera directly against a wall or other object improves stability (see **FIGURE 9-3**). Try to have at least three points of contact between your body and the ground, wall, or other stable object. Always avoid situations where your position or equipment causes you to strain while taking the photograph. Make sure to stand in a position that leaves you relaxed and comfortable.

- **Optimizing your camera grip**  It's important to hold your camera firmly with both hands, but without straining (see **FIGURE 9-4**). When using long telephoto lenses, make sure to

◄ **FIGURE 9-3**
Photographer leaning against a wall to brace his camera

▲ **FIGURE 9-4**
It's important to hold your camera firmly but not tensely and to use both hands.

place one hand under the lens and the other on your camera. Make sure that your arms remain close to your body and in a comfortable position. Practice with using your camera can make your grip feel more natural and train your hands for the task. Make sure you keep yourself warm so you don't shiver and do have optimal sensation in your hands.

- **Using a better shutter-button technique**  Always try to press the shutter button halfway first, then gently press the button with no more pressure or speed than necessary. It can help to pay attention to breathing. Try taking a deep breath, exhaling halfway, then pressing the shutter button.

- **Taking multiple shots in rapid succession**  Often the very act of knowing you'll have to hold your hands steady can make it more difficult to do so. When shooting in short bursts—three images is likely enough—you'll likely find a difference in sharpness between each, as shown in **FIGURE 9-5**. In part, that is because you're less concerned about individual shots. Review these at full resolution by zooming in on the image either on your camera or in post-production, because differences often won't be as pronounced as the example here.

**FIGURE 9-5**
Significant blur (left), less blur (middle, the keeper), medium blur (right)

## OTHER TECHNIQUES AND EQUIPMENT ADVICE

Clearly, the best way to minimize handheld camera shake is not to hold your camera in the first place and use a tripod instead. See Chapter 4 for more about camera tripods to improve your tripod technique. To steady your shots without a tripod, you can set your camera on a surface to brace it, use image stabilization, and avoid using telephoto lenses.

- **Setting your camera on a firm surface to brace it**  Although setting your camera on a surface can produce sharper photos than using a tripod, it can also restrict composition. On the other hand, bracing can make for interesting perspectives because it encourages taking shots from angles other than eye level (see **FIGURE 9-6**).

  You can frame your shots by choosing an appropriate position on uneven ground or by placing your lens cap or another object underneath the camera body to position and level the shot. Make sure to use a *remote release* device to trigger your camera's shutter or set your camera to self-timer mode. With SLR cameras, using the *mirror lock-up (MLU)* setting can improve results if the option is available. The MLU setting helps ensure all vibrations caused by a flipping SLR mirror have time to die down before the exposure begins.

- **Using image stabilization**  Image stabilization comes in several variations based on manufacturer. It is abbreviated as IS (image stabilization), VR (vibration reduction), or SR (shake reduction). These features can greatly reduce the effect of camera movement, especially with telephoto lenses. Stabilization enables handheld shots at shutter speeds that are 5 to 10 times slower than otherwise possible. Although this can improve results, it cannot work miracles and usually works best in conjunction with a proper handheld technique.

- **Avoiding telephoto lenses**  Using a fancy image-stabilized lens isn't the only way to reduce the appearance of shake. Getting a little closer to your subject and using a wider angle lens will reduce the impact of shaky hands. It can also have the added benefit of creating a more interesting perspective. You can read more on lens selection in Chapter 3.

**FIGURE 9-6**
Example of a photograph taken by setting the camera on the ground and aiming using a lens cap

# USING SHUTTER SPEED CREATIVELY

A camera's shutter speed can control exposure, and it's one of the most powerful creative tools in photography. It can convey motion, freeze action, isolate subjects, and smooth water, among other abilities. This section describes how to achieve these various effects, in addition to hopefully stimulating other creative ideas for using shutter speed in everyday shots. For a background on how it factors into exposure, see Chapter 1 on camera exposure, which includes aperture, ISO, and shutter speed.

As you learned in Chapter 1, a camera's shutter is like a curtain that opens and lets in light to start the exposure, then closes to end it. A photo therefore doesn't just capture a moment in time but instead represents an average of light over the time frame of an exposure. *Shutter speed* is used to describe this duration.

Whenever a scene contains moving subjects, the choice of shutter speed determines what will appear frozen and what will be blurred, like in **FIGURE 9-7**. However, you cannot change the shutter speed in isolation, at least not without also affecting the exposure or image quality. If your goal is minimizing image blur caused by camera movement, you therefore might want to first try the techniques for reducing camera shake, as described in the previous section.

The combinations of ISO speed and f-number/aperture in **TABLE 9-1** enable an amazingly broad range of shutter speeds. Regardless of the combination, more light permits faster shutter speeds, whereas less light permits slower shutter speeds.

For a given exposure, SLR cameras typically have a much greater range of shutter speeds than smaller cameras. The range is roughly 13–14 stops (or 10,000×) with most SLR cameras but is often closer to 9–10 stops (or 1,000×) with compact cameras or smartphones. See Chapter 4 for more information on comparisons between camera types.

 **TECHNICAL NOTE**

At very short exposure times (typically 1/500 second or faster), the shutter mechanism works more like a moving slit than a curtain. In that case, the shutter speed instead represents the amount of time that each region of the sensor is exposed to light, not the total duration of its exposure to light.

**FIGURE 9-7**
Slow shutter speed (left), fast shutter speed (right)

**TABLE 9-1** Adverse Effects of Fast and Slow Shutter Speeds

|  | CAMERA SETTINGS | ADVERSE SIDE EFFECTS |
|---|---|---|
| **FASTER SHUTTER SPEEDS** | Higher ISO speed | Increased image noise |
|  | Lower f-number | Shallower depth of field |
| **SLOWER SHUTTER SPEEDS** | Lower ISO speed | Reduced handheld-ability |
|  | Higher f-number | Decreased sharpness* |

*Note that the decrease in sharpness occurs only if the f-number increases so much that it causes visible diffraction.

## CONVEYING MOTION

Although some might see still photography as restrictive for conveying motion, many see it as liberating because still capture often allows more control over how motion is conveyed. For instance, a subject in motion can be rendered as an unrecognizable streak, a more defined blur, or a sharp image with everything else blurred (as in **FIGURE 9-8**). These choices are all under the photographer's control.

**FIGURE 9-8**
Controlling the feel of the subject's motion by allowing blur

Achieving the intended amount of blur can be difficult. For a given shutter speed, three subject traits determine how blurred the result will appear:

- **Speed of the subject**  Subjects that are moving faster will generally appear more blurred. This is perhaps the most obvious of the three traits.

- **Direction of motion**  Subjects that are moving toward or away from the camera usually won't become as blurred as those moving across the frame, even if both subjects are moving at the same speed.

- **Magnification**  A given subject will appear more blurred if it occupies a greater percentage of your image frame. This is perhaps the least obvious, but is most easily controlled, because subject magnification is the combined effect of focal length and subject distance, where closer subjects and longer focal lengths (greater zoom) increase magnification.

 **TECHNICAL NOTE**

The display size of your LED screen can be important. Blur that appears acceptable on the small screen size may appear too pronounced on large screens or prints.

Developing intuition for what shutter speeds to use in different scenarios can be difficult, but plenty of experimentation will help you on your way.

A slow shutter speed can emphasize a stationary subject. For example, a person standing still among a bustling crowd will stand out from the surrounding motion. Similarly, using a moving train as a background when the shutter speed is slowed to about 1/10 to 1/2 second can emphasize the subject against a moving background, as shown in **FIGURE 9-9**.

**FIGURE 9-9**
A 1/6-second handheld photo of a statue in front of a moving train

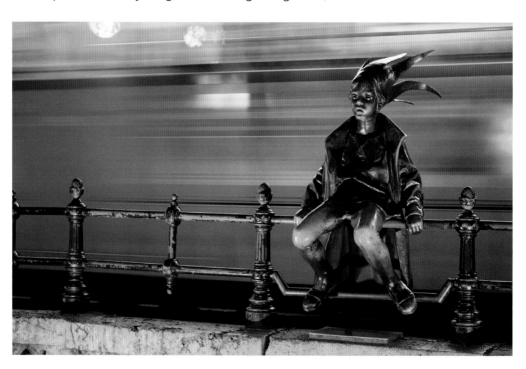

A specific but common application of using shutter speed to convey motion is capturing moving water (see **FIGURE 9-10**). Shutter speeds of around 1/2 second or longer can make waterfalls appear silky or make waves look like a surreal, low-lying mist.

In the example in **FIGURE 9-10**, freezing the motion of splashing water required a shutter speed of 1/400 second. Because this is a wide-angle photo, a faster shutter speed could have achieved a similar look if the camera were instead zoomed in to just a portion of the waterfall.

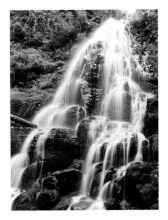 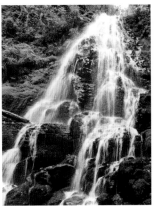  

| 1/2 second | 1/10 second | 1/30 second | 1/400 second |

**FIGURE 9-10**
The effect of shutter speed on rendering water in motion

## MOVING WITH THE SUBJECT

Depending on the subject, you can move with the subject to keep it in focus while rendering everything else blurred. This requires the camera either to be located on the moving subject or to follow the moving subject, which is known as *panning*.

Taking a photo from a moving car, an amusement park ride (safety first!), or another moving object can create interesting effects, as you can see in **FIGURE 9-11**.

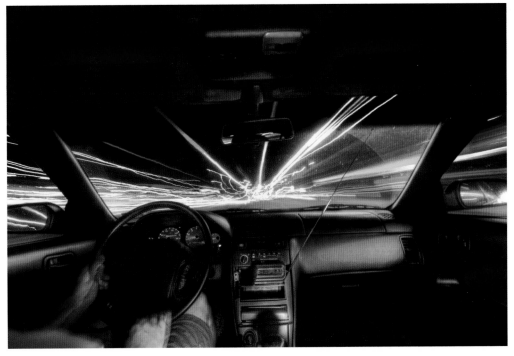

**FIGURE 9-11**
Taken from a moving car at night with a shutter speed of 15 seconds (photo courtesy of Dan DeChiaro at *www .flickr.com/photos/ dandechiaro*)

The required shutter speed will depend on the speed of motion in addition to the stability of the moving object. Somewhere around 1/30 of a second is a good starting point. You can then adjust accordingly after viewing the results on your camera's screen.

The panning technique doesn't mean that the camera has to travel at the same speed as the subject. It just means that the image frame has to track the motion. Even fast subjects can be captured by slowly pivoting the camera, especially if the subject is far away and you're using a telephoto lens.

To pan, follow your subject in a smooth motion and press the shutter button—all in one continuous motion.

**FIGURE 9-12**
A lens with additional stabilizing modes

A successful panning shot will use a shutter speed just slow enough to cause the background to streak, but fast enough so that the subject appears sharp. This can be tricky to achieve. Experiment and take more shots than you would for still subjects. Achieving longer streaks produces a much more dramatic effect, but is also more challenging to achieve while maintaining a sharp subject. Using an image-stabilized lens that has *one-axis stabilization*, as shown in **FIGURE 9-12**, or a tripod with a pan-tilt head, can help you achieve this dramatic effect.

Panning requires a textured background that isn't completely out of focus; otherwise, the background streaks will be less visible. Subject backgrounds that are closer will appear to streak more for a given shutter speed and panning rate.

 **TECHNICAL NOTE**

Figure 9-12 shows a Canon lens with "mode 2" IS, which uses one-axis stabilization that is designed for panning. Nikon lenses with vibration reduction (VR) automatically switch to panning mode when the lens motion is in one direction.

A benefit to panning is that it permits slower shutter speeds than would otherwise be needed to capture a sharp subject. For example, available light might only permit a shutter speed of 1/50 second—which might be insufficient to render a particular moving subject as sharp without panning. With panning, this 1/50-of-a-second shutter speed might be fast enough to make the subject appear sharp.

## FREEZING HIGH-SPEED MOTION

High-speed photography is capable of new and exciting representations of subjects in motion. Examples include water droplets, wildlife in motion, and moments in sports—among many other opportunities. **FIGURE 9-13** shows one such example of high-speed photography.

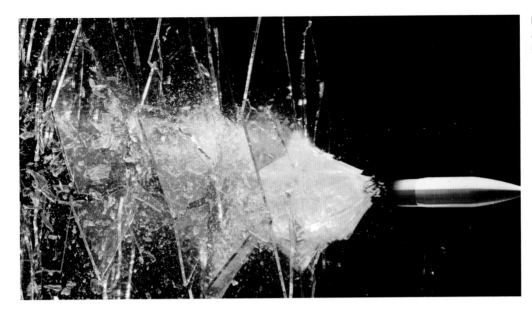

**FIGURE 9-13**
An example of high-speed photography

Capturing fast-moving subjects can be challenging. Anticipating when your subject will be in the desired position is important because shutter speeds faster than 1/5 second are faster than our own reaction time. Waiting and pressing the shutter button when the subject is perfectly as you want it will cause you to miss the moment.

To make matters worse, many cameras have a delay between when the shutter button is pressed and the exposure begins. This is known as *shutter lag*. With SLR cameras, this may be just 1/10 to 1/20 second, but with other cameras, this can be as high as 1/2 second. These lag times are in addition to the time that it takes your camera to autofocus. *Pre-focusing* on or near your expected subject location can greatly reduce shutter lag. The pre-focusing technique works by pressing the shutter button halfway while aiming at an object at a similar distance to your anticipated subject location, then pressing the shutter fully to initiate the exposure only once your subject is nearing its desired location. Some photographers may even also turn off autofocus once they have pre-focused to further minimize shutter lag. For more on pre-focusing, see the section "Understanding Autofocus" on page 196.

Sharp, high-speed photos require you to be attentive to variations in subject motion, potentially timing the shot to coincide with a relative pause in the action. For example, try to time your shot for when the subject is at their highest point in a jump or when they are changing directions. At these points, they are moving the slowest. Even with proper timing, you might be better off setting your camera to *continuous shot mode* (or an equivalent setting). This will let you capture a burst of images while you hold down the shutter button, thereby increasing the chances of capturing the right moment. Another option would be to use a specialized camera device that's designed to trigger the shutter with specific events, such as a loud sound or subject motion.

**TECHNICAL NOTE**

Just because a subject is moving at a given speed doesn't mean that portions of the subject might not be moving even faster. For example, the arms and legs of a runner might be moving much faster than the body. The *subject speed* refers to the speed in the direction across your frame (side to side). You can typically get away with a 4× slower shutter speed for subjects moving directly toward or away from you and a 2× slower shutter speed for subjects moving toward or away from you at an angle.

Knowing which shutter speed to choose to capture motion takes practice. Most cameras are only capable of maximum shutter speeds up to 1/2000 to 1/8000 second. If you need a shutter speed exceeding the capabilities of your camera, your other options are to try panning with the subject to offset some of their motion and to use flash photography.

## ZOOMING BLUR

Another interesting technique is to change the zoom during the exposure, often called a *zoom burst*. You can achieve this look by setting your camera on a tripod, by using a shutter speed of 1/15 to 1/2 second, or by zooming while not moving the camera. You can try zooming during part of the exposure to lessen the blurring effect, as you can see in **FIGURE 9-14**.

Zooming causes radial blur, mostly near the edges of the frame, with the center appearing more or less unblurred. The effect can be used to draw attention to a subject at the center of the frame or to make the viewers feel as though they're moving rapidly.

**FIGURE 9-14**
An example of a zoom burst (photo courtesy of Jeremy Vandel at *www.flickr.com/photos/jeremy_vandel*)

The zoom burst technique is usually only possible with SLR cameras, but may be possible with other cameras that have manual zoom capabilities. Zoom burst can also be replicated using still photos and post-processing filters, such as Photoshop's radial blur filter.

## ADDING ARTISTIC EFFECTS

Sometimes photographers will intentionally add camera shake to induce blur and give their image a unique and artistic effect, as in **Figures 9-15** and **9-16**.

You typically need to use shutter speeds of 1/30 to 1/2 second or more. This is just beyond the limit of sharp handheld shots, but not so long that the subject will become smoothed out entirely. Predicting the result can be difficult, so these types of shots often require many attempts using different shutter speeds before you are able to achieve the desired look. Some painted effects are easier to achieve with filters in Photoshop or other editing software than in the camera.

◀ **Figure 9-15**
Artistic painted effect using vertical blurring

▲ **Figure 9-16**
Abstract blurred light effect

## ADDITIONAL NOTES ON SHUTTER SPEED

So far, you've seen several creative ways of using shutter speed. However, the amount of light may prevent you from selecting the desired shutter speed, even after all combinations of ISO speed and aperture have been considered.

To allow for faster shutter speeds, you can try switching to a lens with a larger maximum aperture, or you can add more light to the scene by changing the shooting location or using a flash. To use slower shutter speeds, you can block some of the light by using a neutral density (ND) filter or a polarizing filter, or can use the image-averaging technique, as you learned in Chapter 5, to create a longer effective exposure.

Key points to remember are knowing when to use shutter priority mode and how to avoid unintentional camera shake. Shutter priority mode can be a useful tool when the appearance of motion is more important than depth of field or just to let you know if

your desired shutter speed is even possible using the available light. It allows you to pick a desired shutter speed and then lets the camera's metering choose an aperture (and possibly ISO speed) that will achieve the correct exposure.

# UNDERSTANDING AUTOFOCUS

A camera's autofocus system adjusts the camera lens to focus on the subject and can mean the difference between a sharp photo and a missed opportunity. Despite a seemingly simple goal—sharpness at the focus point—the inner workings of how a camera focuses are not simple. Knowing how autofocus works enables you to both make the most of its assets and avoid its shortcomings.

Autofocus (AF) works either by using contrast sensors within the camera (known as *passive AF*) or by emitting a signal to illuminate or estimate the distance to the subject (known as *active AF*). Passive AF can use either contrast detection or phase detection methods. Both rely on contrast for achieving accurate autofocus.

> **TECHNICAL NOTE**
>
> Autofocus technology is always changing, so your camera's implementation may differ from the exact description in this section. The recommendations still apply to the focusing technique.

## HOW AUTOFOCUS SENSORS WORK

**FIGURE 9-17**
Example of increasing contrast at the focal point as the subject comes into focus

A camera's autofocus sensor(s) are the real engine behind achieving accurate focus. The sensors are overlaid in various arrays across your image's field of view. Each sensor measures relative focus by assessing changes in contrast at its respective position in the image. Maximal contrast is assumed to correspond with maximal sharpness, as shown in **FIGURE 9-17**.

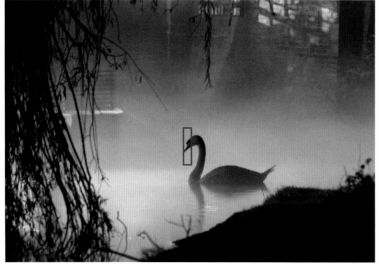

The process of autofocusing generally works as follows:

1. An autofocus processor (AFP) makes a small change in the focusing distance.

2. The AFP reads the AF sensor to assess whether focus has improved and by how much.

3. Using the information from the second step, the AFP sets the lens to a new focusing distance.

4. The AFP may repeat the second and third steps until satisfactory focus has been achieved.

This process is usually completed within a fraction of a second. For difficult subjects, the camera may fail to achieve satisfactory focus and will give up on repeating the preceding sequence, resulting in failed autofocus. This is the dreaded "focus-hunting" scenario where the camera focuses back and forth repeatedly without achieving a focus lock. This does not mean that focus is not possible for the chosen subject, however, and it may be possible to improve performance.

## IMPROVING AUTOFOCUS PERFORMANCE

The subject matter you are shooting can have an enormous impact on how well your camera's autofocus performs—often even more so than variation between camera models, lenses, or focus settings. The three most important factors influencing autofocus are the light level, subject contrast, and camera or subject motion. Each factor can be used to offset deficiencies in another factor; you may be able to achieve autofocus even for a fast-moving subject if that same subject is well lit, for example. However, your autofocus technique can also improve focus accuracy regardless of these three factors. Because contrast can also vary within a subject, where you choose to locate autofocus plays a key role in the resulting image. Selecting a sharp edge or pronounced texture to focus on can improve autofocus performance dramatically.

**FIGURE 9-18** highlights potential autofocus locations that are all at the same focusing distance but that achieve substantially different results. With this image, fortunately the location where autofocus performs best happens to also correspond with the subject's face.

**FIGURE 9-19** is more problematic because autofocus performs best on the background, not the subject.

If you focused on the fast-moving light sources behind the subject, you would risk an out-of-focus image due to the speed of those light sources. Furthermore, even if focus could be achieved on those light sources, you would also risk having the image appear back-focused because the depth of field is shallow (because a wide aperture is

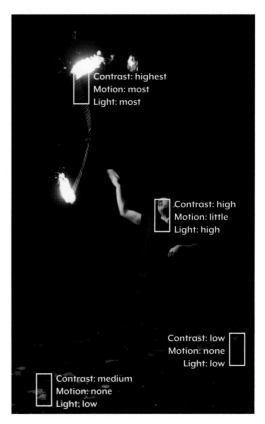

**FIGURE 9-18**
Less motion, high contrast, and strong lighting result in the best autofocus choice for this image

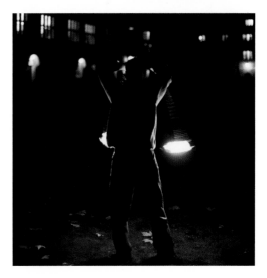

**FIGURE 9-19**
Example of a backlit subject that would be challenging for autofocus because it lacks a statically lit foreground

required to achieve a sufficiently fast shutter speed under dim lighting). Alternatively, focusing on the subject's brighter outline would perhaps be the best approach, with the caveat that the highlight is rapidly changing position and intensity, depending on the location of the moving light sources.

If your camera had difficulty focusing on the subject's bright outline, you might choose a lower contrast but stationary and reasonably well-lit area to focus on. A possible focus point would be the subject's foot or the leaves on the ground at the same distance from the camera as the subject.

These decisions often have to be anticipated or made within a fraction of a second without the convenience of lengthy analysis. Additional techniques for autofocusing on still and moving subjects are provided later in this discussion.

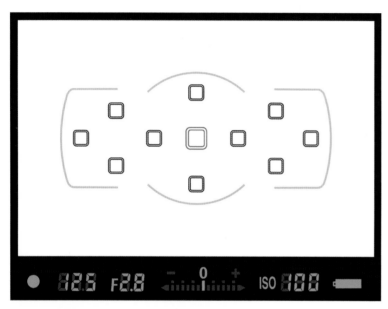

**FIGURE 9-20**
Sample autofocus locations as they might appear in your camera's viewfinder

## NUMBER AND TYPE OF AUTOFOCUS POINTS

The robustness and flexibility of autofocus is primarily a result of the number, position, and type of autofocus points in a given camera model (see **FIGURE 9-20**). High-end SLR cameras can have 45 or more AF points, whereas other cameras can have as few as one central AF point. Three sample layouts of autofocus sensors are shown in **FIGURE 9-21**.

For SLR cameras, the number and accuracy of autofocus points can change depending on the maximum aperture of the lens being used. This is an important consideration when choosing a camera lens. Even if you do not plan on using a lens at its maximum aperture, it can still help the camera achieve better focus accuracy because the maximum aperture is always what drives autofocus prior to an exposure. Because the central AF sensor is almost always the most accurate, if your subject is off-center, it is often better to achieve focus lock by pointing the lens directly at the subject before recomposing the frame.

Multiple AF points can work together for improved reliability, or they can work in isolation for improved specificity. Your camera settings often control how this works without you knowing. For example, some cameras have an "auto depth of field" feature that ensures a cluster of focus points are all within an acceptable level of focus, which can be handy for group photos. Alternatively, your camera may use multiple autofocus points to better track a moving subject, as described in the next section.

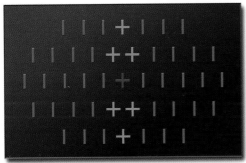

High-end SLR at f/2.8

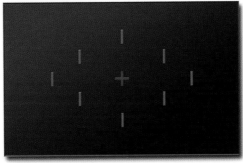

Entry to mid-range SLR at f/2.8

**Figure 9-21**
Three layouts of auto-focus sensor types for different apertures

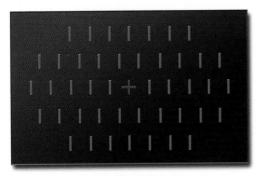

High-end SLR at f/4.0

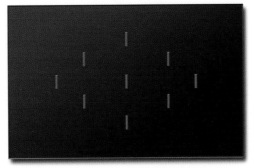

Entry to mid-range SLR at f/4.0

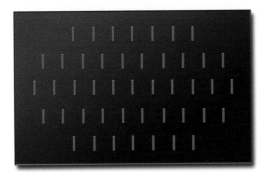

High-end SLR at f/5.6

Entry to mid-range SLR at f/5.6

## COMPARING AF MODES

The most widely supported camera focus mode is *one-shot focusing*, which is best for stationary subjects. The one-shot mode is susceptible to focus errors with fast-moving subjects because it requires focus lock before a photo can be taken and does not anticipate subject motion. One-shot focusing may also make it difficult to visualize a moving subject in the viewfinder because focus is not maintained while you hold the shutter button halfway.

Many cameras support an autofocus mode that continually adjusts the focus distance. Canon cameras refer to this as *AI Servo focusing*, whereas Sony and Nikon cameras refer to this as *continuous focusing*. It is intended for moving subjects and works by predicting where the subject will be in the future based on estimates from previous focus distances. The camera focuses at predicted distances in advance to account for the shutter lag (the delay between pressing the shutter button and the start of the exposure). This greatly increases the probability of correct focus for moving subjects.

**FIGURE 9-22** shows a graph of tracking speed versus distance, assuming that the subject is oncoming or receding. Here, sample values are for ideal contrast and lighting, using the Canon 300 mm f/2.8 IS L lens.

**FIGURE 9-22**
Blue and red lines represent the max tracking speed versus the subject's distance with high-end and mid-range cameras, respectively.

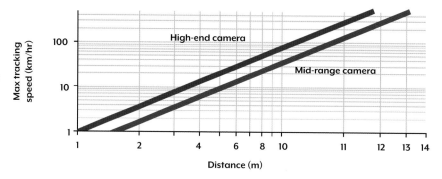

The figure shows that the greater the subject distance, the higher the max tracking speed. The blue line is above the red line because the high-end camera can track a faster subject at the same distance as the mid-range camera. The plot provides a rule-of-thumb estimate for other cameras as well, although the key takeaway is that the faster your subject is moving, the farther they will need to be for accurate autofocus. Actual maximum tracking speeds also depend on how erratically the subject is moving, the subject contrast and lighting, the type of lens, and the number of autofocus sensors being used to track the subject. Be aware that using focus tracking can dramatically reduce the battery life of your camera, so use it only when necessary.

## AUTOFOCUS ASSIST BEAM

Many cameras come equipped with an *AF assist beam*, a type of active autofocus that uses a visible or infrared beam to help the autofocus sensors detect the subject. This works by temporarily illuminating the subject prior to the exposure in order to achieve focus lock, then deactivating the illumination once the exposure begins. The AF assist beam can be very helpful in situations where your subject is not adequately lit or has insufficient contrast for autofocus, but it can also reduce the autofocus speed.

Some cameras use a built-in infrared light source for the AF assist, whereas digital SLR cameras often use either a built-in or external flash. When a flash is used, the AF assist beam might have trouble achieving focus lock if the subject moves a lot between flash firings. Use of the AF assist beam is therefore only recommended with still subjects.

## BEST PRACTICE FOR AUTOFOCUS IN ACTION PHOTOS

Autofocus will almost always perform best with action photos when the AI Servo or continuous focusing mode is used. Focusing performance can be improved dramatically by ensuring that the lens does not have to search over a large range of focus distances.

The best way of achieving quick focus lock is to pre-focus your camera where you anticipate the subject will be. In **FIGURE 9-23**, you could pre-focus on the side of the road because it is close to where you expect the biker to pass by.

Some SLR lenses have a minimum focus distance switch. Setting this to the greatest distance possible (assuming the subject will never be closer) can improve performance because it restricts the range of distance over which your camera searches for focus.

Continuous autofocus mode shots can still be taken even if focus lock has not been achieved.

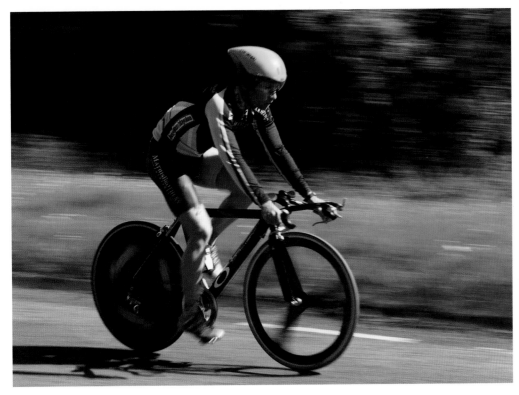

**FIGURE 9-23**
Pre-focusing on the edge of the road and anticipating movement help achieve this capture.

## BEST PRACTICE FOR PORTRAITS AND OTHER STILL PHOTOS

It is best to take photos of stationary subjects using the one-shot autofocus mode. This will ensure that focus lock has been achieved before the exposure. The usual focus point requirements of contrast and strong lighting still apply, although you need to ensure your subject is relatively still.

Accurate focus is especially important for portraits, which typically have a shallow depth of field. The eye is usually the best focus point, both because this is an artistic standard and because it has good contrast. Thankfully, many modern cameras have advanced focus algorithms that specifically identify a person's head or eyes and automatically use them for autofocus. This focusing feature is usually indicated by a box that appears around a subject's head when you press the shutter button halfway while taking a group photo or portrait.

Although the central autofocus sensor is usually most sensitive, more accurate subject distance estimation is achieved using the off-center focus points for off-center subjects. This is because the focus distance will always be behind the subject if you first use the central AF point and then recompose. The error increases as the subject gets closer and is more apparent with a shallow depth of field.

Because the most common type of AF sensor is the vertical line sensor, focus may be more accurate when your focus point contains primarily vertical contrast. In low-light conditions, you may be able to achieve a focus lock not otherwise possible by rotating the camera 90 degrees during autofocus if your subject matter is primarily composed of horizontal contrast.

In **FIGURE 9-24**, the stairs are composed primarily of horizontal lines, which means that most of the contrast is in the vertical direction.

If your camera does not have cross-type AF sensors, achieving a focus lock in portrait orientation may be challenging with the image in **FIGURE 9-24**. If you wanted to focus near the back of the set of stairs in the foreground, you could improve your chances of achieving focus lock by first rotating your camera in landscape orientation during autofocus and then rotating back to portrait orientation for the exposure. This situation is unlikely to be encountered in typical photography, but it highlights a key weakness of cameras without cross-type AF sensors.

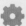 **TECHNICAL NOTE**

For further reading on where to focus rather than how, see "Understanding Depth of Field" on page 14.

# UNDERSTANDING COMPOSITION

The rule of thirds is a powerful composition technique for making photos more interesting and dynamic. It's also one of the most well-known. We'll use examples to demonstrate why the rule works, when it's okay to break the rule, and how to make the most of it to improve your photography.

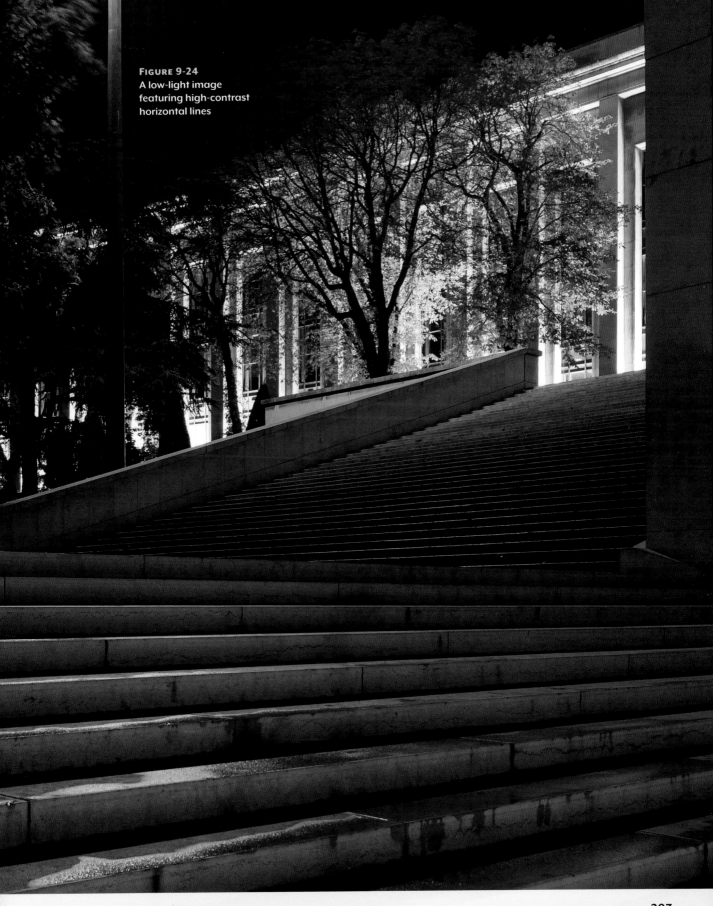

**FIGURE 9-24**
A low-light image featuring high-contrast horizontal lines

## THE RULE OF THIRDS

The *rule of thirds* states than an image is most pleasing when subjects are composed along imaginary lines that divide the image into thirds vertically and horizontally, as demonstrated in **FIGURE 9-25**.

It is actually quite amazing that a rule so mathematical can be applied to something as varied and subjective as a photograph. But it works, and surprisingly well.

The rule of thirds is all about creating the right aesthetic tradeoffs. It often creates a sense of balance, without making the image appear too static, and a sense of complexity, without making the image look too busy.

In **FIGURE 9-26**, note that the tallest rock formation (a tufa) aligns with the right third of the image and how the horizon aligns with the top third.

The darker foreground tufa also aligns with both the bottom and left thirds of the photo. Even in an apparently abstract photo, there can still be a reasonable amount of order and organization.

The "rule" is really just a guideline: you don't need to worry about perfectly aligning everything with the thirds of an image. What's usually most important is that your main subject or region isn't always in the direct middle of the photograph. For landscapes, this usually means having the horizon align with the upper or lower third of the image. For subjects, this usually means photographing them to either side of the photo. This can make landscape compositions much more dynamic and give subjects a sense of direction.

For example, in **FIGURE 9-27**, the biker was placed along the left third because he was traveling to the right.

◀ **FIGURE 9-26**
Composition by rule of thirds

▲ **FIGURE 9-27**
Off-center subjects can create a sense of direction

## IMPROVING EXISTING PHOTOS BY CROPPING

It is often quite amazing how you can resurrect an old photo and give it new life by doing something as simple as cropping it, as demonstrated in **Figures 9-28** and **9-29**.

In the seascape example in **Figure 9-29**, part of the empty sky was cropped so that the horizon aligns with the upper third of the image, thus adding emphasis to the foreground and mountains.

If there's nothing in the image to apply the rule of thirds to, it would be an extremely abstract composition. However, the spirit of the rule may still apply in order to give the photo a sense of balance without making the subject appear too static and unchanging.

◄ **Figure 9-28**
Uncropped original

▼ **Figure 9-29**
Cropped version

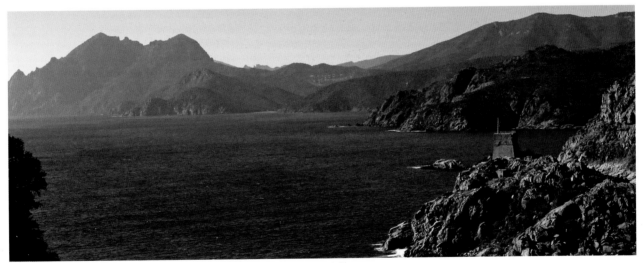

In the example in **FIGURE 9-30**, it isn't immediately apparent what can be aligned with the "thirds." In this composition, the C-shaped region of light is aligned to the left third. The image is brighter to the left compared to the right, effectively creating an off-center composition and balance.

**FIGURE 9-30**
Working with an abstract composition

## BREAKING THE RULE OF THIRDS

The free-spirited, creative artist in you probably feels a bit cramped by the seeming rigidity of the rule of thirds. However, all rules are bound to be broken—and this one's no exception. It's acceptable to break the rule, as long as it is for a good cause.

A central tenet of the rule of thirds is that it's not ideal to place a subject in the center of a photograph. But this doesn't work as well if you want to emphasize a subject's symmetry. The example in **FIGURE 9-31** does just that.

There are many other situations where it might be better to ignore the rule of thirds than to use it. You might want to make your subject look more confrontational by placing them in the center of the image, for example. Alternatively, you might want to knock things out of balance by shifting your framing relative to where you'd expect it based on the rule of thirds.

It's important to ask yourself what is special about the subject and what you want to emphasize. Defining the mood you want to convey can often be facilitated by using the rule of thirds. If it helps you achieve any of these goals, then use it. If not, then don't let it get in the way of your composition.

**FIGURE 9-31**
Example of beneficial symmetry

# SUMMARY

In this final chapter, you learned a variety of tips and techniques for controlling your camera and improving image quality. You first learned how to reduce camera shake, which can often matter more than using high-end lenses or a high-megapixel camera. Then you learned how to think about your exposures more creatively by using shutter speed to control the appearance of motion, including various effects ranging from freezing action to smoothing water to creating motion streaks from panning. You also learned how autofocus works and how its performance is influenced by light level, subject contrast, and camera or subject motion.

# Cleaning Camera Sensors

**IF YOU'RE USING AN SLR CAMERA,** you'll eventually encounter spots in your images. When this happens, you need to know if what you're seeing is from sensor dust or the result of a dirty viewfinder, mirror, or lens. If it turns out to be dust on the sensor, you need to know how to clean the sensor and how to minimize the risk of this happening again.

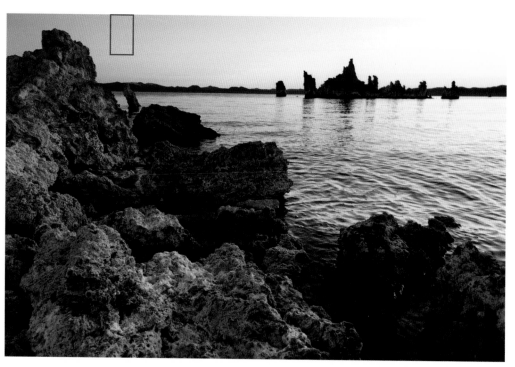

A dirty camera sensor is most apparent in smooth, light regions of images, such as bright skies, as shown in **Figures 1** and **2**.

The appearance can change, depending on the nature of the dust, image content, and exposure settings, but will likely look similar to the example in **Figure 2**. Even if dust isn't immediately apparent, it can reduce image quality by decreasing contrast. In **Figure 2**, some of the spots are less pronounced than the others.

The dust spots appear diffuse because the particles themselves aren't actually sitting on the camera sensor's photosites; the particles are resting slightly above the sensor on the outermost surface of the sensor's filters. This causes the particle to cast a shadow, which is what we're actually seeing in the image—not the dust itself. At wide apertures (lower f-numbers), the dust is often barely visible because the incoming light (shown as orange arrows in **Figures 3** through **5**) hits the dust from a wide range of angles, which as you recall from Chapter 8 creates "soft" lighting. Similarly, at narrow apertures (higher f-numbers), the dust becomes more visible because the lighting effectively becomes "harder."

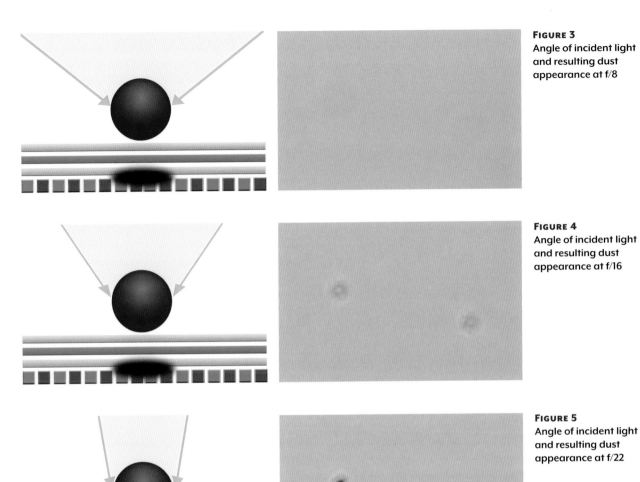

**Figure 3**
Angle of incident light
and resulting dust
appearance at f/8

**Figure 4**
Angle of incident light
and resulting dust
appearance at f/16

**Figure 5**
Angle of incident light
and resulting dust
appearance at f/22

# OTHER POTENTIAL DUST REPOSITORIES

Just because you see spots in your viewfinder and/or images doesn't necessarily mean you need to clean your camera sensor. Other potential dust repositories include the viewfinder, viewfinder focusing screen, SLR mirror, and front and rear of the lens.

## VIEWFINDER-FOCUSING SCREEN AND SLR MIRROR

This type of dust is clearly visible on surfaces in the viewfinder (see **FIGURES 6** and **7**) and doesn't alter the image file. If you look through your viewfinder and change the f-stop (for example, hold the depth of field preview button), viewfinder dust will appear the same size, regardless of the f-stop.

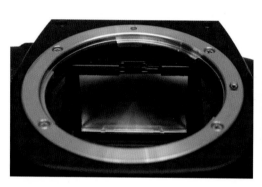

**FIGURE 6**
SLR camera-focusing screen

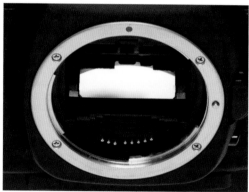

**FIGURE 7**
SLR camera mirror

## FRONT OR REAR OF YOUR LENS

Dust on a lens is tricky to diagnose because spots on your lens may impact your image and be mistaken for dust on the sensor. If you change your camera lens (see **FIGURES 8** and **9**) and the spots remain, they are probably from the sensor. Lens dust generally appears larger and more diffuse than sensor dust, and it is usually only visible with wide-angle lenses at high f-stops (near f/22+).

Dust on the front or rear lens element will become more apparent when you aim your camera at a clear sky or light-colored wall. If this isn't the case and you're still seeing spots in your images, it is safe to assume that the dust is on your camera's sensor.

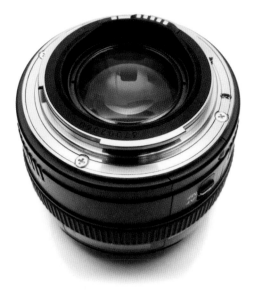

**FIGURE 8**
Lens rear element

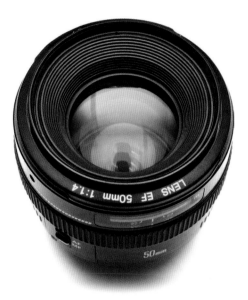

**FIGURE 9**
Lens front element

# HOW TO LOCATE SENSOR DUST

Although sensor dust is never ideal, sometimes it's helpful to know just how dirty the sensor really is. If there are more spots than you thought and these are near the middle of the frame, they are more likely to affect your images. Some dust is often acceptable when weighed against the risk of scratching your sensor or SLR mirror during the cleaning process.

The easiest way to assess the severity of the dust on your sensor is by following these steps:

1.  Aim your camera at a smooth, light background (such as a white wall).

2.  Defocus the lens so the background appears smooth and textureless.

3.  Apply a +1 or +2 stop exposure compensation.

4.  Take a photo at your lens's highest f-stop setting.

The resulting image provides an excellent map of sensor dust, as shown in **FIGURE 10** (note that the image contrast has been exaggerated to highlight dust spots). To see the dust better, you can use post-processing. For example, in Photoshop, you can increase the image's contrast using "auto levels" or drag the black point slider of the levels tool to the right while holding the ALT key. Be aware that your dust map is reversed compared to the position of the dust on the sensor. For example, spots at the top of the image are created by dust at the bottom of the sensor, and vice versa.

**FIGURE 10**
Example of a sensor dust map

# BEST PRACTICES FOR KEEPING YOUR SENSOR CLEAN

The old saying "an ounce of prevention is worth a pound of cure" certainly applies to camera sensor dust. If you're extra careful and minimize potentially contaminating events, you'll require fewer sensor cleanings over the lifetime of your camera.

Techniques for minimizing dust deposits in your camera include:

**FIGURE 11**
Example of a self-clean menu

- **Lens changes** Try to avoid unnecessarily changing out lenses, and when you must change out lenses, do so in an environment with clean, still air, if possible. Be sure to change out lenses quickly and to face the camera sensor sideways or downward during the lens change to reduce the chance of dust settling. Use covers for the rear element of your lenses when they're not mounted (see **FIGURE 8** for uncovered rear element) to avoid dust collecting on the lens: any dust collected on the rear element may later transfer to the sensor when the lens is mounted.

- **Self-cleaning sensors** If you're fortunate enough to have a digital SLR camera that automatically cleans the sensor every time the camera is turned on or off (as depicted in the menu in **FIGURE 11**), you'll find the process a lot easier. This feature is surprisingly effective and decreases how often you have to physically clean the sensor, but it will not remove all types of dust. Particulates accumulate in the camera body, thus increasing the risk of them landing on the sensor over time.

# SENSOR-CLEANING METHODS

A camera sensor should only be cleaned when absolutely necessary, because cleaning carries a risk of damaging the sensor or SLR mirror.

 **TECHNICAL NOTE**

Strictly speaking, only the outermost layer of the filter that covers the sensor is what actually gets cleaned, not the sensor itself. Replacing this filter is much less expensive than replacing a sensor. The camera can usually be repaired by the manufacturer.

Cleaning a camera's sensor, shown in **Figure 12**, is risky because it requires flipping up the SLR mirror to give open access to the sensor. What's more, if the camera's battery dies before cleaning is complete, the mirror can shut onto your hand and/or cleaning apparatus, potentially damaging the mirror in the process. In addition, direct contact with the sensor can introduce new contaminants and drag existing dust across the sensor's surface, creating micro-abrasions or scratches.

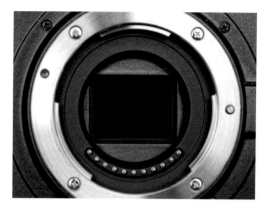

In consideration of the risks, if you do decide that your sensor needs cleaning, how aggressively you clean should fit the severity of the problem. Listed in order of increasing effectiveness (and increasing risk), the most common types of cleaning devices include a dust blower, sensor brush (sweep), a cleaning stamp or lens pen, and a sensor swab (wipe or wand).

**Figure 12**
SLR camera sensor

- **Dust blower**  This cleaning method carries the least risk of damage because the blower (shown in **Figure 13**) never comes into direct contact with the sensor. This method is also the least effective. Blowing dust may just move it around and can potentially make the problem worse. Only use a blower specifically designed for camera sensors. Compressed air blowers are unnecessary and generally emit air at too high a pressure. Some compressed air blowers also use a damaging coolant liquid, so those not specifically designed for optics should be avoided.

**Figure 13**
A cleaning bulb or dust blower

- **Cleaning brush or sweep**  A lens brush (shown in **Figure 14**) is a good compromise between risk and effectiveness. It can often remove all but the most stubborn dust, and it generally has little risk of scratching surfaces because the brush is designed to make light contact. Some designs can remove individual particles without sweeping over the whole sensor. An added bonus to these cleaning devices is that you can use a sensor brush to remove dust from your SLR mirror, lenses, and focusing screen. Avoid inadvertent contact with either the mirror or focusing screen and clean only when the battery is well charged.

- **Cleaning stamp or lens pen**  A cleaning stamp (shown in **Figure 15**) makes contact with the sensor, but it isn't dragged across the sensor surface. Because it lifts rather than drags dust and dirt, it is less likely to scratch surfaces. The tip usually consists of deformable silicone, which is pressed onto the sensor's surface to mold around particulates, hold onto them, and lift them from the surface. It is a good idea to avoid using products that work by using an adhesive, as this can potentially leave a residue on the sensor.

**Figure 14**
Lens brush or sweep

**Figure 15**
Lens pen or cleaning stamp

- **Sensor swab, wipe, or wand** Swabs, wipes, and wands can remove even the most enduring particles, but these require a careful technique. As you can see in **FIGURE 16**, the device usually consists of a small, flat-edged paddle that is wrapped in a special lint-free tissue that has sensor-cleaning fluid applied. Make sure to get one with a width that's appropriate for your sensor size (cropped sensors generally need a narrower swab than full-frame sensors).

**FIGURE 16**
Sensor swab or wipe

Sometimes several devices can be purchased together as a sensor-cleaning kit (shown in **FIGURE 17**), but if you only plan on using one type, the sensor brush or stamp is usually adequate. It's often a good idea to try several tools in succession (although some people skip the blower). Ideally, you won't ever have to use a sensor swab, but if you do and have been doing maintenance with other tools, most of the larger and more abrasive particles will have been removed prior to you risking full contact with the swab.

**FIGURE 17**
Cleaning equipment
for the sensor, lens,
and lens filter

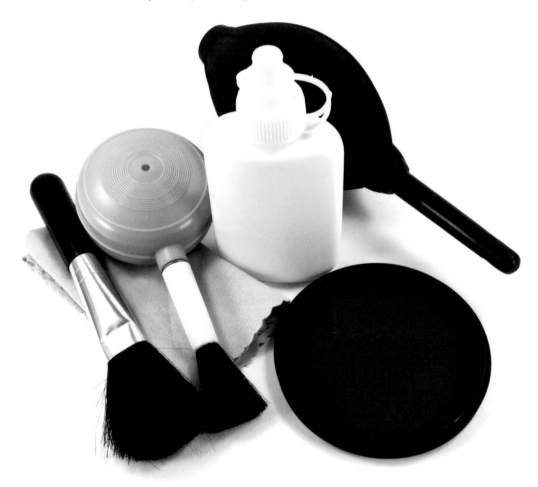

# HOW TO CLEAN YOUR SENSOR

Knowing what cleaning might entail can give you a better idea of whether this is something you're comfortable doing yourself. The procedure shown **FIGURES 18** and **19** provides the general steps for cleaning with a sensor brush and/or sensor swab tool. Although these steps are a tested guide, you should always consult the instructions come with your specific tool.

In **FIGURES 18** and **19**, the light blue represents the tip of your sensor cleaning swab or brush tool. The dark rectangular region represents the camera sensor. The arrow is the path the tool should move along. These diagrams assume that your cleaning tool is the width of your sensor. Follow this motion only once; sweeping back and forth is less effective and has more potential for damaging the sensor.

**FIGURE 18**
Side view of the camera sensor

**FIGURE 19**
Face view of the camera sensor

## PREPARATION FOR CLEANING

The cleaning process can be easier and more effective with the following preparation:

- **Become familiar with the process**  Read through all the steps for cleaning ahead of time so you are familiar with each and ready to perform them in succession.

- **Check the battery**  Fully charge your camera battery.

- **Plan a time**  Set aside a block of 15–20 minutes when you are unlikely to be interrupted. Also, plan to turn off your mobile phone while cleaning to minimize distractions.

- **Choose a location**  Pick a clean environment with still air.

- **Arrange the tools**  Have all necessary tools ready and easily accessible.

- **Prepare**  It's good practice to clean the camera body, lens, and lens mounts with a damp cloth to remove dust that could end up on your sensor later.

- **Set camera to cleaning mode**  Set your camera to its manual cleaning mode. Consult your camera manual if necessary.

- **Position your camera**  Remove the lens and place your camera on its back on a flat surface that allows good visibility and easy access to the sensor.

## CHOOSE A CLEANING METHOD

Next, you'll want to decide on your sensor-cleaning tool:

- **Sensor blower**  Turn the camera over so the sensor is facing downward and then send several puffs of air into the camera body. After each puff, wait 5–10 seconds for dust to settle out. You'll usually need to use one of the other tools as well.

- **Sensor brush**  Gently place the bristled end of the brush at the edge of your camera sensor and follow the motion shown in **FIGURES 18** and **19**. Apply only very light pressure—much less than if you were painting—and whisk away the dust. Brushes work by attracting dust particles to their fibers electrostatically, so you don't need to scrub the sensor. Try to prevent the brush bristles from touching anything outside the sensor's edges, as this may transfer camera lubricants or other contaminants onto the sensor.

- **Sensor stamp**  Gently press the cleaning end of this tool against your camera sensor's surface. Avoid dragging it across the surface, which may leave streaks or create scratches. If the stamp area is smaller than your sensor's area, use placements that minimize the number of times the stamp needs to be pressed against the sensor.

- **Sensor swab**  If necessary, affix the cleaning tissue to the end of your cleaning tool and place two to three drops of cleaning fluid on the tip. Some tools come already prepared, so this step might not be necessary. Gently place the tissue-covered end of your tool on the edge of the sensor and follow the motion shown in **FIGURES 18** and **19**. Be sure not to apply more pressure than you would when writing with a fountain pen.

When you are done cleaning, it is good to verify the results. Turn your camera off and reattach your lens. Take a test photo of a smooth, light surface using your lens's highest f-stop value (review the "How to Locate Sensor Dust" on page 213 for additional details on performing this step). If the remaining dust is still unacceptable, you'll need to repeat the cleaning and perhaps use more aggressive methods.

# ALTERNATIVES TO CLEANING SENSORS YOURSELF

If the thought of cleaning the sensor makes you nervous, it should. A lot can go wrong if you aren't careful. If you'd rather play it safe, your alternatives are to edit out the spots or have someone else clean the sensor.

- **Editing out the spots**  Using the clone and healing brush tools in Photoshop can be a very effective way of removing dust spots. This works well if the spots are easy to edit and if the dust problem remains minor. Editing software sometimes has dust map features that digitally edit dust spots that occur in the same locations of each photo. Eventually you'll have to get the sensor cleaned, though.

- **Having someone else clean the sensor**  You can always send your camera to the manufacturer or a camera store so that it can be cleaned by a professional. If you plan on having a local store perform the cleaning, make sure to verify up front that they will insure your camera against any potential sensor damage. Also, check your camera immediately by taking a test photo upon pickup.

# INDEX

diffusers, 125–126, 130, 168
digital SLR cameras, xiv–xv
    f-stop increments, 6
    focal lengths, 48
    ISO ranges, 7
    maximum aperture ranges, 53, 54
    pixel size, 79
    summary comparisons, 74–75
    viewfinders, 76
digital zoom, 51
distance
    and depth, 62, 65–68, 138, 156, 160
    of light source, 169–170
distortion, 44–45, 63
documentary photography, 48
DSLR cameras. See digital SLR cameras
dusk, 151
dust, 210–213
dynamic range, 80, 113

**E**

edge distortion, 63
editing. See also Photoshop
    dust spot removal, 218
    image averaging, 109–110
    of lighting, 112, 118, 121
    red-eye reduction, 129
    software, 36, 39, 195
electronic viewfinders (EVF), 76
enclosed spaces, 60
evaluative metering, 12, 13
EVF. See electronic viewfinders (EVF)
exposure. See also flash exposure
    concepts, 2
    in high- and low-key images, 29–31, 137
    uneven, 61–62, 112–113
exposure compensation
    with flash, 134–136
    in fog, 155
    silhouettes, 159
    using, 13–14
exposure modes, 8–10, 81
exposure times
    and focal length, 48, 83
    in fog, 162
    and motion, 104, 105, 107–109
exposure triangle, 2, 184–185

**F**

f-stops
    and aperture, 5–7, 51–52, 54
    with neutral density filters, 106–107, 114
    in pre-set modes, 9
    and shutter speed, 184, 189

fill flash, 128, 132–133, 134, 176, 179
fill light ratio, 176–177
fill lighting, 175–180
filter mounting systems, 110–111
filters. See also graduated neutral density (GND)
    filters; neutral density (ND) filters
        in digital sensor arrays, 23–24, 25
        lens, 92–95
        stacking, 94, 111
fixed-pattern noise, 36
flare. See lens flare
flash brackets, 127
flash diffusers, 125–126, 130
flash exposure, 131–135
flash exposure compensation (FEC), 134–136, 179
flash exposure lock (FEL), 139
flash lighting. See also fill flash
    with AF assist beam, 201
    and camera type, 81
    concepts and equipment, 124–130, 131, 166
flash metering, 138–139
flash ratio, 132–133, 134, 135–136, 176–177, 179
focal lengths, 46–49, 56, 64
focal plane, 15
focus
    accuracy of, 68–69
    and recompose, 69, 198
    tracking, 200
focus lock, 198, 200–201, 202
fog
    and camera protection, 162–163
    distance and depth, 67–68, 156
    lighting in, 154–155, 157–158
    location and timing, 160–162
    silhouettes in, 159
foreground, 58, 67, 68
frame rates, 81
freeze, 3–4, 190–191, 193–194

**G**

ghosting, 94
glare, 102–103, 125–126, 139
GND. See graduated neutral density (GND) filters
golden hour, 145, 149–151
gradients
    in GND filters, 114–117
    Photoshop, 112, 119
graduated neutral density (GND) filters, 61–62, 92, 111–121
grain, 34. See also noise
gray cards, 11
grayscale images, 20, 147

**H**

handheld shooting
    settings for, 5, 7, 134
    techniques, 185–186
hard edge GND filters, 115–117
hard light, 125, 139, 166–169, 178–179, 210–211
haze. See also fog
    filters for, 92, 93
high dynamic range (HDR) photography, 80, 84, 121
high-key images, 28–31, 137, 176
high-speed photography, 193–194
highlights
    clipped, 31, 80
    in histograms, 26–27, 28–29
    and light source, 166–168
histograms, 26–33
hot shoe mounts, 131

**I**

illumination. See light and lighting
image averaging, 109–110
image bit depth, 20–21
image histograms, 26–33
image quality
    filters and, 94, 119, 120
    lens types and, 77
    sensor size and, 79–80
    and UV filters, 93
image stabilization (IS), 84, 187, 192
incident light, 10–11, 211
interior spaces, 60
IS (image stabilization), 84, 187, 192
ISO speed
    in exposure modes, 9
    in exposure triangle, 2, 184
    and image noise, 7, 36, 40, 80
    and neutral density filters, 106
    settings, 35, 81, 84, 189

**J**

JPEG file bit depth, 21

**K**

key lights, 166–175
key triangle, 171–173

**L**

Landscape mode, 9
landscape photography. See also natural lighting
    camera direction, 146
    cameras for, 25, 79
    composition, 58

GND filters, 61, 112, 114–119
lenses, 48, 67–68
layering, 67–68
LCD/LED screens, 5, 76, 81, 97, 190
lens collars, 87
lens filters, 92–95. *See also* graduated neutral density (GND) filters; neutral density (ND) filters; polarizing filters/polarizers
lens flare, 48, 62, 93, 94
lens hoods, 62
lenses. *See also* telephoto lenses; wide-angle lenses
changing, 214
dust on, 212
elements, xii–xiii, 44, 213
and f-stop values, 6
fixed vs. interchangeable, 74–75, 77–79, 81
types, 43, 49–51, 54
light and lighting. *See also* flash lighting; natural lighting; portrait photography
and aperture settings, 5
and autofocus, 197–198
color filters for, 93–94
concepts, xii
distribution, 124–126
with neutral density filters, 106–107
positioning, 126
and shutter speed, 3, 195–196
in viewfinders, 76
light-gathering ability, 51–52, 54
light meters, 10–11
lighting direction, 166, 170–175
live-view rear LCD, 81
loop lighting, 173
low-key images, 28–31, 137, 176
luma noise, 39–40
luminance, 11

## M

M mode. *See* Manual mode
macro lenses, 77, 78
macro photography, 78, 86
manual control, 81
Manual mode, 8, 9, 133, 134
matrix metering, 12, 13
maximum apertures, 52–54
medium-angle lenses, 48
medium-telephoto lenses, 64, 71
metering, 10–14, 136–139
microlens arrays, 26
middle gray, 11
midtones, 26–27, 28, 30, 113
mini tripods, 88
minimum apertures, 53
mirror lock-up (MLU), 187

mirror mechanism, 76, 81
mirrorless cameras, xv, 48, 74–75, 76
mist. *See* fog
moiré, 25
monopods, 89
motion
and autofocus, 200
and neutral density filters, 104, 105
and shutter speed, 3–5
motion blur
creative use of, 189–195
and curtain syncs, 140–141
with image averaging, 109–110
shutter speed, 2, 3
multiple exposures, 119

## N

natural lighting
and cloud cover, 153–154
components and quality, 144–153
as fill lighting, 180
in mist and fog, 154–155, 157–158
silhouettes in, 159
neutral density (ND) filters, 92, 104–111
Night/low-light mode, 9
noise
and camera type, 80
concepts, 2, 34–41
in fog, 162
and microlens design, 26
and shutter speed, 189
noise-reduction software, 36, 39

## O

off-axis/on-axis fill light, 177–179, 180
one-axis stabilization, 192
one-over-focal-length rule, 49, 83
one-shot focusing, 200, 202
opening up. *See* f-stops
optical low-pass filter (OLPF), 25
optical quality, 44
optical zoom, 51
overcast sunlight, 152–153
overexposure
clipping, 31
defined, 2
and noise, 38
unintentional, 11, 13–14, 184

## P

P mode. *See* Program mode
painted effects, 195
pan-tilt tripod heads, 86
panning, 191–192
panoramic photos, 84, 103

partial metering, 11–13
perspective
creative, 88, 187
and focal lengths, 46–47, 49–51
telephoto, 65–66
wide-angle, 56–58
photography
investments and shooting style, 81
learning and mastery, xi, xvi
photon collection. *See* photosites
Photoshop
filters, 112, 118–119, 121, 195
locating sensor dust with, 213
photosites, xiv, 22–26
pinhole cameras, 17
pixels
in fixed-pattern noise, 36
on histogram axis, 26–27
in sensor arrays, 22–26
size, 16, 40, 79–80
point-and-shoot cameras. *See* compact cameras
polarizing filters/polarizers, 60–61, 92, 95–104, 111, 147
Portrait mode, 9, 202
portrait photography
depth of field, 53, 79
fill lighting, 175–180
focal lengths, 48, 57
focus, 202
light distribution, 125
metering, 13
natural lighting, 152
single light source lighting, 166–175
posterization, 21, *22*
pre-focusing, 193, 201
pre-set modes, 8–10
prime lenses, 51, 54
print size and circles of confusion, 15–16
Program mode, 8, 9, 133, 134

## Q

quick-release mechanisms, 87

## R

radial blend GND, 115
random noise, 36
RAW files, 81, 93
red-eye reduction, 129
reflectance, 10–11, 13–14, 137, 138–139
reflected light, 10–11, 92, 101, 168
reflections, 92, 101, 139, 146
reflectors, 180
Rembrandt lighting, 171–173
remote release devices, 187